PENGUIN

WHAT IS ART?

COUNT LEO TOLSTOY was born in 1828 on the family estate of Yasnaya Polyana, in the Tula province, where he spent most of his early years, together with his several brothers. In 1844 he entered the University of Kazan to read Oriental languages and later law, but left before completing a degree. He spent the following years in a round of drinking, gambling and womanizing until, weary of his idle existence, he joined an artillery regiment in the Caucasus in 1851. He took part in the Crimean war and after the defence of Sevastopol wrote *The Sevastopol Sketches* (1855–6), which established his literary reputation. After leaving the army in 1856 Tolstoy spent some time mixing with the literati in St Petersburg before travelling abroad and then settling at Yasnaya Polyana, where he involved himself in the running of peasant schools and the emancipation of the serfs. His marriage to Sofya Andreyevna Behrs in 1862 marked the beginning of a period of contentment centred on family life; they had thirteen children. Tolstoy managed his vast estates, continued his educational projects, cared for his peasants and wrote both his great novels, *War and Peace* (1869) and *Anna Karenin* (1877). During the 1870s he underwent a spiritual crisis, the moral and religious ideas that had always dogged him coming to the fore. *A Confession* (1879–82) marked an outward change in his life and works; he became an extreme rationalist and moralist, and in a series of pamphlets written after 1880 he rejected church and state, indicted the demands of flesh and denounced private property. His teachings earned him numerous followers in Russia and abroad, and also led finally to his excommunication by the Russian Holy Synod in 1901. In 1910, at the age of eighty-two, he fled from home 'leaving this worldly life in order to live out my last days in peace and solitude'; he died some days later at the station master's house at Astapovo.

RICHARD PEVEAR was born in Waltham, Massachusetts, in 1943. He has published translations of Alain, Yves Bonnefoy and Alberto Savinio, as well as two books of poetry. He and his wife, Larissa

Volokhonsky, who was born in Leningrad, have translated works by Pavel Florensky, Samuel Marshak, Daniil Kharms, Henri Volohonsky, Alexei Khvostenko, Fyodor Dostoyevsky and Nikolai Gogol. Their translation of *The Brothers Karamazov* received the PEN translation award in 1991, and they translated Bulgakov's *The Master and Margarita* for Penguin Classics. They live in France.

LEO TOLSTOY

WHAT IS ART?

TRANSLATED BY RICHARD PEVEAR
AND LARISSA VOLOKHONSKY

PENGUIN BOOKS

PENGUIN BOOKS

Published by the Penguin Group
Penguin Books Ltd, 80 Strand, London WC2R 0RL, England
Penguin Putnam Inc., 375 Hudson Street, New York, New York 10014, USA
Penguin Books Australia Ltd, 250 Camberwell Road, Camberwell, Victoria 3124, Australia
Penguin Books Canada Ltd, 10 Alcorn Avenue, Toronto, Ontario, Canada M4V 3B2
Penguin Books India (P) Ltd, 11 Community Centre, Panchsheel Park, New Delhi – 110 017, India
Penguin Books (NZ) Ltd, Cnr Rosedale and Airborne Roads, Albany, Auckland, New Zealand
Penguin Books (South Africa) (Pty) Ltd, 24 Sturdee Avenue, Rosebank 2196, South Africa

Penguin Books Ltd, Registered Offices: 80 Strand, London WC2R 0RL, England

www.penguin.com

This translation first published 1995

042

Typeset by Datix International Limited, Bungay, Suffolk
Printed and bound in Great Britain by Clays Ltd, Elcograf S.p.A.
Set in 10/12.75 Monophoto Bembo

ISBN-13: 978–0–14–044642–5

www.greenpenguin.co.uk

Contents

Preface

A friend of mine turned on his radio early one morning in Moscow about twenty years ago and heard a rasping old recording of an old man's voice saying, 'It is impossible to live like this – impossible, impossible, impossible!' Then a calm Soviet announcer interrupted: 'You have just been listening to the voice of the great Russian writer Lev Nikolaevich Tolstoy.' The words come in fact from Tolstoy's article of 1882 *On the Occasion of the Moscow Census*, but they are the refrain of almost all he wrote in the last thirty years of his life.

Anger, but also anguish, spurred Tolstoy to a long series of polemical books and tracts, culminating in *What is Art?*, which he worked at for fifteen years and finally completed in 1898. They also nourished in a more complex and ambiguous way his artistic works of the same period – *The Death of Ivan Ilych*, *The Devil*, *The Kreutzer Sonata*, *Master and Man*, *Father Sergius*. Only his very last novella, the serene and perfect *Hadji Murat*, is free of these enormous inner tensions, as if through art Tolstoy had attained a moment of reconciliation, returning in spirit to the Caucasus he had first known as a young man in 1851.

The anger that prompted Tolstoy's polemical campaign of the 1880s and 1890s, which made him world-famous and brought him flocks of disciples and visitors in his last years, was both an expression of his will to dominate others, to be a 'spiritual master', and a shield or cover to conceal his inner anguish. The first intense experience of this anguish came upon him strangely and suddenly one night in 1869. He was then forty-one years old, a famous author (the final part of *War and Peace* was given to the publisher in October 1869; the earlier parts were already in their second edition), happily married, the father of a young family, and on his way to Penza to buy some land. On 4 September 1869 he wrote to his wife:

The day before yesterday I spent the night in Arzamas, and an extraordinary thing happened to me. At two o'clock in the morning, a strange anxiety, a fear, a terror such as I have never before experienced came over me. I'll tell you the details later, but never have I known such painful sensations, and may God keep everyone else from them. I got up quickly and gave orders to harness the horses. While they were harnessing up, I slept and awoke again feeling quite well. Yesterday these feelings came back while we were on the road, but much attenuated; I was prepared and resisted them, the more so as they were less strong. Today I feel quite well, cheerful, so far as that is possible away from you. In the course of this trip, I have felt for the first time how close you are to me, you and the children. I can be alone as long as I am constantly occupied, as in Moscow, but once I have nothing to do, I feel clearly that I cannot be alone.

In 1884 Tolstoy began to write a slightly fictionalized account of this night of sudden, inexplicable terror, to which (borrowing from Gogol) he gave the title *Diary of a Madman*. The story was left unfinished, but the experience obviously continued to haunt him. 'An abyss had opened before him which threatened to swallow him,' wrote the philosopher Lev Shestov, 'he saw the triumph of death on earth, he saw himself a living corpse.' This was the 'madness' behind all his reasoning.

In *Anna Karenina*, finished in 1877, Tolstoy shows his semi-autobiographical hero, Konstantin Levin, as similarly death-infected, struggling with this power that threatened to tear him away from all that he loved and lived for. In the eighth and final part of the novel we read:

All that spring he was not himself and lived through terrible moments.

'Without knowing what I am and why I am here, it is impossible for me to live. And I cannot know that, and consequently it is impossible for me to live,' Levin would say to himself.

'In infinite time, in the infinity of matter, in infinite space, a bubble-organism separates itself, this bubble holds out for a while and then bursts, and this bubble is me.'

This was a tormenting untruth, but it was the sole, the ultimate result of age-long labours of human thought in that direction.

This was the ultimate belief on which all the researches of the human mind in almost all fields were built. This was the reigning conviction, and from among all other explanations Levin, himself not knowing when and how, had involuntarily adopted precisely it, as being at any rate the most clear.

Yet it was not only untrue, it was the cruel mockery of some evil power, evil, adverse, and such as it was impossible to submit to.

It was necessary to be delivered from this power. And deliverance was in everyone's reach. It was necessary to stop this dependence on evil. And there was one means – death.

And, happy in his family life, a healthy man, Levin was several times so near to suicide that he hid a rope lest he hang himself with it, and was afraid to go about with a rifle lest he shoot himself.

But Levin did not shoot himself or hang himself and went on living.

A few pages further on, Levin is watching his peasants at the threshing. It is one of his 'most tormenting' days:

'Why is all this being done?' he thought. 'What am I standing here and making them work for? Why are they all bustling about and trying to show me their zeal? Why is this old woman, Matryona, my acquaintance, toiling so? (I treated her when a beam fell on her during the fire),' he thought, looking at a thin woman who, as she moved the grain with a rake, stepped tensely with her black-tanned bare feet over the hard, uneven threshing floor. 'That time she got well; but today or tomorrow, or in ten years, they'll bury her and nothing will be

left of her, nor of that saucy one in the red skirt who is beating the grain from the chaff with such a deft and easy movement. She'll be buried, too, and so will this piebald gelding, very soon,' he thought, looking at the heavy-bellied horse, breathing rapidly with flared nostrils, that was treading and turning the slanted wheel. 'He'll be buried, and Fyodor the feeder, with his curly beard full of chaff and the shirt torn on his white shoulder, will also be buried. And now he's ripping the sheaves open, and giving orders, and yelling at the women, and straightening the belt on the flywheel with a quick movement. And moreover, not only they, but I, too, will be buried and nothing will be left. What for?'

But in another moment this same Fyodor will be responsible for Levin's sudden 'conversion'. They get into a discussion of human character, and Fyodor says:

'Just so, then – people are different. One man lives only for his own needs – take Mityukha even, he just stuffs his belly full, but Fokanych – he's an upright old man. He lives for the soul. He remembers God.'

'How is it he remembers God? How is it he lives for the soul?' Levin almost cried out.

'We all know how – according to the truth, to God. People are different. Now, take you even, you wouldn't offend anyone either . . .'

'Yes, yes, good-bye!' Levin said, breathless with excitement, and, turning, he took his stick and quickly walked towards home. At the peasant's words about Fokanych living for the soul, according to the truth, to God, it was as if vague but important thoughts burst in a crowd from some locked-up place and, all straining for the same goal, whirled in his head, blinding him with their light.

Suddenly Levin *knows*. He realizes that 'nobody is free of doubt about other things, but nobody ever doubts this one thing, every-

body always agrees with it'. This certainty was what Levin needed
and could not find for himself – a collective certainty, a universal
agreement, beyond reason. This is what the peasant's words suddenly
revealed to him. Certainty of what? Levin thinks to himself:

... Fyodor says it is bad to live for one's belly, and that one
must live for truth, for God, and I understand him from a
single hint! And I, and millions of people who lived ages ago
and are living now, peasants, the poor in spirit, and wise men
who have thought and written about it and who in their
obscure language say the same thing – we all agree on this one
thing: what one must live for, and what is good. I, together
with all people, have only one firm, unquestionable and
clear knowledge, and this knowledge cannot be explained by
reason – it is outside it, and has no causes, and can have no
consequences.

If the good has a cause, it is no longer the good; if it has a
consequence – a reward – it is also not the good. Therefore the
good is outside the chain of causes and effects.

And it is precisely this that I know, and that we all know.

And when Levin's thoughts turn to the Church, from which he
has always kept his distance, he now sees it in the light of his new
faith:

In place of each of the Church's beliefs there could be put the
belief in serving truth instead of needs. And each of them not
only did not violate it, but was necessary for the accomplish-
ment of that chief miracle, constantly manifested on earth,
which consists in it being possible for each person, along with
millions of the most diverse people, sages and holy fools,
children and old men – along with everyone, with some
peasant, with Lvov, with Kitty, with beggars and kings – to
understand with certainty one and the same thing and to
compose that life of the soul which alone makes life worth
living and is alone what we value.

Finally, at the very end of *Anna Karenina*, Levin comes to his fullest affirmation:

> Yes, the one obvious, unquestionable manifestation of the divinity is the laws of the good disclosed to the world by revelation, and which I feel in myself, and in the acknowledgement of which I do not so much unite myself as I am united, whether I will or no, with others in one community of believers which is called the Church.

Readers of Tolstoy's later philosophical and polemical writings, of *What is Art?* in particular, will find in them many of the features of Levin's new faith – the absolute and revealed nature of the good, the identification of the good with God, the unity and unanimity of mankind in service of the good – what Tolstoy came to call 'true Christianity'. They will also find some crucial differences, which I will come to in a moment. But if I have quoted at such length from *Anna Karenina*, it is because in his artistic works Tolstoy reveals more than his conclusions; he reveals what lies behind the struggle to arrive at them and to hold to them – here, that inexplicable terror, that sense of nullity, that obsession with death which Tolstoy shared with his hero. He also shows, perhaps not altogether unintentionally, the human situation of his 'thinker', the figure of the landowner as home-grown philosopher, the sort of village explainer we meet later in Tolstoy's own tracts. And by this constant reasoning and substituting of one belief for another, he hints at the instability of such conversions.

Tolstoy converted himself momentarily along with his hero, and turned to the community of the Orthodox Church. He became a practising Christian. In July 1877, just after finishing *Anna Karenina*, he made the first of four visits to the monastery of Optino, famous at the time for its elders (*startsy*) and for its translation and publication of the major works of Eastern Orthodox spirituality. (Gogol had visited Optino in the 1850s, and in 1878 Dostoevsky made a pilgrimage there with the young poet and philosopher, Vladimir Soloviev.) Tolstoy met the elder Amvrosy, now Saint Amvrosy,

and was deeply impressed by his wisdom and spiritual force. Afterwards, he continued to attend church services for another year or so, noting some of the occasions in his diary ('took communion,' 'went to matins'). But a new crisis was brewing in him. Suddenly, in a diary entry dated 30 October 1879, we read: 'Only the persecuted are in the truth, the Paulicians, Donatists, Bogomils, and others like them. And fully so, because they have suffered violence.' So he ranged himself on the side of the heretics, purifiers or opponents of the Church (almost the same list of sects is repeated approvingly twenty years later in *What Is Art?*). There was too much in the dogmas, the mysteries and the authority of the Church that his reason and conscience could not accept. Later in that same year he turned his back just before taking communion and walked out of the church, never to return.

Tolstoy referred to this rejection as the moment of his conversion to 'true Christianity'. In his *Confession*, written in December 1879 but left unfinished and published only in 1911, he described his spiritual state in anguished terms and gave the reasons for his sudden break with the Church. By March of the next year, he had produced a *Critique of Dogmatic Theology*, the first of his attacks on the Church's supposed perversion of the Christian truth, a work which, as Shestov wrote, 'in its sacrilegious raillery yields nothing to the writings of Voltaire'. He then began work on a *Conflation and Translation of the Four Gospels*, his personal version of the New Testament, purged of references to Christ's divinity, to miracles, the supernatural, redemption, immortality, all of which he considered irrational and pernicious additions to the teaching of Christ. This work occupied him sporadically for several years. Returning to Optino in the summer of 1881, he presented his new views to the elder Amvrosy, denouncing the Church and disputing certain points in the Gospels, and this time he came away disappointed with the elder's 'blind faith'. He was then drafting a full explanation of 'true Christianity', which was published in 1884 under the title *What I Believe*. And he was beginning to attract disciples.

The castigator of the Church soon became the castigator of the State and society as well. This was a result of his return to Gospel

purity, but also of his move in 1882 from his country estate at Yasnaya Polyana to Moscow, where he reluctantly settled with his family for the sake of the children's education and entry into social life. There for the first time he became conscious of the horrors of urban poverty. He encountered the homeless in charity shelters during his work for the Moscow census, and felt that it was 'impossible, impossible, impossible' for the wealthy to live as they did in the face of such wretchedness and hopelessness. He gave money to some of these people, but quickly realized that personal charity was not enough. He used the occasion to lash out at society, at his own class, in his article on the Moscow census and in its fuller development, *What Then is to Be Done?*, published in 1886. This was followed by *Church and State* (1891), and then by the most complete expression of his combined social and spiritual message, *The Kingdom of God is Within You* (1894).

Essentially, Tolstoy's teaching is a form of Christian anarchism, based on the principle of brotherly love and on certain precepts from the Sermon on the Mount: do not be angry; do not commit adultery; do not swear oaths; do not resist evil; love your enemies (see Matthew 5:21–43). With this Gospel distillation he combined the general outlook of a nineteenth-century liberal and specifically the view of history as the process of moral evolution of the masses and the effacement of governments. The good, he believed, would lead mankind eventually to a stateless, egalitarian, agrarian society of non-smoking, teetotal vegetarians dressed as peasants and practising chastity before and after marriage. This would be the Kingdom of God on earth.

In fact, the idea was not at all new to Tolstoy. In a diary entry dated 4 March 1855, we read:

Yesterday a conversation on the divine and faith led me to a great, an immense thought, to the realization of which I feel capable of devoting my life. – This thought is to found a new religion corresponding to the evolution of humanity, a religion of Christ, but stripped of faith and mysteries, a practical religion which promises no future blessedness, but grants

blessedness on earth. ... To act *consciously* for the union of men with the help of religion, that is the basis of a thought which, I hope, will sustain me.

Tolstoy was then twenty-seven years old. What is remarkable is that the same thought could still sustain him at the age of seventy, when he finally sat down and wrote *What is Art?*

The figure Tolstoy made for himself, or of himself, has the age-old features of the sectarian – the claims of purity and truth in his teaching, coming from a direct relation to God; the denial of all authority other than God's and of all responsibility other than to God; the rejection of all forms of ritual, sacrament, symbolism, mediation; the condemnation of luxury, inequality and other social abuses; the call for plain living and abstention; the Manichaean notion that the flesh and matter in general are evil. However, perhaps not surprisingly, he also has certain traits of the Russian nihilists of the 1860s. He has the heavy rationalism and moralism of the nihilists, their defiant manner, their deliberately crude and emphatic prose style. His polemical treatment of the question of art, in particular, has much in common with nihilist criticism.

The ambition of young radical writers like Nikolai Dobrolyubov (1836–61) and Dmitri Pisarev (1840–68) was to serve the advancement of the people, to destroy all that enslaved them, to achieve social justice in Russia, and through Russia to save the world. They were 'idealists' who clothed their ideals in the terms of positivism, utilitarianism, rational egoism. Service in the cause of the people was the only criterion they allowed. It was Pisarev especially who raised the question of the utility of art, attacked 'art for art's sake', proclaimed that 'boots are higher than Pushkin', and denounced poetry that gives pleasure to the wealthy few while the people suffer. The nihilists reproached Pushkin not only for his trivial verses, but for dying in a duel, and they condemned the raising of a monument to 'the singer of women's little feet'. All this anger from the 1860s sounds again in Tolstoy's writing of 1898.

But, though he had been no partisan of Pisarev, these attitudes

also were not new to Tolstoy. For instance, in a notebook entry dated 13 August 1865, we read:

> The universal national mission of Russia consists in introducing into the world the idea of a social structure without landed property.
>
> *La propriété, c'est le vol* ['Property is theft'] will remain a truth truer than the English Constitution as long as the human race exists. – It is the *absolute* truth . . . The Russian revolution will not be against the Tsar and despotism, but against landed property.

Tolstoy had met the libertarian socialist, Pierre-Joseph Proudhon, whose famous saying he quotes, in Brussels, in 1861, and had obviously been much impressed by him. He also borrowed the title of *War and Peace* from one of Proudhon's books. In the great novel itself there is a debunking of opera very similar in method and tone to the repeated mockery of opera, Wagner's especially, in *What is Art?*. And then there is also the two-hundred-page epilogue to the novel, in which Tolstoy 'voluptuously surrenders to his two demons, *didacticism* and *depoetization*' (the words are Marie Sémon's, from her excellent book, *Les femmes dans l'oeuvre de Léon Tolstoï*). As Lev Shestov wrote more sharply: '. . . the entire epilogue to *War and Peace* is an impertinent, deliberately impertinent, challenge hurled by Count Tolstoy at all educated men – if you will, at the entire conscience of our time.'

Didacticism and depoetization are given free rein in *What is Art?*, which is another 'challenge hurled at all educated men'. And here Tolstoy goes further than the nihilists dared to go. He negates more. He condemns not only Pushkin but Shakespeare, Dante, Goethe, Raphael, Michelangelo, Bach, Beethoven – and his own novels. As examples of good art he cites an anonymous story about a chicken, the singing of the peasant women on his estate to the banging of scythes, the most sentimental of genre paintings, doorknobs, china dolls. There is deliberate provocation in all this, but

there is also a sort of logical helplessness, as if he were forced to go where his demons led him.

Because Tolstoy conceived his mission in religious terms, his formulation of the question of art is more radical than that of the nihilists. He attacks not only the circumstances in which art is produced or its ideological content, but the very make-up of the work of art, its essence, in his dismissal of the criterion of beauty. It is true, however, that the question of art is ultimately a religious question, and because he conceives it at that level, Tolstoy is able to make some very accurate (and occasionally very funny) observations about modern art and modern artists. For instance, he writes: 'In Russia we have the painter Vasnetsov. He painted the icons for the Kiev cathedral; everyone praises him as the founder of some sort of new Christian art of a lofty sort. He worked for decades on these icons. He was paid tens of thousands of roubles. And all these icons are bad imitations of imitations of imitations, and do not contain one scintilla of feeling.' Vasnetsov was a nineteenth-century painter, trained to work in oils on canvas. His new icons for the Kiev cathedral were as bad as Tolstoy thought, if not for the reasons he thought. I have chosen this example because it allows me to place Tolstoy's thought in relation to that of a younger Russian contemporary, Pavel Florensky (1882–1937), who also wrote about art and aesthetics and who was also no admirer of Vasnetsov's icons. In this way two religious formulations of the question can be compared – the Tolstoyan, with its rejection of the criterion of beauty, and the traditionally Christian, for which beauty is the criterion not only of art but of all spiritual endeavour.

Florensky, mathematician, theologian and Orthodox priest, was at the centre of what has been called the 'renaissance of Russian religious thought' in the first decades of this century, which produced such thinkers as Vasili Rozanov, Nikolai Berdyaev, Lev Shestov, Sergei Bulgakov, and which drew inspiration from the works of Vladimir Soloviev and Dostoevsky. In his book *Iconostasis*, Florensky describes the state of modern (post-medieval) religious art in terms almost identical with Tolstoy's. He speaks of art beginning to follow 'exclusive paths' and taking on 'unusual, mysteriously

compound forms, some sort of rebuses of the spiritual world', of the loss of 'contemplative clarity and directness', resulting in works 'accessible only to the few', 'allegorized symbols', 'abstract schemas conventionally expressed with sensuality and frivolity', revealing 'an apostasy from universal mankind'. Virtually the same words appear on page after page of *What is Art?*. But when it comes to the question of Vasnetsov's icons, the opposition of these two ways of thinking reveals itself: Tolstoy finds Vasnetsov's icons excessively imitative and lacking in feeling; Florensky finds them excessively original and lacking in truth.

Tolstoy's most basic tenet, placed in italics in the fifth section of *What Is Art?*, is the following:

Art is that human activity which consists in one man's consciously conveying to others, by certain external signs, the feelings he has experienced, and in others being infected by those feelings and also experiencing them.

Infectiousness is Tolstoy's criterion of art, whatever the worth of the feelings it conveys. Good art, then, is art which conveys to others the artist's experience of the feeling of the good, so that they become infected by the same feeling. In the seventh section, Tolstoy defines the good in contradistinction to the beautiful:

The good is the eternal, the highest aim of our life. No matter how we understand the good, our life is nothing else than a striving towards the good – that is, towards God.

The good is indeed a fundamental concept, which metaphysically constitutes the essence of our consciousness, a concept undefinable by reason.

The good is that which no one can define, but which defines everything else.

But the beautiful, if we are not to content ourselves with words, but speak of what we understand – the beautiful is nothing other than what is pleasing to us.

... The more we give ourselves to beauty, the more re-

moved we are from the good. I know that the usual response
to this is that there exists a moral and spiritual beauty, but that
is only a play on words, because by spiritual or moral beauty
we mean nothing other than the good.

Christian tradition, represented by Florensky but going back to
the earliest fathers of the Church, has understood the nature of
artistic activity, of the artistic image or symbol, and the relations of
beauty and the good in a profoundly different way. Beauty here is
that 'intelligent light' which reveals the object in its 'first-created'
truth. This simple assertion implies a complex theological understand-
ing which cannot be summarized in so brief a space. In *The Pillar
and Foundation of Truth* (1914), Florensky himself resorts to the
analogy of physical light to explain it. Everything else in the
material world seems beautiful to us indirectly, by way of a certain
intellectual satisfaction it gives us. 'Light, on the contrary, is beautiful
beyond all fragmentation, beyond all form; it is beautiful in itself,
and through itself makes beautiful all that appears.' Light appears
and makes appear. To contemplate the object is also to contemplate
the light in which it appears. Light makes contemplation possible; it
is that which can be revealed and at the same time that which
reveals. 'Thus,' Florensky writes, 'if beauty is revealability, and
revealability is light, then, I repeat, beauty is light and light is
beauty. The absolute light is then the absolutely beautiful – Love
itself in its completeness, which (through itself) makes every person
spiritually beautiful. The Holy Spirit, who crowns the love of the
Father and the Son, is both the subject and the organ for contemplat-
ing the beautiful.'

This light, or beauty, comes to us. That is the most telling point
in Florensky's commentary. It is joined with matter. It 'co-inheres',
to use the term of another Christian thinker of this century, the
English poet Charles Williams. It makes radiant.

In Greek, the word for ascetic endeavour, the life of anchorites
and elders, is *philokalia*. As opposed to *philosophia*, the love of
wisdom, *philokalia* is the love of beauty. The aim of the ascetic life,
then, is not the mortification of the flesh but its glorification – the

real creation of real beauty. Florensky comments: 'And indeed asceticism creates not a "good" man, but a *beautiful* one, and the distinctive quality of the holy ascetics is not at all their "goodness", which occurs also in carnal men, even in quite sinful ones, but a spiritual *beauty*, the dazzling beauty of the radiant, light-bearing person . . .' *Philokalia* is 'not science, not even moral endeavour, but *art*, and, moreover, it is art *par excellence* – the "art of arts" '.

The reality of beauty, in this Christian understanding, is most fully attained in the flesh, in the face of the saint. It also inheres, or it *therefore* inheres, in the icon, the symbol of the 'light-bearing face'. Symbol is not opposed to reality here, as a 'mere' symbol of it, but expresses the unity of two realms, the penetration of the divine into this world, the 'mutual penetration of two beings'. The symbol has an inner connection with what it symbolizes; it manifests the reality of what it symbolizes, and does not merely refer to it. This Florensky calls his 'most basic thought: that what is named in the name, what is symbolized in the symbol, the reality of what is pictured in the picture, is indeed present, and therefore the symbol *is* the symbolized'.

The symbol is what it symbolizes, if only partially, and gives a knowledge of what would not be knowable otherwise. The icon painter does not invent, but 'lifts the scales that cover our spiritual vision' and allows us to see the archetype. The criterion of the truth or spiritual penetration of the painter's image is its beauty – what the scholar Sergei Averintsev, in a recent article, calls 'the union in severe, chaste expression' of holiness and beauty, adding that 'only the severe meaning of the whole justifies this admiration of beauty . . . vouching that this beauty will not degenerate into outward show and hedonistic caprice . . .' (*The Baptism of Rus' and the Path of Russian Culture*). The unity of the symbol embodies the mystical structure of reality.

At some point the co-inherence of the symbol began to come apart, or to be dismantled by a rationalizing critique. According to Florensky, the process dates back to the sixteenth century in Russia and a century or so earlier in the West. The loss of the 'meaning of the whole' led in time to the triumph of 'outward show and

hedonistic caprice', and thus to Vasnetsov's icons. Tolstoy agrees. It was when the upper, educated classes found it no longer possible to believe in the Church's teaching, he says, that the so-called Renaissance came about. And it was then that art ceased to be of and for the whole people, and became exclusive, addressed to wealthy patrons, flattering to princes and popes. In other words, it was then that art 'as we know it' was born and set out on its few centuries of accelerated development, its evolution and exhaustion of formal possibilities. The dismantling of the symbol begins with the separation of knowledge from mystery, the denial of the archetype, of participation in divine reality. It is true that at the same time, as Tolstoy asserts, mankind also became separated in a new way, ceased to co-inhere, social life became disharmonious, city and country were cut off from each other, the social classes fell into mutual antagonism. But Tolstoy sees no relation between these two developments, and advocates the total dismantling of the symbol even as he proclaims the coming union of all mankind.

Florensky's meditations on icon and symbol, his return to the integral understanding of Christian religious thought, led him to a radical formulation of the question of art which in its completeness and clarity is far removed from the aesthetics of the Kantians, the Hegelians, the French eclectic spiritualists, the English psycho-physiologists – all of whom are summed up and dismissed by Tolstoy in the opening chapters of *What is Art?*. But it is even farther removed from the 'true Christian' aesthetics of the sage of Yasnaya Polyana.

Tolstoy's reason rejected the mystical structure of reality embodied in what he called 'Church Christianity'. He denied the possibility of sacraments, which are symbols in the most real sense. And in art, too, he reserved his greatest scorn for the symbolists – especially the French poets of that school and their masters, Baudelaire and Verlaine. It is true that symbols cannot be purposely created; there are very few of them, and they are gifts, not human creations. There is, then, something innately absurd in being a 'symbolist'. But who was more aware of that absurdity than Baudelaire? Who more than he understood the ambiguous role the artist played in

modern life? The symbolists were aware of the separation of the 'themes', the dissolution of the symbol, and that this dissolution did not alter the mystical structure of reality but brought about a 'pseudometamorphosis' in our perception of it. Baudelaire portrays the poet as a sinner who, in his negative creations, holds open the space of the symbol and almost reinvents its lost unity. But only 'in art', of course.

Tolstoy, on the other hand, saw the artist as a shaper of life itself, as a 'teacher of mankind' and a 'leading person' in mankind's forward movement towards the good. For him the categories of 'poet' and 'sinner' were mutually exclusive. He wanted to purify art of all non-good feelings, all false and enslaving mysteries, all that is ambiguous, irrational, antinomic. He wanted art to progress towards – what? More singing and banging on scythes? More stories about chickens? The intensity of the attack and the poverty of the outcome suggest that Tolstoy had other motives for his polemic than an interest in the question of his title.

Dante, whom Tolstoy dismisses as both false and outdated, also showed himself as a sinner, a man lost in a dark wood; his vision came to him in that darkness. Tolstoy allows himself no such candour. As Lev Shestov wrote, he 'does not speak with his disciples outside of school; he imparts to them only "conclusions" and hides from them that anguished and painful travail of his soul which he considers exclusively "the master's business"'. The neo-pagan Nietzsche is one of Tolstoy's targets in *What is Art?*. Yet Shestov is right when he says that Tolstoy's 'God is the good' is no different from Nietzsche's 'God is dead.' Tolstoy's heaven is empty. It was this that he concealed behind the 'brilliant edifice of his preaching'. It is the abyss of the night in Arzamas, and it is within the prophet himself. If he succeeded in hiding it from his followers, he never managed to hide it from his own eyes.

The last act in the life of this torn man, the avowed enemy of the Church, who in 1901 had finally attained excommunication, was a last journey to the monastery of Optino. In the night of 27 October 1910, at the age of eighty-two, abandoning his family and his disciples, he set out like his own Father Sergius in search of 'solitude

and silence'. So he explained in the note he left for his wife. What more he may have been seeking, we do not know. But we do know, from the testimony of the monks, that having arrived at the monastery, he tried three times to call on the elder Iosif. Three times he paced around the monk's cell, went up to the door, put his hand on the latch, hesitated, and turned away again. In the end he left the monastery, and shortly afterwards he died, still on the road.

RICHARD PEVEAR

Bibliographical Note

RELATED WORKS BY LEO TOLSTOY:

A Confession and Other Religious Writings, translated and with an introduction by Jane Kentish. London: Penguin, 1988.

Diaries (two volumes), edited and translated by R. F. Christian. New York: Scribner/Macmillan, 1985.

The Kingdom of God is Within You, translated by Constance Garnett. Lincoln: University of Nebraska Press, 1984.

Letters, selected, edited and translated by R. F. Christian. New York: Scribner, 1978.

What Then Must We Do?, translated by Aylmer Maude, introduction by Ronald Simpson. Devon: Green Books, 1991.

Writings on Civil Disobedience and Non-violence, introduction by David H. Albert, foreword by George Zabelka. Philadelphia and Santa Cruz: New Society Publishers, 1987.

SELECTED REFERENCES:

Averintsev, Sergei. 'The Baptism of Rus' and the Path of Russian Culture'. In *One Thousand Years: The Christianization of Ancient Russia*, edited by Yves Hamant. Paris: UNESCO, 1989.

Bayley, John. *Tolstoy and the Novel*. London: Chatto & Windus, 1966. A study of Tolstoy as artist.

Berlin, Isaiah. *The Hedgehog and the Fox*. London: Weidenfeld and Nicolson, 1954.

Fry, Roger. *Vision and Design*. Oxford: Oxford University Press, 1981. Contains an essay on Tolstoy's aesthetics, originally published in 1909.

Sémon, Marie. *Les femmes dans l'œuvre de Léon Tolstoï*. Paris: Institut d'Etudes Slaves, 1984.

————. *Tolstoi Pèlerin*. In *Cahiers Léon Tolstoï 7*. Paris: Institut d'Etudes Slaves, 1993. An account of Tolstoy's four 'pilgrimages' to the monastery of Optino.

Shestov, Lev. *Dostoevsky, Tolstoy and Nietzsche*, translated by Bernard Martin and Spencer Roberts. Athens: Ohio University Press, 1969. Contains two works: *The Good in the Teaching of Tolstoy and Nietzsche* (1900), and *Dostoevsky and Nietzsche: The Philosophy of Tragedy* (1903).

————. *In Job's Balances*, translated by Camilla Coventry and C. A. Macartney. Athens: Ohio University Press, 1975. Contains an important essay on Tolstoy's last works.

————. *Speculation and Revelation*, translated by Bernard Martin. Athens: Ohio University Press, 1982. Contains an essay on reason and faith in Tolstoy.

Wilson, A. N. *Tolstoy*. London: Penguin, 1988. An excellent biography.

A Note on the Text

Owing to Tolstoy's difficult relations with the Russian censors in his later years, the first publication of *What is Art?* in any language was Aylmer Maude's English translation of 1898, made with the author's approval and at his urging. Later, Tolstoy changed the selection of poems in the appendix, added a second appendix, and revised the text considerably. That accounts for most of the differences between Maude's version and the present one, which has been made from the text of the 'Jubilee Edition' of Tolstoy's works, volume 15 (Moscow, 1983). The translations of French poems in the notes are by Richard Pevear.

WHAT IS ART?

Pick up any newspaper of our time, and in every one of them you will find a section on theatre and music; in almost every issue you will find a description of some exhibition or other, or of some particular painting, and in every one you will find reports on newly appearing books of an artistic nature – poetry, stories, novels.

Immediately after the event, a detailed description is published of how this or that actress or actor played this or that role in such and such a drama, comedy or opera, and what merits they displayed, and what the contents of the new drama, comedy or opera were, and its merits or shortcomings. With the same detail and care they describe how such-and-such an artist sang such-and-such a piece, or performed it on the piano or the violin, and what the shortcomings or merits of the piece and of the performance were. In every large town there will always be, if not several, then certainly one exhibition of new paintings, whose merits and shortcomings are analysed with the greatest profundity by critics and connoisseurs. Almost every day new novels and poems appear, separately or in magazines, and the newspapers consider it their duty to give their readers detailed reports on these works of art.

To support art in Russia, where only a hundredth part of what would be needed to provide all the people with the opportunity of learning is spent on popular education, the government gives millions in subsidies to academies, conservatories and theatres. In France eight millions are allotted to art, and the same in Germany and England. In every large town huge buildings are constructed for museums, academies, conservatories, dramatic schools, and for performances and concerts. Hundreds of thousands of workers – carpenters, masons, painters, joiners, paper-hangers, tailors, hairdressers, jewellers, bronze founders, typesetters – spend their whole lives in hard labour to satisfy the demands of art, so that there is hardly

another human activity, except the military, that consumes as much effort as this.

But it is not only that such enormous labour is expended on this activity – human lives are also expended on it directly, as in war: from an early age, hundreds of thousands of people devote their entire lives to learning how to twirl their legs very quickly (dancers); others (musicians) to learning how to finger keys or strings very quickly; still others (artists) to acquiring skill with paint and to depicting all they see; a fourth group to acquiring skill in twisting every phrase in all possible ways and finding a rhyme for every word. And these people, often very kind, intelligent, capable of every sort of useful labour, grow wild in these exceptional, stupefying occupations and become dull to all serious phenomena of life, one-sided and self-complacent specialists, knowing only how to twirl their legs, tongues or fingers.

But this, too, is not all. I recall attending once a rehearsal of one of the most ordinary new operas, such as are produced in all European and American theatres.

I arrived when the first act had already begun. To enter the auditorium I had to pass backstage. I was led through dark underground corridors and passages of the enormous building, past immense machines for the changing of sets and lighting, where in darkness and dust I saw people working at something. One of the workers, his face grey and thin, wearing a dirty blouse, with dirty workman's hands, the fingers sticking out, obviously tired and displeased, walked past me, angrily reproaching another man for something. Going up a dark stairway, I came out backstage. Amid piled-up sets, curtains, some poles, there were dozens, if not hundreds, of painted and costumed people standing or milling around, the men in costumes closely fitted to their thighs and calves, and the women, as usual, with their bodies bared as much as possible. These were all singers, male and female chorus-members, or ballet dancers, awaiting their turns. My guide led me across the stage, over a plank bridge through the orchestra, where sat about a hundred musicians of all sorts, and into the dark stalls. On an elevation between two lamps with reflectors, in an armchair with a music-stand in front of

it, baton in hand, sat the director of the musical part, who conducted the orchestra and singers and the overall production of the entire opera.

When I arrived, the performance had already begun, and a procession of Indians bringing home a bride was being presented on stage. Besides the costumed men and women, two other men in short jackets were running and fussing about the stage: one was the director of the dramatic part, and the other, who stepped with extraordinary lightness in his soft shoes as he ran from place to place, was the dancing master, who received more pay per month than ten workers in a year.

These three directors were trying to bring together the singing, the orchestra and the procession. The procession, as usual, was done in pairs, with tinfoil halberds on their shoulders. They all started from one place and went around, and around again, and then stopped. For a long time the procession did not go right: first the Indians with halberds came out too late, then too early, then they came out on time but crowded together too much as they exited, then they did not crowd but failed to take their proper places at the sides of the stage, and each time everything stopped and was started over again. The procession began with a recitative by a man dressed up like some sort of Turk, who, opening his mouth strangely, sang: 'I accompany the bri-i-ide.' He would sing it and wave his arm — bare, of course — from under his mantle. And the procession would start. But right away the French horn does something wrong at the end of the recitative, and the conductor, recoiling as if some disaster has taken place, raps on the music-stand with his baton. Everything stops, and the conductor, turning to the orchestra, falls upon the French horn, abusing him in the rudest terms, of the sort that coachmen use, for having played a wrong note. And again everything starts over. The Indians with halberds again come out, stepping softly in their strange shoes; again the singer sings: 'I accompany the bri-i-ide.' But this time the pairs stand too close together. Again the rapping of the baton, the abuse, and it starts over. Again, 'I accompany the bri-i-ide,' again the same gesture with the bare arm from under the mantle, and the pairs, again

stepping softly, halberds on their shoulders, some with serious and sad faces, some exchanging remarks and smiling, take their places in a circle and begin to sing. All is well, it seems; but again the baton raps, and the conductor, in a suffering and spiteful voice, begins to scold the male and female chorus-members: it turns out that they fail to raise their arms from time to time while singing, as a sign of animation. 'Have you all died, or what? Cows! If you're not dead, why don't you move?' Again it starts, again 'I accompany the bri-i-ide,' again the female chorus-members sing with sad faces, now one and now another of them raising an arm. But two of the female chorus-members exchange remarks – again a more vehement rapping of the baton. 'What, have you come here to talk? You can gossip at home. You there, in the red trousers, move closer. Look at me. From the beginning.' Again, 'I accompany the bri-i-ide.' And so it continues for one, two, three hours. The whole of such a rehearsal continues for six hours on end. The rapping of the baton, the repetitions, the positionings, the correctings of the singers, the orchestra, the processions, the dancing, all of it seasoned with angry abuse. The words 'asses, fools, idiots, swine' I heard addressed to the musicians and singers a good forty times in the course of one hour. And the unfortunate, physically and morally crippled person – flautist, horn player, singer – to whom the abuse is addressed, keeps silent and does what is demanded, repeats 'I accompany the bri-i-ide' twenty times over, sings one and the same phrase twenty times over, and again marches about in his yellow shoes with a halberd on his shoulder. The conductor knows that these people are so crippled as to be no longer fit for anything except blowing a horn or walking about with a halberd in yellow shoes, and at the same time they are accustomed to a sweet, luxurious life and will put up with anything only so as not to be deprived of this sweet life – and therefore he calmly gives himself up to his rudeness, the more so in that he has seen it all in Paris and Vienna and knows that the best conductors behave that way, that it is the musical tradition of great artists, who are so enthralled by their great artistic feat that they have no time to sort out the feelings of the performers.

It is hard to imagine a more repulsive sight. I have seen one

worker scold another for not supporting the weight piled on him while unloading goods, or a village elder at haymaking abuse a worker for not building a proper rick, and the worker would be obediently silent. But however unpleasant it was to see, the unpleasantness was softened by awareness of the fact that some necessary and important task was being done, that the mistake for which the superior scolded the worker might have ruined something necessary.

What, then, was being done here, and why, and for whom? It was quite possible that he, the conductor, was also worn out, like that worker; one could even see that he was indeed worn out; but who told him to suffer? And on account of what was he suffering? The opera they were rehearsing was of the most ordinary kind, for those who are accustomed to them, but made up of the greatest absurdities one could imagine: an Indian king wants to get married, a bride is brought to him, he disguises himself as a minstrel, the bride falls in love with the sham minstrel and is in despair, but then learns that the minstrel is the king himself, and everyone is very pleased.

That there never were and never could be any such Indians, and that what was portrayed bore no resemblance not only to Indians but to anything else in the world, except other operas – of that there can be no doubt. That no one speaks in recitative, or expresses their feelings in a quartet, standing at a set distance and waving their arms, that nowhere except in a theatre does anyone walk that way, with tinfoil halberds, in slippers, by pairs, that no one ever gets angry that way, is moved that way, laughs that way, cries that way, and that no one in the world can be touched by such a performance – of that there can also be no doubt.

Involuntarily, a question comes to mind: for whom is this being done? Who can like it? If there are occasional pretty tunes in the opera, which it would be pleasant to hear, they could be sung simply, without those stupid costumes, processions, recitatives and waving arms. As for the ballet, in which half-naked women make voluptuous movements, intertwining in various sensual garlands, it is a downright depraved performance. So that one simply fails to

7

understand for whom it is intended. For a cultivated man it is unbearable, tiresome; to a real working man it is totally incomprehensible. It might be pleasing, and then just barely, to some depraved artisans who have picked up a gentlemanly spirit but have not yet been satiated with gentlemanly pleasures, and who want to give testimony of their civilization, or else to young lackeys.

And all this vile stupidity is produced not only with no kindly merriment, with no simplicity, but with spite and beastly cruelty.

It is said that this is done for the sake of art, and that art is a very important thing. But is it true that this is art, and that art is such an important thing that such sacrifices should be offered to it? This question is particularly important because art, for the sake of which the labour of millions of people, and the very lives of people, and, above all, love among people, are offered in sacrifice, this very art is becoming something more and more vague and indefinite in people's minds.

Criticism, in which lovers of art used to find support for their judgements of art, has lately become so contradictory that, if we should exclude from the realm of art all that the critics of various schools deny the right of belonging to art, almost no art would be left.

Like theologians of various trends, so artists of various trends exclude and destroy each other. Listen to the artists of the present-day schools and you will see in all branches of art one set of artists denying the others: in poetry, the old romantics deny the Parnassians and decadents; the Parnassians deny the romantics and the decadents; the decadents deny all their predecessors and the symbolists; the symbolists deny all their predecessors and *les mages*,[1] while *les mages* simply deny all their predecessors; in the novel, naturalists, psychologists and naturists deny each other. And it is the same in drama, painting and music. So that art, which consumes enormous amounts of human labour and of human lives, and breaks down love among people, not only is not anything clearly and firmly defined, but is understood in such contradictory ways by its lovers, that it is difficult to say what generally is understood as art, and particularly as good, useful art, in the name of which such sacrifices as are offered to it may rightly be offered.

II

Every ballet, circus, opera, operetta, exhibition, painting, concert, printing of a book, requires the intense effort of thousands and thousands of people, working forcedly at what are often harmful and humiliating tasks.

It would be well if artists did the whole job themselves, but no, they all need the help of workers, not only to produce art, but also to maintain their – for the most part luxurious – existence, and they get it in one way or another, in the form of fees from wealthy people, or in government subsidies – in our country, for instance, given them in millions for theatres, conservatories, academies. And this money is collected from the people, whose cow has to be sold for the purpose, and who never benefit from those aesthetic pleasures that art affords.

For it was well for a Greek or Roman artist, or even for a Russian artist of the first half of our century, when there were slaves and it was considered a proper thing in all good conscience to make people serve one and one's own pleasure; but in our time, when everyone is at least dimly aware of the equal rights of all people, it is impossible to make people labour forcedly for art, without first resolving the question whether it is true that art is such a good and important thing as to redeem this coercion.

If not, it is dreadful to think that terrible sacrifices are quite possibly being offered to art in labour, people's lives and morals, while this art is not only not useful, but is even harmful.

And therefore, for a society within which works of art emerge and are supported, it is necessary to know whether all that passes for art is indeed art, and whether all that is art is good, as is thought in our society, and, if it is good, whether it is important and worth the sacrifices demanded for its sake. And it is still more necessary for every conscientious artist to know that, so as to be confident that everything he does has meaning and is not a passion of the little circle of people among whom he lives, arousing in him a false confidence that he is doing a good thing, and that what he takes

9

from other people as support of his – for the most part very luxurious – life will be compensated by the productions on which he is now working. And therefore the answers to these questions are especially important for our time.

What, then, is this art which is considered so important and necessary for mankind that it can be offered the sacrifices not only of human labour and lives, but also of goodness, which are offered to it?

What is art? Why even ask such a question? Art is architecture, sculpture, painting, music, poetry in all its forms – that is the usual answer of the average man, of the art lover, and even of the artist himself, who assumes that what he is talking about is understood quite clearly and in the same way by all people. But in architecture, one may object, there are simple buildings that are not works of art, and buildings that claim to be works of art, but are unsuccessful, ugly, and which therefore cannot be regarded as works of art. What, then, is the sign of a work of art?

It is exactly the same in sculpture, and in music, and in poetry. Art in all its forms borders, on the one hand, on the practically useful, and on the other, on unsuccessful attempts at art. How to separate art from the one and the other? The average educated man of our circle, and even the artist who is not especially concerned with aesthetics, will also not find this a difficult question. He thinks the answer was found long ago and is well known to everyone.

'Art is that activity which manifests beauty,' such an average man will reply.

'But, if art consists in that, then is a ballet or an operetta also art?' you will ask.

'Yes,' the average man will reply, albeit with some uncertainty. 'A good ballet and a graceful operetta are also art in as much as they manifest beauty.'

But even without going on to ask the average man what distinguishes the good ballet or the graceful operetta from the ungraceful – a question it would be very difficult for him to answer – if you ask the same average man whether one can regard as art the activity of the costume-maker and hairdresser who adorn the figures and faces

of women in the ballet or operetta, or the activity of the tailor Worth, or of the perfumer or the chef, he would in the majority of cases deny that the activity of the tailor, the hairdresser, the costume-maker and the chef belong to the realm of art. But here the average man will be mistaken, precisely because he is an average man and not a specialist, and has not studied the questions of aesthetics. If he should study them, he would see in the famous Renan, in his book *Marc Aurèle*,[2] a discussion about the art of the tailor being art, and about the dullness and limitedness of people who do not see in woman's attire a matter of the highest art. '*C'est le grand art,*' he says. Moreover, the average man would learn that in many aesthetic systems – for instance, in the aesthetics of the learned professor Kralik, *Weltschönheit, Versuch einer allgemeinen Ästhetik,* and in Guyau's *Les problèmes de l'esthétique*[3] – the arts of costume, of taste and of touch are recognized as arts.

'*Es folgt nun ein Fünfblatt von Künsten, die der subjectiven Sinnlichkeit entkeimen* [There follows then a cinquefoil of arts growing out of the subjective senses],' says Kralik. '*Sie sind die ästhetische Behandlung der fünf Sinne.*'[4]

These five arts are the following:

Die Kunst des Geschmacksinns – the art of the sense of taste.

Die Kunst des Geruchsinns – the art of the sense of smell.

Die Kunst des Tastsinns – the art of the sense of touch.

Die Kunst des Gehörsinns – the art of the sense of hearing.

Die Kunst des Gesichtsinns – the art of the sense of sight.

Of the first, *die Kunst des Geschmacksinns*, the following is said:

Man hält zwar gewöhnlich nur zwei oder höchstens drei Sinne für würdig, den Stoff künstlerischer Behandlung abzugeben, aber ich glaube nur mit bedingtem Recht. Ich will kein allzu grosses Gewicht darauf legen, dass der gemeine Sprachgebrauch manch andere Künste, wie zum Beispiel die Kochkunst, kennt.

And further on:

Und es ist doch gewiss eine ästhetische Leistung, wenn es der Kochkunst gelingt aus einem thierischen Kadaver einen

Gegenstand des Geschmacks in jedem Sinne zu machen. Der Grundsatz der Kunst des Geschmacksinns (die weiter ist als die sogenannte Kochkunst) ist also dieser: Es Soll alles Geniessbare als Sinnbild einer Idee behandelt werden und in jedesmaligem Einklang zur auszudrückenden Idee.[5]

Like Renan, the author also recognizes a *Kostumkunst*, and so on.

The same opinion is held by the French writer Guyau, who is very highly esteemed by some writers of our time. In his book *Les problèmes de l'esthétique*, he speaks seriously of the senses of touch, taste and smell giving or being able to give aesthetic impressions:

> Si la couleur manque au toucher, il nous fournit en revanche une notion, que l'œil seul ne peut nous donner et qui a une valeur esthétique considérable: celle *du doux, du soyeux, du poli*. Ce qui caractérise la beauté du velours, c'est la douceur au toucher non moins que son brillant. Dans l'idée que nous nous faisons de la beauté d'une femme, la velouté de sa peau entre comme élément essentiel.
>
> Chacun de nous probablement avec un peu d'attention se rappellera des jouissances du goût, qui ont été de véritables jouissances esthétiques.[6]

And he tells how a glass of milk drunk in the mountains gave him *aesthetic* pleasure.

Thus the notion of art as the manifestation of beauty is not at all as simple as it seems, especially now when our senses of touch, taste, and smell are included in it, as they are by the latest aestheticians.

But the average man either does not know or does not want to know this, and is firmly convinced that all questions of art are simply and clearly resolved by the recognition of beauty as the content of art. For the average man it seems clear and comprehensible that art is the manifestation of beauty; and by beauty all questions of art are explained to him.

But what is this beauty which, in his opinion, makes up the content of art? How is it defined, and what is it?

As happens with everything, the more vague and confused the concept conveyed by a word, the greater is the aplomb and assurance with which people use the word, pretending that what is understood by this word is so simple and clear that it is not even worth talking about what it actually means. This is how people usually act with regard to questions of religious superstition, and this is how they act in our time with regard to the concept of beauty. It is assumed that everyone knows and understands what is meant by the word beauty. And yet not only is this not known, but now, after mountains of books have been written on the subject by the most learned and profound men over the course of one hundred and fifty years – since 1750, when Baumgarten founded aesthetics[7] – the question of what beauty is remains completely open, and each new work on aesthetics resolves it in a new way. One of the latest books I happen to have read on aesthetics is a nice little book by Julius Mithalter, entitled *Rätsel des Schönen* ['The Riddle of the Beautiful']. And this title expresses quite correctly the state of the question of what beauty is. After thousands of learned men have discussed it for one hundred and fifty years, the meaning of the word beauty has remained a riddle. The Germans resolve this riddle after their own fashion, albeit in hundreds of different ways; the psychologist-aestheticians, mostly Englishmen of the Herbert Spencer–Grant Allen school,[8] also each in his own fashion; the French eclectics and the followers of Guyau and Taine,[9] also each in his own fashion – and all these men know all the preceding solutions of Baumgarten, Kant, Schelling, Schiller, Fichte, Winckelmann, Lessing, Hegel, Schopenhauer, Hartmann, Schassler, Cousin, Lévêque, and others.[10]

What, then, is this strange concept of beauty, which seems so comprehensible to those who do not think about what they are saying, while for one hundred and fifty years, philosophers of various nations and of the most various trends have been unable to agree on its definition? What is this concept of beauty, upon which the reigning doctrine of art is based?

In Russian, by the word *krasota* ['beauty'] we mean only that which is pleasing to the sight. Though lately people have begun to say of an action that it is *nekrasivy* ['unbeautiful', i.e. bad] or of music that it is *krasivaya* ['beautiful'], this is not really Russian.

A Russian man of the people, who does not know foreign languages, will not understand you if you tell him that a man who gave his last clothes to another, or something like that, acted *krasivo*, or that by deceiving another he acted *nekrasivo*, or that a song is *krasivaya*. In Russian, an action can be kind and good, or wicked and unkind; music can be pleasant and good, or unpleasant and bad, but it can never be either beautiful or unbeautiful.

A man, a horse, a house, a view, a movement may be beautiful, but of actions, thoughts, character, music, we may say they are good, if we like them very much, or not good, if we do not like them; we can say 'beautiful' only of what is pleasing to our sight. So that the word and concept 'good' includes within itself the concept 'beautiful', but not vice versa: the concept 'beautiful' does not cover the concept 'good'. If we say of an object valued for its appearance that it is 'good', we are thereby saying that this object is also beautiful; but if we say it is 'beautiful', that by no means implies that the object is good.

Such is the meaning ascribed to the words and concepts 'good' and 'beautiful' by the Russian language, and therefore by the sense of the Russian people.

In all European languages, the languages of those people among whom the doctrine of beauty as the essence of art has spread, the words *beau*, *schön*, *beautiful*, *bello*, while keeping the meaning of beauty of form, have also come to signify 'good-ness' – that is, have come to replace the word 'good'.

So that these languages now quite naturally employ such expressions as *belle âme*, *schöne Gedanken*, or *beautiful deed*, and yet these languages do not have an apposite word for defining beauty of form and must employ such combinations of words as *beau par la forme*, and so on.

Observing the meaning that the word 'beauty', 'the beautiful', has in the Russian language, and in the languages of the people among whom aesthetic theory has been established, we see that the word 'beauty' is endowed by these people with some special meaning – namely, the meaning of 'good'.

The remarkable thing is that since we Russians have begun to

adopt European views of art more and more, the same evolution has begun to occur in our language as well, and people speak and write with complete assurance, and without surprising anyone, of beautiful music and unbeautiful actions or even thoughts, whereas forty years ago, in my youth, the expressions 'beautiful music' and 'unbeautiful actions' were not only not in use, but incomprehensible. Evidently this new meaning with which European thought has endowed beauty is beginning to be adopted by Russian society as well.

What, then, is this meaning? What, then, is beauty as understood by European people?

In order to answer this question, I will cite at least a small number of those definitions of beauty most widely spread in existing aesthetic systems. I especially beg the reader not to be bored and to read what is cited here, or, what would be better still, to read some work on aesthetics. Not to speak of voluminous German works, some good choices for this purpose are the German book by Kralik, the English one by Knight,[11] and the French one by Lévêque. It is necessary to read some work on aesthetics in order to form a personal idea of the diversity of judgements and the terrible vagueness that reign in this sphere of opinion, and not to trust the words of others in this important matter.

Here, for example, is what the German aesthetician Schassler says about the character of all aesthetic research in the preface to his famous, voluminous and thorough book on aesthetics:

One hardly finds in any other area of philosophical science such methods of research and exposition, crude to the point of contradiction, as in the area of aesthetics. On the one hand, fine phrase-making without any content, distinguished for the most part by an altogether one-sided superficiality; on the other hand, together with all its indisputable depth of research and wealth of content, a repulsive clumsiness of philosophical terminology, which clothes the simplest things in the garb of abstract scientificality, as if to make them worthy thereby of entering the bright mansions of the system; and, finally,

between these two methods of research and exposition there is a third, forming a transition from the one to the other, as it were, a method consisting of eclecticism, flaunting now its fine phrase-making, now its pedantic scientificality ... A form of exposition that does not fall into any of these three defects, but is truly concrete and, while being of substantial content, expresses it in clear and popular philosophical language, is nowhere more rarely to be encountered than in the area of aesthetics.

It is enough simply to read the book of this same Schassler to be convinced of the correctness of his judgement.

The French writer Véron, in the preface to his very good book on aesthetics, says of this same subject:

Il n'y a pas de science qui ait été de plus, que l'esthétique, livrée aux réveries des métaphysiciens. Depuis Platon jusqu'aux doctrines officielles de nos jours, on a fait de l'art je ne sais quel amalgame de fantaisies quintessenciées et de mystères transcendentaux, qui trouvent leur expression suprême dans la conception absolue du beau idéal prototype immuable et divin des choses réelles.[12]

This judgement is more than correct, as the reader will be convinced if he takes the trouble to read the following definitions of beauty which I have copied down from the major writers on aesthetics.

I will not cite the definitions of beauty ascribed to the ancients – Socrates, Plato, Aristotle, and up to Plotinus – because in fact the concept of beauty separate from the good, which constitutes the basis and aim of aesthetics in our time, did not exist among the ancients. In transferring ancient judgements of beauty to our own concept of beauty, as is usually done in aesthetics, we give their words a meaning they did not have (on which see the excellent book of Bénard, *L'esthétique d'Aristote*, and Walter's *Geschichte der Ästhetik im Altertum*).[13]

III

I will begin with the founder of aesthetics, Baumgarten.

According to Baumgarten, the object of logical knowledge is *truth*; the object of aesthetic (that is, sensuous) knowledge is *beauty*. Beauty is the perfect (the absolute) perceived by the senses. Truth is the perfect perceived by reason. The good is the perfect attained by the moral will.

Beauty, according to Baumgarten, is defined by correspondence, that is, by the order of the parts in their mutual relations to each other, and in their relation to the whole. The aim of beauty itself is to be pleasing and to arouse desire (*Wohlgefallen und Erregung eines Verlanges*) – a thesis directly contradictory to Kant's notion of the main property and token of beauty.

As for the manifestations of beauty, Baumgarten thinks that we perceive the highest manifestation of beauty in nature, and therefore the imitation of nature is, according to Baumgarten, the highest task of art (also a thesis directly contradictory to the judgements of the latest aestheticians).

Passing over Baumgarten's not very remarkable followers – Maier, Eschenburg and Eberhardt[14] – who only slightly modified their teacher's views by distinguishing the pleasant from the beautiful – I will set down the definitions of beauty in writers who came directly after Baumgarten and who define beauty quite differently. These writers are Schütz, Sulzer, Mendelssohn and Moritz.[15] In contradiction to Baumgarten's main thesis, these writers recognize as the aim of art not beauty, but the good. Thus Sulzer says that only that which contains the good can be recognized as beautiful. According to Sulzer, the aim of the whole life of mankind is the welfare of social life. It is attained through education of the moral sense, and art should be subservient to this aim. Beauty is that which evokes and educates this sense.

Mendelssohn understands beauty in almost the same way. Art, according to Mendelssohn, is a carrying of the beautiful, perceived by some vague sense, to the level of the true and the good. And the aim of art is moral perfection.

For aestheticians of this tendency, the ideal of beauty is a beautiful soul in a beautiful body. So that for them the division of the perfect (the absolute) into its three forms, of the true, the good and the beautiful, is completely effaced, and beauty again merges with the good and the true.

However, not only is this understanding of beauty not retained by later aestheticians, but there appears the aesthetics of Winckelmann, again completely opposite to these views, most decisively and sharply separating the tasks of art from the aim of the good, and setting as the aim of art an external and even merely plastic beauty.

According to the famous work of Winckelmann,[16] the law and aim of all art is beauty alone, completely separate from and independent of the good. Beauty can be of three kinds: (1) beauty of form; (2) beauty of idea, expressed in the pose of the figure (with regard to plastic art); (3) beauty of expression, which is possible only in the presence of the first two conditions. This beauty of expression is the highest aim of art, and was in fact realized in antique art. Consequently, the art of the present day should strive to imitate antique art.

Beauty is understood in the same way by Lessing and Herder, then by Goethe and all prominent German aestheticians up to Kant, from whose time, again, a different understanding of art begins.

In England, France, Italy and Holland at this same time, independently from the German writers, native aesthetic theories were born, just as unclear and contradictory, and all these aestheticians, in exactly the same way as the Germans, place the concept of beauty at the foundation of their reasoning, understanding it as something that exists absolutely and either merges more or less with the good, or has the same root. In England, at around the same time as Baumgarten, or even a little earlier, Shaftesbury, Hutcheson, Home, Burke, Hogarth[17] and others wrote on art.

According to Shaftesbury, what is beautiful is harmonious and proportionate; what is beautiful and proportionate is true; and what is beautiful and at the same time true, is also pleasant and good. Beauty, according to Shaftesbury, is known only by the spirit. God

is the principal beauty – the beautiful and the good proceed from a single source. Thus, even though Shaftesbury regards beauty as something separate from the good, they still merge again into something inseparable.

According to Hutcheson, in his *Origin of Our Ideas of Beauty and Virtue*, the aim of art is beauty, the essence of which consists in the manifestation of unity within diversity. In the perception of what is beautiful we are guided by ethical instinct ('an internal sense'). This instinct may be contrary to the aesthetic one. Thus, according to Hutcheson, beauty no longer always coincides with the good, but is separate from it and sometimes contrary to it.

According to Home, beauty is that which is pleasant. And therefore beauty is determined only by taste. The basis for correct taste consists in the greatest wealth, fullness, force and diversity of impressions being contained within the strictest limits. This is the ideal of the perfect work of art.

According to Burke, in his *Philosophical Enquiry into the Origin of Our Ideas of the Sublime and Beautiful*, the sublime and the beautiful, which constitute the aim of art, are based on the sense of self-preservation and the sense of communality. These senses, considered at their sources, are means for maintaining the *gens* through the individual. The first is achieved by nourishment, defence and war; the second by communion and reproduction. And therefore self-preservation and the war connected with it are the source of the sublime, while communality and the sexual need connected with it are the source of beauty.

Such were the main English definitions of art and beauty in the eighteenth century.

In France at the same time, Père André, Batteux,[18] and, later, Diderot, D'Alembert and, to some extent, Voltaire, wrote on art.

According to Père André (*Essai sur le Beau*), there are three kinds of beauty: (1) divine beauty, (2) natural beauty and (3) artificial beauty.

According to Batteux, art consists in imitating the beauty of nature, and its aim is pleasure. Diderot's definition of art is the same. The arbiter of what is beautiful is supposed to be taste, just as

with the English. But not only are the laws of taste not established, it is even acknowledged that to do so is impossible. D'Alembert and Voltaire were of the same opinion.

According to Pagano,[19] an Italian aesthetician of the same time, art consists in the uniting into one of the beauties scattered through nature. The ability to see these beauties is taste; the ability to unite them in one whole is artistic genius. Beauty, according to Pagano, merges with the good in such fashion that beauty is the good made manifest, while the good is inner beauty.

According to other Italians — Muratori in his *Riflessioni sopra il buon gusto intorno le scienze e le arti*, and especially Spaletti in his *Saggio sopra la belezza*[20] — art comes down to an egoistic sensation, based, as in Burke, on the striving for self-preservation and communality.

Among the Dutch, Hemsterhuis,[21] who influenced the German aestheticians and Goethe, is noteworthy. According to his teaching, beauty is that which gives us the greatest pleasure, and that which gives us the greatest pleasure is that which gives us the greatest number of ideas within the shortest time. The pleasure of the beautiful is the highest knowledge to which man can attain, because it gives the greatest number of perceptions in the shortest time.

Such were the theories of aesthetics outside Germany during the last century. In Germany, after Winckelmann, there again appeared a completely new aesthetic theory, that of Kant, which more than all others clarifies the essence of the concept of beauty, and therefore also of art.

Kant's aesthetics is based on the following: man, according to Kant, perceives nature outside himself and himself in nature. In nature outside himself he seeks the true; within himself he seeks the good — the first is a matter of pure reason, and the second of practical reason (freedom). Besides these two means of perception, there is, according to Kant, also the power of judgement (*Urteilskraft*), which forms judgements without concepts and produces pleasure without desire (*Urteil ohne Begriff und Vergnügen ohne Begehren*). It is this power which constitutes the basis of the aesthetic sense. And beauty, according to Kant, is in a subjective sense that which,

without concepts and without practical benefit, is generally and necessarily pleasing, and in an objective sense is the form of a purposeful object in so far as it is perceived without any notion of its purpose.

Beauty is defined in the same way by Kant's followers, Schiller among them. According to Schiller, who wrote much on aesthetics, the aim of art, as with Kant, is beauty, the source of which is pleasure without practical usefulness. So that art may be called play, though not in the sense of a worthless occupation, but in the sense of a manifestation of the beauty of life itself, which has no other aim than beauty.

Besides Schiller, the most remarkable of Kant's followers in the field of aesthetics were Jean-Paul and Wilhelm Humboldt, who, while adding nothing to the definition of beauty, clarified its various kinds – drama, music, the comic, etc.

After Kant, besides some second-rate philosophers, Fichte, Schelling, Hegel and their followers wrote on aesthetics. According to Fichte, consciousness of the beautiful arises in the following way. The world – that is, nature – has two sides: it is the product of our limitation, and it is also the product of our free ideal activity. In the first sense, the world is limited, in the second it is free. In the first sense, every body is limited, distorted, compressed, constrained, and we see ugliness; in the second, we see inner fullness, vitality, regeneration – we see beauty. Thus the ugliness or beauty of an object, according to Fichte, depends on the point of view of the contemplator. And that is why beauty is located, not in the world, but in the beautiful soul (*schöner Geist*). Art, then, is the manifestation of this beautiful soul, and its aim is education, not only of the mind, which is the work of the scholar, not only of the heart, which is the work of the moral preacher, but of the whole man. And therefore the token of beauty is not in anything external, but in the presence of a beautiful soul in the artist.

Following Fichte, Friedrich Schlegel and Adam Müller defined beauty along the same lines. According to Schlegel, beauty in art is understood too incompletely, one-sidedly and separately; beauty is not only in art, but also in nature, and also in love, so that the truly

beautiful is expressed in the union of art, nature and love. Therefore Schlegel recognizes moral and philosophical art as inseparable from aesthetic art.

According to Adam Müller,[22] there are two beauties: one is a social beauty which attracts people as the sun attracts the planets – this is predominantly antique beauty; the other is an individual beauty, which becomes so because he who contemplates it himself becomes a sun that attracts beauty – this is the beauty of the new art. A world in which all contradictions are harmonized is the highest beauty. Every work of art is a repetition of this universal accord. The highest art is the art of life.

The next philosopher to have great influence on the aesthetic notions of our time was Schelling, a contemporary of Fichte and his followers. According to Schelling, art is the product or consequence of a world view in which the subject becomes its own object, or the object itself its own subject. Beauty is the representation of the infinite within the finite. And the main character of the work of art is unconscious infinity. Art is the uniting of the subjective with the objective, of nature and reason, of the unconscious with the conscious. And therefore art is the highest means of knowledge. Beauty is the contemplation of things in themselves, as they are in the foundation of all things (*in den Urbildern*). The beautiful is produced not by the artist, through his own knowledge or will, but by the idea of beauty itself.

Among Schelling's followers the most notable was Solger with his *Vorlesungen über Ästhetik*.[23] According to Solger, the idea of beauty is the principal idea of any thing. In the world we see only the perversion of the principal idea, but art, through imagination, may rise to the height of the principal idea. And therefore art is the likeness of creation.

According to another of Schelling's followers, Krause,[24] true and real beauty is the manifestation of the idea in an individual form; and art is the realization of beauty in the realm of the free human spirit. The highest stage of art is the art of life, which directs its activity to the adornment of life, so as to make it a beautiful place for the beautiful man to live.

After Schelling and his followers comes the new aesthetic teaching of Hegel, still held to this day, consciously by many, unconsciously by most. This teaching is not only no clearer or more definite than the preceding ones, but is, if such were possible, still more foggy and mystical.

According to Hegel, God manifests himself in nature and art in the form of beauty. God expresses himself in two ways: in the object and in the subject, in nature and in spirit. Beauty is the idea shining through matter. Only the spirit, and all that partakes of the spirit, is truly beautiful, and therefore the beauty of nature is merely a reflection of the beauty proper to the spirit: the beautiful has only spiritual content. But the spiritual must manifest itself in a sensuous form. Yet the sensuous manifestation of the spirit is merely an appearance (*Schein*). This appearance is the sole reality of the beautiful. Art, then, is the realization of this appearance of the idea, and is a means, together with religion and philosophy, of bringing to consciousness and giving utterance to the profoundest tasks of men and the highest truths of the spirit.

Truth and beauty, according to Hegel, are the same. The only difference is that truth is the idea in itself, as it exists in itself and is thinkable, while the idea expressed externally becomes, for consciousness, not only true but also beautiful. The beautiful is the manifestation of the idea.

After Hegel came his many followers: Weisse, Arnold Ruge, Rosenkrantz, Theodor Vischer,[25] and others.

According to Weisse, art is the introduction (*Einbildung*) of the absolute spiritual essence of beauty into external, dead and indifferent matter, understood, apart from the beauty introduced into it, as the negation of any existence in itself (*Negation alles Fürsichseins*).

In the idea of truth, says Weisse, there lies a contradiction between the subjective and the objective sides of knowledge, in that the singular *I* perceives the *All*. This contradiction can be removed by means of a concept that would unite into one the moments of allness and oneness, which fall into two in the concept of truth. This concept would be a reconciled (*aufgehoben*) truth — and beauty is such a reconciled truth.

According to Ruge, a strict Hegelian, beauty is the self-expressing idea. The spirit, as it contemplates itself, finds itself expressed either fully – and then this full self-expression is beauty – or not fully – and then the need arises in it to change its imperfect expression, in which event spirit becomes creative art.

According to Vischer, beauty is the idea in the form of a limited manifestation. The idea itself is not indivisible, but constitutes a system of ideas which are represented by ascending and descending lines. The higher the idea, the more beauty it contains, but even the lowest contains beauty, because it constitutes a necessary link in the system. The highest form of the idea is the person, and therefore the highest art is that which has the highest person for its subject.

Such are the German theories of aesthetics of the Hegelian tendency only; but aesthetic discussions are not thereby exhausted: alongside Hegelian theories, there appeared simultaneously in Germany theories of beauty which not only do not recognize Hegel's propositions about beauty as the manifestation of the idea, and art as the expression of this idea, but which are directly opposed to such a view, deny it, and laugh at it. Such are the theories of Herbart[26] and, particularly, of Schopenhauer.

According to Herbart, beauty does not and cannot exist in itself; what exists is only our judgement, and it is necessary to find the principles of this judgement (*ästhetisches Elementarurteil*). These principles of judgement are related to impressions. There exist certain relations which we call beautiful, and art consists in finding these relations – simultaneous in painting, plastic art and architecture; both successive and simultaneous in music; and successive alone in poetry. In opposition to the previous aestheticians, Herbart holds that beautiful objects often express nothing at all – a rainbow, for example, which is beautiful owing to its line and colours, and by no means with regard to its mythical significance as Iris or the rainbow of Noah.

Another opponent of Hegel was Schopenhauer, who denied the entire system of Hegel, including his aesthetics.

According to Schopenhauer, the will is objectivized in the world on various levels, and the higher the level of its objectivization, the

more beautiful it is – each level having its own beauty. Abstraction from our own individuality and contemplation of one of these levels of the manifestation of will gives us the consciousness of beauty. All men, according to Schopenhauer, possess the ability to perceive this idea on its different levels and thereby to be liberated for a time from their person. The artistic genius has this ability in the highest degree, and therefore manifests the highest beauty.

After these more prominent figures there come less original German writers, who excercised less influence, such as Hartmann, Kirchmann, Schnasse, Helmholtz to some extent, Bergmann, Jungmann[27] and a numberless host of others.

According to Hartmann, beauty is not in the external world, not in the thing in itself, nor in the soul of man, but in the semblance (*Schein*) produced by the artist. A thing is not beautiful in itself, but the artist transforms it into beauty.

According to Schnasse, there is no beauty in the world. In nature there is only an approximation of it. Art gives what nature cannot give. Beauty is manifested in the activity of the free I, conscious of a harmony that is not in nature.

Kirchmann wrote on practical aesthetics. According to Kirchmann, there are six realms of history: the realms of (1) knowledge, (2) wealth, (3) morality, (4) religion, (5) politics and (6) beauty. Activity within this last realm is art.

According to Helmholtz, who wrote on beauty in relation to music, beauty in a musical work is invariably attained only by following laws – but these laws are unknown to the artist, and therefore beauty is manifested in the artist unconsciously and cannot be subjected to analysis.

According to Bergmann in his *Über das Schöne*, beauty cannot be defined objectively; beauty is perceived subjectively, and therefore the task of aesthetics is to determine what is pleasing to whom.

According to Jungmann, beauty is first of all a supersensory quality; secondly, beauty produces pleasure in us through contemplation alone; thirdly, beauty is the basis of love.

In recent times, the aesthetic theories of the French, the English and other nations have been represented mainly by the following:

In France, the prominent writers on aesthetics have been Cousin, Jouffroy, Pictet, Ravaisson,[28] and Lévêque.

Cousin was an eclectic and a follower of the German idealists. According to his theory, beauty always has a moral basis. Cousin refutes the proposition that art is imitation, and that the beautiful is that which is pleasing. He maintains that beauty can be defined in itself and that its essence consists in diversity and unity.

After Cousin, Jouffroy wrote on aesthetics. Jouffroy, too, was a follower of the German aestheticians, and a disciple of Cousin. In his definition, beauty is the expression of the invisible by means of natural tokens which make it manifest. The visible world is the clothing by means of which we see beauty.

The Swiss writer Pictet repeated Hegel and Plato, supposing beauty to consist in the immediate and free manifestation of the divine idea, which manifests itself in sensuous images.

Lévêque was a follower of Schelling and Hegel. According to him, beauty is something invisible concealed in nature. Power of spirit is the manifestation of ordered energy.

Similarly indefinite were the opinions on the essence of beauty expressed by the French metaphysician Ravaisson: *'La beauté la plus divine et principalement la plus parfaite – contient le secret.'* In his opinion, beauty is the aim of the world: *'Le monde entier est l'œuvre d'une beauté absolue, qui n'est la cause des choses que par l'amour qu'elle met en elles.'*[29]

I have purposely left these metaphysical expressions untranslated because, foggy though the Germans may be, the French, once they have read the Germans and begun to imitate them, surpass them by far, putting together concepts of various sorts and substituting one for another without discrimination. So the French philosopher Renouvier, also discussing beauty, says: *'Ne craignons pas de dire qu'une verité qui ne serait pas belle, n'est qu'un jeu logique de notre esprit et que la seule verité solide et digne de ce nom c'est la beauté.'*[30]

Besides these idealistic aestheticians, who wrote and still write under the influence of German philosophy, in France recently Taine, Guyau, Cherbuliez, Coster[31] and Véron have influenced the understanding of art and beauty.

According to Taine, beauty is the manifestation of the essential character of some significant idea, more perfect than that in which it is expressed in reality.

According to Guyau, beauty is not anything foreign to the object itself, is not some parasitic growth on it, but is the very blossoming of that being in which it is manifest. Art is the expression of life, reasonable and conscious, which evokes in us, on the one hand, the deepest sensations of existence, and, on the other hand, the loftiest feelings, the most exalted thoughts. Art raises man from his personal life into universal life not only by means of participation in the same ideas and beliefs, but also by means of the same feelings.

According to Cherbuliez, art is an activity which (1) satisfies our innate love of images (appearances); (2) introduces ideas into these images; and (3) gives pleasure simultaneously to our senses, heart and reason. Beauty, according to Cherbuliez, is not a property of objects, but is an act of our soul. Beauty is an illusion. There is no absolute beauty, but we think beautiful that which we think is characteristic and harmonious.

According to Coster, ideas of the beautiful, the good and the true are innate. These ideas illuminate our reason and are identical with God, who is goodness, truth and beauty. The idea of beauty includes within itself unity of essence, diversity of component elements, and that order which unity introduces into the diversity of life's manifestations.

I will cite, for the sake of completeness, some of the most recent writings on art.

La psychologie du beau et de l'art, by Mario Pilo.[32] According to Mario Pilo, beauty is the product of our physical sensations. The aim of art is pleasure, but for some reason this pleasure must be regarded as highly moral.

Then there are the *Essais sur l'art contemporain* of H. Fierens Gevaert,[33] according to whom art depends on its connections with the past and on the religious ideal that an artist of the present sets for himself, lending his work the form of his own individuality.

Then there is Sâr Peladan's *L'art idéaliste et mystique*. According to Peladan, beauty is one of the expressions of God. '*Il n'y a pas d'autre*

Realité que Dieu, il n'y a pas d'autre Verité que Dieu, il n'y a pas d'autre Beauté que Dieu.'[34] This is a very fantastic and ignorant book, but characteristic in its propositions and in the modicum of success it is having among French youth.

Such are all the aesthetic systems spread in France recently, to which Véron's book, *L'esthétique*, stands as an exception in its clarity and intelligence. Though it does not give a precise definition of art, it at least removes from aesthetics the foggy concept of absolute beauty.

According to Véron, art is the manifestation of feelings (*émotion*), conveyed externally by a combination of lines, forms, colours, or a sequence of gestures, sounds, or words subject to certain rhythms.

In England during this time, writers on aesthetics define beauty more and more frequently not by its proper quality, but by taste, and the question of beauty is replaced by the question of taste.

After Reid,[35] who recognized beauty as being dependent solely on the contemplator, Alison, in his book *On the Nature and Principles of Taste* (1790), proves the same thing. The same was also asserted by Erasmus Darwin, grandfather of the famous Charles. He says that we find beautiful that which in our view is connected with what we love. Along the same lines is Richard Knight's book, *An Analytical Inquiry into the Principles of Taste* (1805).

Along the same lines are the majority of English aesthetic theories. In England, at the beginning of this century, the prominent writers on aesthetics were Charles Darwin (to some extent), Spencer, Todhunter, Morley, Grant Allen, Ker and Knight.[36]

According to Charles Darwin in his *Descent of Man* (1871), beauty is a feeling proper not only to man but to animals, and therefore to the ancestors of man as well. Birds adorn their nests and appreciate the beauty of their mates. Beauty has influence on marriage. Beauty includes the notion of differing characters. The art of music originated in the calling of male to female.

According to Spencer, the origin of art is play – a thought already expressed by Schiller. In the lower animals, all the energy of life is spent on maintaining and continuing life itself; but in man, after these needs have been satisfied, there remains a surplus of

energy. It is this surplus that is used in play, which passes into art. Play is a likeness of real action; art is the same.

The sources of aesthetic pleasure are: (1) that which exercises the senses (sight, or some other) in the fullest way, with least detriment and greatest exercise; (2) that which gives the greatest variety of evoked feelings; and (3) the combination of the first two with the idea they produce.

According to Todhunter, in *The Theory of the Beautiful* (1872), beauty is infinite attractiveness, which we perceive both through reason and through the enthusiasm of love. The recognition of beauty as beauty depends on taste and can in no way be defined. The only approximation to a definition is the greater cultivation of people; but what this cultivation is never gets defined. The essence of art, of that which touches us by means of lines, colours, sounds, words, is a product, not of blind forces, but of forces that are reasonable, that strive, aiding one another, for a reasonable aim. Beauty is a reconciliation of contraries.

According to Morley, in *Sermons Preached Before the University of Oxford* (1876), beauty is found in man's soul. Nature speaks to us of the divine, and art is the hieroglyphic expression of the divine.

According to Grant Allen, a follower of Spencer, in his *Psychological Aesthetics* (1877), beauty is of physical origin. He says that aesthetic pleasure originates in the contemplation of the beautiful, and the idea of the beautiful is the result of a physiological process. Play is the beginning of art; having a surplus of physical force, man gives himself to play; having a surplus of receptive force, man gives himself to the activity of art. The beautiful is that which affords the greatest stimulation with the least expenditure. Differing evaluations of the beautiful come from taste. Taste can be cultivated. One must trust in the judgement of 'the finest nurtured and most discriminative men' – that is, men capable of a better evaluation. These people shape the taste of the next generation.

According to Ker, in his *Essay on the Philosophy of Art* (1883), beauty gives us the means fully to comprehend the objective world without that reference to other parts of the world which is indispensable for science. And therefore art abolishes the contradiction between

unity and multiplicity, between law and phenomenon, between subject and object, uniting them in one. Art is the manifestation and affirmation of freedom, because it is free of the darkness and incomprehensibility of finite things.

According to W. A. Knight (*Philosophy of the Beautiful*, II, 1893), beauty is, as with Schelling, the union of object and subject; it is the extraction from nature of that which is proper to man, and the consciousness in oneself of that which is common to the whole of nature.

The judgements of beauty and art cited here are far from exhausting all that has been written on the subject. Moreover, new writers on aesthetics appear every day, and the judgements of these new writers contain the same strange, spellbound obscurity and contradictoriness in their definition of beauty. Some continue by inertia the mystical aesthetics of Baumgarten and Hegel, with various modifications; others transfer the question to the realm of the subjective and discover that the principles of the beautiful are a matter of taste; still others – aestheticians of the very latest formation – discover the origin of beauty in the laws of physiology; a fourth group, finally, considers the question quite independently of the notion of beauty. Thus, according to Sully,[37] in *Studies in Psychology and Aesthetics* (1874), the concept of beauty is completely abolished, since art, in Sully's definition, is the production of an abiding or transient object capable of giving active enjoyment and a pleasurable impression to a certain number of spectators or listeners, regardless of the advantage to be derived from it.

IV

What then follows from all these definitions of beauty offered by the science of aesthetics? If we set aside those totally inaccurate definitions of beauty which do not cover the idea of art, and which place it now in usefulness, now in expediency, now in symmetry,

or in order, or in proportionality, or in polish, or in harmony of parts, or in unity within diversity, or in various combinations of all these principles – if we set aside these unsatisfactory attempts at objective definition, all the aesthetic definitions of beauty come down to two fundamental views: one, that beauty is something existing in itself, a manifestation of the absolutely perfect – idea, spirit, will, God; the other, that beauty is a certain pleasure we experience, which does not have personal advantage as its aim.

The first definition was adopted by Fichte, Schelling, Hegel, Schopenhauer, and by the philosophizing Frenchmen – Cousin, Jouffroy, Ravaisson *et al.*, not to mention the second-rate aesthetic philosophers. The same objective-mystical definition of beauty is held by the greater portion of educated people in our time. It is a widely spread understanding of beauty, especially among people of the older generation.

The second definition of beauty, as a certain pleasure we receive which has no personal advantage as its aim, is spread mostly among English aestheticians, and is shared by the other, mostly younger, portion of our society.

Thus there exist (and it could not be otherwise) only two definitions of beauty: one the objective and mystical one, which merges this concept with the highest perfection, with God – a fantastic definition, not based on anything; the other, on the contrary, a very simple and clear subjective one, which considers beauty to be that which is pleasing (I do not add 'without aim or advantage', because the word *pleasing* of itself implies this absence of any consideration of advantage).

On the one hand, beauty is understood as something mystical and very exalted, but unfortunately very indefinite and, therefore, inclusive of philosophy, religion, and life itself, as in Schelling, Hegel and their German and French followers; or, on the other hand, according to the definition of Kant and his followers, beauty is only a particular kind of disinterested pleasure that we receive. In this case the concept of beauty, though seemingly very clear, is unfortunately also imprecise, because it expands in the other direction – meaning that it includes the pleasure derived from drinking, eating, touching soft skin, etc., as is admitted in Guyau, Kralik *et al.*

It is true that, in following the development of the teaching concerning beauty, one can observe that at first, from the time when aesthetics emerged as a science, the metaphysical definition of beauty prevailed, while the closer we come to our own time, the more there emerges a practical definition, recently acquiring a physiological character, so that one even comes upon aestheticians such as Véron and Sully, who attempt to do without the concept of beauty entirely. But such aestheticians have very little success, and the majority of the public, and of artists and scholars as well, firmly hold to the concept of beauty as defined in the majority of aesthetic systems – that is, either as something mystical or metaphysical, or as a particular kind of pleasure.

What essentially is this concept of beauty, to which people of our circle and day hold so stubbornly for the defining of art?

We call beauty in the subjective sense that which affords us a certain kind of pleasure. In the objective sense, we call beauty something absolutely perfect which exists outside us. But since we recognize the absolutely perfect which exists outside us and acknowledge it as such only because we receive a certain kind of pleasure from the manifestation of this absolutely perfect, it means that the objective definition is nothing but the subjective one differently expressed. In fact, both notions of beauty come down to a certain sort of pleasure that we receive, meaning that we recognize as beauty that which pleases us without awakening our lust. In such a situation, it would seem natural for the science of art not to content itself with a definition of art based on beauty – that is, on what is pleasing – and to seek a general definition, applicable to all works of art, on the basis of which it would be possible to resolve the question of what does or does not belong to art. But as the reader may see from the passages I have cited from works on aesthetics, and still more clearly from the works themselves, if he should take the trouble to read them, no such definition exists. All attempts to define absolute beauty in itself – as an imitation of nature, as purposefulness, as correspondence of parts, symmetry, harmony, unity in diversity and so on – either do not define anything, or define only certain features of certain works of art, and are far from

embracing everything that all people have always regarded and still regard as art.

An objective definition of art does not exist; the existing definitions, metaphysical as well as practical, come down to one and the same subjective definition, which, strange as it is to say, is the view of art as the manifestation of beauty, and of beauty as that which pleases (without awakening lust). Many aestheticians have felt the inadequacy and instability of such a definition, and, in order to give it substance, have asked themselves what is pleasing and why, thus shifting the question of beauty to the question of taste, as did Hutcheson, Voltaire, Diderot *et al.* But (as the reader can see both from the history of aesthetics and from experience) no attempts to define taste can lead anywhere, and there is not and can never be any explanation of why something is pleasing to one man and not to another, or vice versa. Thus, existing aesthetics as a whole consists not in something such as might be expected of an intellectual activity calling itself a science – namely, in a definition of the properties and laws of art, or of the beautiful, if it is the content of art, or in a definition of the properties of taste, if it is taste that decides the question of art and its worth, and then, on the basis of these laws, the recognition as art of those works that fit them, and the rejection of those that do not fit them – but instead it consists in first recognizing a certain kind of work as good because it pleases us, and then in constructing such a theory of art as will include all works found pleasing by a certain circle of people. There exists an artistic canon according to which the favourite works of our circle are recognized as art (Phidias, Sophocles, Homer, Titian, Raphael, Bach, Beethoven, Dante, Shakespeare, Goethe *et al.*), and aesthetic judgements must be such as can embrace all these works. One has no difficulty finding in aesthetic literature judgements of the worth and significance of art based not on known laws, according to which we regard this or that object as good or bad, but on whether it conforms to the artistic canon we have established. The other day I was reading a very nice book by Volkelt.[38] Discussing the requirement of morality in works of art, the author says straight out that it is wrong to bring any moral requirements to art, and as proof he

points out that if such requirements were admitted, Shakespeare's *Romeo and Juliet* and Goethe's *Wilhelm Meister* would not fall under the definition of good art. Since both works belong to the artistic canon, the requirement would be incorrect. And therefore one must find a definition of art that would allow these works of art to fit into it, and, instead of the requirement of morality, Volkelt posits as the basis of art the requirement of significance (*Bedeutungsvolles*).

All existing aesthetic systems are constructed on this plan. Instead of giving a definition of true art and then, depending on whether a work fits or does not fit this definition, judging what is and what is not art, a certain series of works found pleasing for some reason by people of a certain circle is recognized as art, and a definition of art such as will include all these works is then invented. Recently I came across a remarkable confirmation of this method in a very good book, Muther's *History of Nineteenth Century Art*.[39] Setting out to describe the pre-Raphaelites, the decadents and the symbolists, who have already been received into the canon of art, he not only does not dare to denounce this tendency, but makes a great effort to expand his framework so as to include in it the pre-Raphaelites, the decadents and the symbolists, who seem to him to be a legitimate reaction against the excesses of naturalism. Whatever follies may be committed in art, once they are accepted among the upper classes of our society, a theory is at once elaborated to explain and legitimize these follies, as if there had ever been epochs in history when certain exceptional circles of people had not accepted and approved of false, ugly, meaningless art, which left no traces and was completely forgotten afterwards. And we can see by what is going on now in the art of our circle what degree of meaninglessness and ugliness art can attain to, especially when, as in our time, it knows it is regarded as infallible.

Thus the theory of art based on beauty, expounded by aesthetics and professed in vague outlines by the public, is nothing other than the recognition as good of what has been and is found pleasing by us – that is, by a certain circle of people.

In order to define any human activity, one must understand its meaning and significance. And in order to understand the meaning

34

and significance of any human activity, it is necessary first of all to examine this activity in itself, as dependent on its own causes and effects, and not with regard to the pleasure we receive from it.

But if we accept that the aim of any activity is merely our own pleasure, and define it merely by that pleasure, then this definition will obviously be false. That is what has happened with the definition of art. For, in analysing the question of food, it would not occur to anyone to see the significance of food in the pleasure we derive from eating it. Everyone understands that the satisfaction of our taste can in no way serve as a basis for defining the merits of food, and that we therefore have no right to suppose that dinners with cayenne pepper, Limburger cheese, alcohol and so on, to which we are accustomed and which we like, represent the best human food.

In just the same way, beauty, or that which pleases us, can in no way serve as the basis for defining art, and a series of objects that give us pleasure can in no way be an example of what art should be.

To see the aim and purpose of art in the pleasure we derive from it is the same as to ascribe the aim and significance of food to the pleasure we derive from eating it, as is done by people who stand at the lowest level of moral development (savages, for instance).

Just as people who think that the aim and purpose of food is pleasure cannot perceive the true meaning of eating, so people who think that the aim of art is pleasure cannot know its meaning and purpose, because they ascribe to an activity which has meaning in connection with other phenomena of life the false and exclusive aim of pleasure. People understand that the meaning of eating is the nourishment of the body only when they cease to consider pleasure the aim of this activity. So it is with art. People will understand the meaning of art only when they cease to regard beauty – that is, pleasure – as the aim of this activity. To recognize beauty, or the certain kind of pleasure to be derived from art, as the aim of art, not only does not contribute to defining what art is, but, on the contrary, by transferring the question to a realm quite alien to art – to metaphysical, psychological, physiological, and even historical discussions of why such-and-such a work is pleasing to some, and

such-and-such is not pleasing, or is pleasing to others — makes that definition impossible. And just as discussing why one person likes pears and another meat in no way helps to define what the essence of nourishment is, so, too, the resolution of questions of taste in art (to which all discussions of art involuntarily come down) not only does not contribute to understanding what makes up that particular human activity which we call art, but makes that understanding completely impossible.

To the question, what is this art to which are offered in sacrifice the labours of millions of people, the very lives of people, and even morality, the existing aesthetic systems give answers all of which come down to saying that the aim of art is beauty, and that beauty is known by the pleasure it gives, and that the pleasure given by art is a good and important thing. That is, that pleasure is good because it is pleasure. So that what is considered the definition of art is not a definition of art at all, but is only a ruse to justify those sacrifices which are offered by people in the name of this supposed art, as well as the egoistic pleasure and immorality of existing art. And therefore, strange as it is to say, despite the mountains of books written on art, no precise definition of art has yet been made. The reason for this is that the concept of beauty has been placed at the foundation of the concept of art.

V

What then is art, if we discard the all-confusing concept of beauty? The latest and most comprehensible definitions of art, independent of the concept of beauty, would be the following: art is an activity already emerging in the animal kingdom out of sexuality and a propensity for play (Schiller, Darwin, Spencer), accompanied by a pleasant excitation of nervous energy (Grant Allen). This is the physiological-evolutionary definition. Or, art is an external manifestation, by means of lines, colours, gestures, sounds, or words, of

emotions experienced by man (Véron). This is the practical defini-
tion. Or, according to Sully's most recent definition, art is 'the
production of some permanent object or passing action, which is
fitted not only to supply an active enjoyment to the producer, but
to convey a pleasurable impression to a number of spectators or
listeners, quite apart from any personal advantage to be derived
from it'.[40]

In spite of the superiority of these definitions over metaphysical
definitions based on the concept of beauty, they are still far from
precise. The first, physiological-evolutionary definition is imprecise
because it speaks not of the activity that constitutes the essence of
art, but of the origin of art. The definition by physiological impact
upon man's organism is imprecise because many other activities of
man can fit into it as well, as occurs in the new aesthetic theories
which reckon as art the making of beautiful clothing and pleasant
perfumes and even foods. The practical definition which supposes
art to be the expression of emotions is imprecise because a man may
express his emotions by means of lines, colours, sounds and words
without affecting others by it, and the expression will then not be
art.

The third definition, by Sully, is imprecise because under the
production of objects that afford pleasure to the producer and a
pleasant impression to the spectators or listeners, apart from any
advantage to them, may be included the performance of magic
tricks, gymnastic exercises and other activities which are not art,
and, on the other hand, many objects that produce an unpleasant
impression, as, for instance, a gloomy, cruel scene in a poetic
description or in the theatre, are unquestionably works of art.

The imprecision of all these definitions proceeds from the fact
that in all of them, just as in the metaphysical definitions, the aim of
art is located in the pleasure we derive from it, and not in its
purpose in the life of man and of mankind.

In order to define art precisely, one must first of all cease looking
at it as a means of pleasure and consider it as one of the conditions
of human life. Considering art in this way, we cannot fail to see that
art is a means of communion among people.

Every work of art results in the one who receives it entering into a certain kind of communion with the one who produced or is producing the art, and with all those who, simultaneously with him, before him, or after him, have received or will receive the same artistic impression.

As the word which conveys men's thoughts and experiences serves to unite people, so art serves in exactly the same way. The peculiarity of this means of communion, which distinguishes it from communion by means of the word, is that through the word a man conveys his thoughts to another, while through art people convey their feelings to each other.

The activity of art is based on the fact that man, as he receives through hearing or sight the expressions of another man's feelings, is capable of experiencing the same feelings as the man who expresses them.

The simplest example: a man laughs, and another man feels merry; he weeps, and the man who hears this weeping feels sad; a man is excited, annoyed, and another looking at him gets into the same state. With his movements, the sounds of his voice, a man displays cheerfulness, determination, or, on the contrary, dejection, calm – and this mood is communicated to others. A man suffers, expressing his suffering in moans and convulsions – and this suffering is communicated to others; a man displays his feeling of admiration, awe, fear, respect for certain objects, persons, phenomena – and other people become infected, experience the same feelings of admiration, awe, fear, respect for the same objects, persons or phenomena.

On this capacity of people to be infected by the feelings of other people, the activity of art is based.

If a man infects another or others directly by his look or by the sounds he produces at the moment he experiences a feeling, if he makes someone yawn when he himself feels like yawning, or laugh, or cry, when he himself laughs or cries over something, or suffer when he himself suffers, this is not yet art.

Art begins when a man, with the purpose of communicating to other people a feeling he once experienced, calls it up again within himself and expresses it by certain external signs.

Thus, the simplest case: a boy who once experienced fear, let us say, on encountering a wolf, tells about this encounter and, to call up in others the feeling he experienced, describes himself, his state of mind before the encounter, the surroundings, the forest, his carelessness, and then the look of the wolf, its movements, the distance between the wolf and himself, and so on. All this – if as he tells the story the boy relives the feeling he experienced, infects his listeners, makes them relive all that the narrator lived through – is art. Even if the boy had not seen a wolf, but had often been afraid of seeing one, and, wishing to call up in others the feeling he experienced, invented the encounter with the wolf, telling it in such a way that through his narrative he called up in his listeners the same feeling he experienced in imagining the wolf – this, too, is art. In just the same way, it is art if a man, having experienced in reality or in imagination the horror of suffering or the delight of pleasure, expresses these feelings on canvas or in marble in such a way that others are infected by them. And in just the same way, it will be art if a man has experienced or imagined the feelings of merriment, joy, sadness, despair, cheerfulness, dejection, and the transitions between these feelings, and expresses them in sounds so that listeners are infected by them and experience them in the same way as he has experienced them.

Feelings, the most diverse, very strong and very weak, very significant and very worthless, very bad and very good, if only they infect the reader, the spectator, the listener, constitute the subject of art. The feeling of self-denial and submission to fate or God portrayed in a drama; the raptures of lovers described in a novel; a feeling of sensuousness depicted in a painting; the briskness conveyed by a triumphal march in music; the gaiety evoked by a dance; the comicality caused by a funny anecdote; the feeling of peace conveyed by an evening landscape or a lulling song – all this is art.

Once the spectators or listeners are infected by the same feeling the author has experienced, this is art.

To call up in oneself a feeling once experienced and, having called it up, to convey it by means of movements, lines, colours, sounds, images expressed in words, so that others experience the same feeling – in this

consists the activity of art. Art is that human activity which consists in one man's consciously conveying to others, by certain external signs, the feelings he has experienced, and in others being infected by those feelings and also experiencing them.

Art is not, as the metaphysicians say, the manifestation of some mysterious idea, beauty, God; not, as the aesthetician-physiologists say, a form of play in which man releases a surplus of stored-up energy; not the manifestation of emotions through external signs; not the production of pleasing objects; not, above all, pleasure; but is a means of human communion, necessary for life and for the movement towards the good of the individual man and of mankind, uniting them in the same feelings.

Just as, owing to man's capacity for understanding thoughts expressed in words, any man can learn all that mankind has done for him in the realm of thought, can in the present, owing to the capacity for understanding other people's thoughts, participate in other people's activity, and can himself, owing to this capacity, convey the thoughts he has received from others, and his own as they have emerged in him, to his contemporaries and to posterity; so, owing to man's capacity for being infected by other people's feelings through art, he has access to all that mankind has experienced before him in the realm of feeling, he has access to the feelings experienced by his contemporaries, to feelings lived by other men thousands of years ago, and it is possible for him to convey his feelings to other people.

If people were incapable of receiving all the thoughts conveyed in words by people living before them, or of conveying their own thoughts to others, they would be like beasts or like Kaspar Hauser.[41]

If men were not possessed of this other capacity – that of being infected by art – people would perhaps be still more savage and, above all, more divided and hostile.

And therefore the activity of art is a very important activity, as important as the activity of speech, and as widely spread.

As the word affects us not only in sermons, orations and books, but in all those speeches in which we convey our thoughts and

experiences to each other, so, too, art in the broad sense of the word pervades our entire life, while, in the narrow sense of the word, we call art only certain of its manifestations.

We are accustomed to regard as art only what we read, hear, see in theatres, concerts and exhibitions, buildings, statues, poems, novels . . . But all this is only a small portion of the art by which we communicate with one another in life. The whole of human life is filled with works of art of various kinds, from lullabies, jokes, mimicry, home decoration, clothing, utensils, to church services and solemn processions. All this is the activity of art. Thus we call art, in the narrow sense of the word, not the entire human activity that conveys feelings, but only that which we for some reason single out from all this activity and to which we give special significance.

This special significance has always been given by all people to the part of this activity which conveys feelings coming from their religious consciousness, and it is this small part of the whole of art that has been called art in the full sense of the word.

This was the view of art among the men of antiquity – Socrates, Plato, Aristotle. The same view of art was shared by the Hebrew prophets and the early Christians; it is understood in the same way by the Muslims and by religious men of the people in our time.

Some teachers of mankind, such as Plato in his *Republic*, the first Christians, strict Muslims, and Buddhists, have often even rejected all art.

People holding this view of art, contrary to the modern view which considers all art good as long as it affords pleasure, thought and think that art, unlike the word, to which one need not listen, is so highly dangerous in its capacity for infecting people against their will, that mankind would lose far less if all art were banished than if every kind of art were tolerated.

Those people who rejected all art were obviously wrong, because they rejected what cannot be rejected – one of the most necessary means of communication, without which mankind cannot live. But no less wrong are the people of our civilized European society, circle and time, in tolerating all art as long as it serves beauty – that is, gives people pleasure.

Formerly, there was fear that among objects of art some corrupting objects might be found, and so all art was forbidden. Now, there is only fear lest they be deprived of some pleasure afforded by art, and so all art is patronized. And I think that the second error is much greater than the first and that its consequences are much more harmful.

VI

But how could it happen that the same art, which in antiquity was either barely tolerated or altogether rejected, should come to be regarded in our time as invariably a good thing, provided it affords pleasure?

It happened for the following reasons.

The appreciation of the merits of art – that is, of the feelings it conveys – depends on people's understanding of the meaning of life, on what they see as good and evil in life. Good and evil in life are determined by what are called religions.

Mankind ceaselessly moves from a lower, more partial and less clear understanding of life to one that is higher, more general and clearer. And, as in every movement, so in this movement there are leaders – those who understand the meaning of life more clearly than others – and among these leading people there is always one who, in his words and in his life, has more vividly, accessibly and forcefully manifested this meaning of life. This man's manifestation of this meaning of life, together with the traditions and rites that usually form around the memory of such a man, is called religion. Religions are indicators of the highest understanding of life accessible at a given time in a given society to the best of the leading people, which is inevitably and unfailingly approached by all the rest of society. And, only because of that, religions have always served and still serve as a basis for evaluating people's feelings. If their feelings bring people closer to the ideal to which their religion points, agree

with it, do not contradict it – they are good; if they move them away from it, disagree with it, contradict it – they are bad.

If religion places the meaning of life in the worship of one God and the fulfilling of what is regarded as his will, as with the Jews, then the feelings resulting from the love of this God and his law, conveyed by art – the sacred poetry of the prophets, the Psalms, the stories in the book of Genesis – make for good, high art. Everything opposed to that, such as conveying the feeling of the worship of alien gods, or feelings discordant with the law of God, will be regarded as bad art. If religion places the meaning of life in earthly happiness, in beauty and strength, then art that conveys the joy and zest of life will be considered good art, while art that conveys feelings of delicacy or dejection will be bad art, as was thought among the Greeks. If the meaning of life lies in the good of the nation or in continuing the way of life of the ancestors and revering them, then art that conveys the feeling of joy in the sacrifice of personal good for the good of the nation or the glorification of the ancestors and the maintaining of their tradition will be considered good art, while art that expresses feelings contrary to these will be considered bad, as among the Romans and the Chinese. If the meaning of life lies in liberating oneself from the bonds of animality, then art that conveys feelings which elevate the soul and humble the flesh will be good art, as it is regarded among the Buddhists, and all that conveys feelings which enhance the bodily passions will be bad art.

Always, in all times and in all human societies, there has existed this religious consciousness, common to all people of the society, of what is good and what is bad, and it is this religious consciousness that determines the worth of the feelings conveyed by art. And therefore, always, in all nations, art that conveyed feelings resulting from the religious consciousness common to the people of the nation was recognized as good and was encouraged, while art that conveyed feelings discordant with the religious consciousness was recognized as bad and was rejected; the whole enormous remaining field of art by which the people communicated among themselves was not valued at all, and was rejected only when it ran counter to

43

the religious consciousness of its time. So it was among all nations: Greeks, Jews, Hindus, Egyptians, Chinese. So it was, too, when Christianity appeared.

Christianity of the earliest time recognized as good works of art only legends, saints' lives, sermons, prayers, hymns that called up in people the feeling of love for Christ, of being moved by his life, the desire to follow his example, the renunciation of earthly life, humility, and love for others. All works that conveyed feelings of personal pleasure were regarded as bad, and therefore Christianity rejected all pagan plastic art, allowing only symbolic plastic images.

So it was among Christians of the first centuries, who received the teaching of Christ, if not quite in its true form, still not in a perverted one, not in a pagan form such as was accepted later on. But with the wholesale conversion of nations to Christianity, by a ruler's decree, as under Constantine, Charlemagne, and Vladimir,[42] there appeared a different, a Church Christianity, closer to paganism than to the teaching of Christ. And this Church Christianity, on the basis of its own teaching, began to evaluate quite differently the feelings of men and the works of art that conveyed them. This Church Christianity not only did not recognize the basic and essential theses of true Christianity – the direct relation of each person to the Father and, following from that, the brotherhood and equality of all men, resulting in the replacement of all forms of violence by humility and love – but, on the contrary, having established a heavenly hierarchy, similar to pagan mythology, and the worship of it, the worship of Christ, of the Mother of God, of angels, apostles, saints, martyrs, and not only of these divinities but also of their images, Church Christianity set up blind faith in the Church and its statutes as the essence of its teaching.

However foreign this teaching was to true Christianity, however base it was in comparison not only with true Christianity, but even with the world view of such Romans as Julian,[43] still, for the barbarians who embraced it, it was a loftier teaching than their former worship of gods, heroes, good and evil spirits. And therefore this teaching was a religion for the barbarians who embraced it. And it was on the basis of this religion that the art of the time was

evaluated; art that portrayed the pious veneration of the Mother of God, Jesus, saints, angels, blind faith in and obedience to the Church, fear of torments and hope of bliss in the life after death, was considered good; art opposed to that was all considered bad.

The teaching on the basis of which this art emerged was a perversion of the teaching of Christ, but the art that emerged from this perverted teaching was still true art, because it corresponded to the religious world view of the people among whom it emerged.

The artists of the Middle Ages, sharing the same religion with the popular masses as the basis for their feelings, while conveying in architecture, sculpture, painting, music, poetry and drama the feelings and moods they experienced, were true artists, and their activity, based on the highest understanding accessible to that time and shared by all, though low for our time, was still true art, common to the whole people.

And so it was until the time when doubt of the truth of the understanding of life expressed by Church Christianity appeared among the upper, wealthy, more educated ranks of European society. But when, after the Crusades, after papal power became highly developed and likewise abused, after people of the wealthy ranks became familiar with ancient wisdom and saw, on the one hand, the reasonable lucidity of the ancient sages, and, on the other, the lack of correspondence between the Church's teaching and the teaching of Christ, it became impossible for them to believe as before in the teaching of the Church.

If ostensibly they still kept to the forms of the Church's teaching, they were no longer able to believe in it and held to it only by inertia, or for the sake of the people, who continued to believe blindly in the teaching of the Church, and whom those of the upper classes considered it necessary to support in their belief for the sake of their own profit. So the Christian teaching of the Church ceased, at a certain moment, to be the general religious teaching of all Christian people. Some – the upper ranks, those in whose hands lay the power and wealth, and therefore the leisure and means to produce and encourage art – ceased to believe in the religious teaching of the Church, while the people went on blindly believing in it.

With regard to religion, the upper ranks in the Middle Ages found themselves in the same situation as the educated Romans before the appearance of Christianity – that is, they no longer believed what the people believed; but they themselves had no belief that they could put in place of the obsolete Church teaching, which had lost its meaning for them.

The only difference was that, while the Romans who lost faith in their god-emperors and household deities, having nothing more to extract from all the complex mythology they had borrowed from all the peoples they had conquered, had to embrace an entirely new world view, the people of the Middle Ages who doubted the truth of the Church's catholic teaching did not have to look for a new teaching. That Christian teaching, which they confessed in its perverted form as the Church's catholic faith, had mapped out the path for mankind so far ahead that they had only to discard the perversions that obscured the teaching discovered by Christ and to adopt it, if not in all, then at least in a small part of its meaning (greater, however, than that adopted by the Church). This very thing was done in part not only by the Reformation of Wyclif, Hus, Luther, Calvin, but by the whole movement of non-Church Christians, represented in early times by the Paulicians, the Bogomils, and later the Waldensians,[44] and all other non-Church Christians, the so-called sectarians. But this could be done and was done by poor people, not the powerful. Only a few among the rich and strong, like Francis of Assisi and others, accepted the Christian teaching in this vital sense, though it destroyed their advantageous position. The majority of people of the upper classes, though at the bottom of their hearts they had already lost faith in the Church's teaching, were unable or unwilling to do so, because the essence of the Christian world outlook they would be adopting, if they were to renounce the Church's faith, was the teaching of the brotherhood and therefore the equality of men, and such a teaching would deny them the prerogatives by which they lived, in which they had grown up and been educated, and to which they were accustomed. At the bottom of their hearts they did not believe in the Church teaching, which had outlived its time and no longer had any true

meaning for them, and since they were unable to adopt true Christianity, the people of these wealthy ruling classes – popes, kings, dukes, and all the mighty of this world – were left without any religion, with nothing but its external forms, which they maintained, considering it not only profitable but necessary for themselves, since this teaching justified the advantages they enjoyed. Essentially, these people did not believe in anything, just as the educated Romans of the first centuries did not believe in anything. And yet the power and wealth were in their hands, and it was they who encouraged art and guided it. And so it was among these people that an art began to grow up which was evaluated not by how well it expressed feelings resulting from the people's religious consciousness, but only by how beautiful it was – in other words, how much pleasure it afforded.

No longer able to believe in the Church religion, which had betrayed its own lie, and unable to adopt the true Christian teaching, which denied their entire life, these wealthy and powerful people, being left without any religious understanding of life, returned willy-nilly to that pagan world view which locates the meaning of life in personal pleasure. Thus there occurred among the upper classes what is known as 'the Renaissance of science and art', which essentially was not merely the denial of any religion, but also the recognition of its needlessness.

The Church teaching, especially the Roman Catholic, is such a coherent system that it cannot be changed or corrected without destroying the whole. As soon as there emerged a doubt of the infallibility of the popes[45] – and this doubt emerged then in all educated people – there inevitably emerged a doubt of the truth of Catholic tradition. And doubt of the truth of the Catholic tradition demolished not only the papacy and Catholicism, but the entire faith of the Church, with all its dogmas, the divinity of Christ, the Resurrection, the Trinity; it also destroyed the authority of the Scriptures, because the Scriptures were recognized as sacred only because tradition had decided so.

Thus the majority of upper-class people at that time, even the popes and clerics, essentially did not believe in anything. They did

not believe in the Church teaching, because they saw its unsoundness; nor could they recognize the moral, social teaching of Christ, as it had been recognized by Francis of Assisi, Kelchitsky[46] and most of the sectarians, because this teaching would destroy their social position. So these people remained without any religious world view. And, having no religious world view, they could not have any other standard for evaluating good and bad art than personal pleasure. Having recognized pleasure – that is, beauty – as the standard of what is good, people of the upper classes of European society returned in their understanding of art to the crude understanding of the primitive Greeks, already condemned by Plato. And, in correspondence with this understanding, a theory of art took shape among them.

VII

Since the time when people of the upper classes lost their faith in Church Christianity, the standard of good and bad art has been beauty – that is, the pleasure afforded by art – and in correspondence with this view of art, an aesthetic theory has taken shape of itself among the upper classes, justifying such an understanding – a theory according to which the aim of art is the manifestation of beauty. The adherents of this aesthetic theory, to confirm its correctness, assert that it was not invented by them, that it lies at the essence of things and was already recognized by the ancient Greeks. But this assertion is completely arbitrary and has no other basis than the fact that for the ancient Greeks, with their lower moral ideal (as compared with the Christian), the idea of the good ($\tau\grave{o}$ $\dot{\alpha}\gamma\alpha\theta\acute{o}\nu$) was not yet sharply distinguished from the idea of the beautiful ($\tau\grave{o}$ $\kappa\alpha\lambda\acute{o}\nu$).

The highest perfection of the good, not only not coincident with beauty, but mainly opposed to it, which the Jews already knew in the time of Isaiah and which was fully expressed by Christianity,

was completely unknown to the Greeks. They thought that the beautiful must necessarily also be good. True, the foremost thinkers – Socrates, Plato, Aristotle – sensed that the good might not coincide with beauty. Socrates expressly subordinated beauty to the good; Plato, in order to unite the two ideas, spoke of a spiritual beauty; Aristotle demanded that art affect people morally (κάθαρσις);[47] but even these thinkers still could not entirely renounce the notion that beauty and the good coincide.

And therefore in the language of that time there came into use the compound word καλοκἀγαθία (beautiful-goodness) to signify this combined notion.

Greek thinkers were obviously beginning to approach the concept of the good expressed by Buddhism and Christianity, and were confused in establishing relations between the good and beauty. Plato's judgements about beauty and the good are full of contradictions. And it was this very confusion of concepts that the people of the European world, who had lost all faith, tried to make into law. They tried to prove that this combination of beauty and good lies at the very essence of the matter, that beauty and the good must coincide, that the word and concept of καλοκἀγαθία, which had meaning for the Greeks, but which has no meaning at all for a Christian, represents the highest ideal of mankind. On this misunderstanding the new science of aesthetics was erected. And in order to justify this new science, the ancient teaching on art was reinterpreted in such fashion as to make it seem that this made-up science had also existed among the Greeks.

In fact, the reasoning of the ancients about art did not resemble ours at all. Thus Bénard writes quite correctly, in his book on Aristotle's aesthetics: '*Pour qui veut y regarder de près, la théorie du beau et celle de l'art sont tout à fait séparées dans Aristote, comme elles le sont dans Platon et chez leurs successeurs.*'[48]

And indeed the reasoning of the ancients on art not only does not confirm our aesthetics, but rather denies its teaching on beauty. And yet all aestheticians, from Schassler to Knight, maintain that the science of the beautiful – aesthetics – was initiated by the ancients – Socrates, Plato, Aristotle – and was supposedly continued to some

extent by the Epicureans and the Stoics – Seneca, Plutarch, and up to Plotinus; but that as the result of some accident, this science somehow suddenly disappeared in the fourth century, was absent for fifteen hundred years, and only after this gap of fifteen hundred years was revived again in Germany, in 1750, in the teaching of Baumgarten.

After Plotinus, says Schassler, fifteen centuries went by during which there was not the slightest scientific interest in the world of beauty and art. Those one and a half thousand years were lost for aesthetics and for the working out of the scholarly structure of this science.[49]

In fact, it was nothing of the sort. The science of aesthetics, the science of the beautiful, did not disappear and could not disappear, because it never existed. The Greeks, like all other peoples always and everywhere, simply regarded art, like any other matter, as good only when it served the good (as they understood it) and bad when it was opposed to this good. The Greeks themselves were so little developed morally that they thought beauty and the good coincided, and on this backward world view of the Greeks was erected the science of aesthetics made up by men of the eighteenth century, and especially turned into a theory by Baumgarten. The Greeks (as anyone can be convinced by reading Bénard's excellent book on Aristotle and his followers, and Walter's book on Plato) never had any science of aesthetics.

Aesthetic theories, and the very name of this science, emerged about one hundred and fifty years ago among the wealthy classes of the Christian European world, simultaneously in various nations – Italian, Dutch, French, English. Its founder, its shaper, the one who gave it scientific, theoretical form, was Baumgarten.

With the pedantic external thoroughness and symmetry typical of the Germans, he invented and expounded this astonishing theory. And, in spite of its striking baselessness, no other theory ever suited so well the taste of the cultured mob, or was adopted with such readiness and absence of criticism. This theory suited the taste of the upper classes so well that to this day, despite its complete arbitrariness and the non-substantiation of its theses, it is repeated by the learned and the unlearned as something indisputable and self-evident.

Habent sua fata libelli pro capite lectoris,[50] and still more so *habent sua fata* the particular theories that come from the state of delusion that society is in, amidst which and for the sake of which these theories are devised. If a theory justifies the false position which a certain part of society is in, then, however baseless and even obviously false the theory may be, it will get adopted and become the belief of that part of society. Such, for instance, is the famous and totally baseless theory of Malthus[51] about the earth's population increasing in geometrical progression while food resources increase only in arithmetical progression, the result being the overpopulation of the earth. Such, too, is the theory, grown out of Malthus, of selection and the struggle for existence as the basis of human progress. Such, too, is the now widely spread theory of Marx that economic progress is inevitable and consists in the swallowing up of all private enterprises by capitalism. However baseless theories of this sort may be, however contradictory they may be to everything mankind knows and recognizes, however obviously immoral they may be, they are accepted on faith, without criticism, and are preached with passionate enthusiasm, sometimes for centuries, until the conditions they justify are done away with or the absurdity of the theories becomes too obvious. Such, too, is the astonishing theory of Baumgarten's trinity – Good, Truth and Beauty – according to which it turns out that the best that can be done by the art of peoples who have lived eighteen hundred years of Christian life is to adopt as its ideal the same one that was held by a small, half-savage, slave-owning people two thousand years ago, who portrayed naked human bodies very well and built buildings pleasing to the eye. No one notices any of these incongruities. Learned men write long, vaporous treatises on beauty as one member of the aesthetic trinity: the beautiful, the true, the good. *Das Schöne, das Wahre, das Gute – le Beau, le Vrai, le Bon* – with capital letters, are repeated by philosophers, aestheticians, artists, private individuals, novelists, pamphleteers, and everyone seems to think that in pronouncing these sacramental words they are speaking of something quite definite and firm – something on which one can base one's judgements. In fact, these words not only have no definite meaning, but they

hinder us from giving any definite meaning to existing art, and are needed only to justify the false significance we ascribe to art that conveys all sorts of feelings, so long as these feelings afford us pleasure.

The moment we renounce for a time the habit of regarding this trinity as having the truth of the religious Trinity, and ask ourselves what we always understand as the meaning of the three words of this trinity, we will be convinced beyond doubt of how utterly fantastic is the uniting of these three utterly different and, above all, incommensurate words and concepts.

The good, the beautiful and the true are put on the same level, and all three concepts are recognized as fundamental and metaphysical. Yet the reality is nothing of the sort.

The good is the eternal, the highest aim of our life. No matter how we understand the good, our life is nothing else than a striving towards the good – that is, towards God.

The good is indeed a fundamental concept, which metaphysically constitutes the essence of our consciousness, a concept undefinable by reason.

The good is that which no one can define, but which defines everything else.

But the beautiful, if we are not to content ourselves with words, but speak of what we understand – the beautiful is nothing other than what is pleasing to us.

The concept of beauty not only does not coincide with the good, but is rather the opposite of it, because the good for the most part coincides with a triumph over our predilections, while beauty is the basis of all our predilections.

The more we give ourselves to beauty, the more removed we are from the good. I know that the usual response to this is that there exists a moral and spiritual beauty, but that is only a play on words, because by spiritual or moral beauty we mean nothing other than the good. Spiritual beauty, or the good, for the most part not only does not coincide with what is usually meant by beauty, but is the opposite of it.

As for truth, it is still less possible to assign to this member of the

supposed trinity not only a oneness with the good or the beautiful, but even any independent existence at all.

We call truth only the correspondence between the manifestation or definition of an object and its essence, or the understanding of the object common to all people. And what is common to the concepts of beauty and truth on the one hand, and the good on the other?

The concepts of beauty and truth not only are not equal with the good, not only are not of one essence with the good, but do not even coincide with it.

Truth is the correspondence between the manifestation and the essence of the object, and is therefore one means of attaining to the good, but in itself truth is neither the good nor the beautiful, and does not even coincide with them.

Thus, for instance, Socrates and Pascal, and many others as well, regarded a knowledge of the truth of useless objects as discordant with the good. As for beauty, truth has nothing in common with it, and is for the most part opposed to it, because, while exposing deception, truth destroys illusion, the main condition of beauty.

And so the arbitrary uniting of these three incommensurable and mutually alien concepts served as the basis for the astonishing theory according to which the difference between good art, conveying good feelings, and bad art, conveying wicked feelings, was totally obliterated; and one of the lowest manifestations of art, art for mere pleasure – against which all teachers of mankind have warned people – came to be regarded as the highest art. And art became, not the important thing it was intended to be, but the empty amusement of idle people.

VIII

But if art is a human activity the aim of which is to convey to others the loftiest and best feelings people have attained to in life,

how could it happen that mankind should live a certain, rather long, period of its life – from the time when people ceased to believe in the Church teaching down to the present day – without this important activity, and be satisfied instead with the worthless activity of art that merely affords pleasure?

In order to answer this question, it is necessary first of all to correct the error people commonly make in ascribing to our art the significance of true, universally human art. We are so used to regarding naïvely as the best human race not just the Caucasian race, but also the Anglo-Saxon if we are English or American, the German if we are German, the Gallo-Latin if we are French, and the Slavic if we are Russian, that when we speak of our art, we are as fully convinced that it is not only true art, but is also the best and the only art. Yet not only is our art not the only art, as the Bible used to be regarded as the only book, but it is not even the art of all Christian mankind, but just the art of a very small section of that part of mankind. It was possible to speak of Hebrew, Greek or Egyptian national art, as it is now possible to speak of a Chinese, Japanese or Indian art common to the whole nation. Such art, common to the whole nation, existed in Russia before Peter the Great, and also in European societies until the thirteenth or fourteenth century; but since people of the upper classes of European society, having lost faith in the Church teaching, did not embrace true Christianity and were left with no faith at all, it is no longer possible to speak of the art of the upper classes of Christian nations as if it were the whole of art. Since the upper classes of the Christian nations lost their faith in Church Christianity, their art has become separated from the art of the whole people, and there have been two arts: the art of the people, and the art of the masters. And therefore the answer to the question of how it could happen that mankind should live for a certain period of time without real art, having replaced it with art that serves pleasure alone, is that it was not the whole of mankind that lived without true art, and not even a considerable part of it, but only the upper classes of European Christian society, and that only for a short period of time – from the beginning of the Renaissance and Reformation to our own day.

And the consequence of this absence of true art has proved to be the very one it had to be: the depravity of the class that avails itself of this art. All the confused, incomprehensible theories of art, all the false and contradictory judgements of it, and, above all, the self-confident stagnation of our art on its own erroneous path – all this is the result of the assertion, now commonly in use and taken as an indisputable truth, but striking in its obvious falseness, that the art of our upper classes is the whole of art, the only true, universal art. In spite of the fact that this assertion, perfectly identical with the assertions of religious people of various confessions who consider theirs the only true religion, is perfectly arbitrary and clearly incorrect, it is calmly repeated by all people of our circle with complete confidence in its infallibility.

The art we possess is the whole of art, the true, the only art, and yet not only do two-thirds of the human race, all the peoples of Asia and Africa, live and die without knowing this only true art, but, furthermore, barely one per cent of all the people in our Christian society benefit from this art which we call the *whole* of art; the remaining ninety-nine per cent of our European people live and die by generations, working hard, without ever tasting this art, which besides is of such a kind that, even if they could avail themselves of it, they would not understand anything. We, according to the aesthetic theory we confess, recognize that art is either one of the highest manifestations of the idea, of God, of beauty, or else is the highest spiritual pleasure; besides that, we recognize that all people have equal rights, if not to material, at least to spiritual, blessings; and meanwhile ninety-nine per cent of our European people, generation after generation, live and die working hard at tasks necessary for the production of our art, from which they do not benefit, and even so we calmly assert that the art we produce is the real, the true, the only, the whole of art.

To the observation that if our art is the true art, all people ought to benefit from it, the usual objection is that if not all benefit from existing art, it is not the art that is to blame, but the wrong organization of society; that it is possible to imagine that in the future physical labour will partly be replaced by machines, will

partly be lightened by its proper distribution, that the work of producing art will be done in turns; that there is no need for the same people constantly to sit under the stage, moving the scenery, lifting machinery, and playing on the piano or the French horn, or setting type and printing books, and that those who do all that can work a small number of hours a day and in their free time benefit from all the blessings of art.

So say the defenders of our exclusive art, but I think that they themselves do not believe what they say, because they cannot be unaware that our refined art could emerge only on the slavery of the popular masses and can continue only as long as this slavery exists, and that the specialists – writers, musicians, dancers and actors – can reach that refined degree of perfection only on condition of the hard work of labourers, and that only on these conditions can there exist the refined public to appreciate such works. Free the slaves of capital, and it will be impossible to produce such refined art.

But even if we admit the inadmissible – that is, that methods can be found to make it possible for all people to benefit from art (or what is regarded as art among us) – another consideration presents itself, showing why present-day art cannot be the whole of art, namely, that it is totally incomprehensible for the people. Poetic works were once written in Latin, but nowadays works of art are as incomprehensible for the people as if they were written in Sanskrit. To this the usual reply is that if the people do not understand our art now, it only proves that they are undeveloped, exactly as it has been with every new step in art. First it was not understood, but later they got used to it.

'The same will happen with present-day art: it will become comprehensible when all the people are as educated as we upper-class people are who produce this art,' say the defenders of our art. But this assertion is obviously still more incorrect than the first one, because we know that the majority of upper-class works of art, such as various odes, narrative poems, dramas, cantatas, pastorals, paintings and so on, which upper-class people admired in their time, have never afterwards been either understood or appreciated

by the great masses, and have remained what they always were – an amusement for the wealthy people of their time, for whom alone they had any significance. From this one can conclude that the same will happen with our art. And when, to prove that the people will in time come to understand our art, it is said that some works of so-called classical poetry, music and painting, which the masses did not like at first, they began to like later, after these works were offered to them from all sides, it only proves that the mob, and a city mob, half corrupted to begin with, can always easily be made accustomed, by perverting its taste, to any art you like. And besides, this art is not produced by the mob, and is not chosen by the mob, but is forcefully thrust upon it in those public places where it has access to art. For the vast majority of working people, our art, inaccessible to them because of its costliness, is also alien to them in its very content, conveying the feelings of people far removed from the conditions of the labouring life led by the greater part of mankind. That which constitutes pleasure for a man of the wealthy classes is not perceived as pleasure by a working man, and calls up in him either no feelings at all, or else feelings completely contrary to those it calls up in an idle and satiated man. Thus, for example, the feelings of honour, patriotism and amorousness, which constitute the main content of present-day art, call up in a working man only perplexity, scorn or indignation. So that even if the majority of working people were given the opportunity, in their time off from labour, to see, to read, to hear – as they do somewhat in the cities, in picture galleries, popular concerts, books – all that constitutes the flower of present-day art, these working people, to the extent that they are working people and do not yet belong partly to the category of those perverted by idleness, would understand nothing of our refined art, and even if they did, the greater part of what they understood would not only not elevate their souls, but would corrupt them. So that for sincere and thinking people there can be no doubt that the art of the upper classes can never become the art of the whole people. And therefore, if art is an important thing, a spiritual blessing, as necessary for all people as religion (as admirers of art like to say), it must then be accessible to all people. And if it

cannot become art for all people, then one of two things: either art is not as important as it is made out to be, or the art which we call art is not important.

This dilemma is insoluble, and therefore intelligent but immoral people boldly resolve it by denying one side of it – namely, the right of the popular masses to benefit from art. These people give direct utterance to what lies at the heart of the matter, which is that only the *schöne Geister*, the elect, as the romantics called them, or the 'supermen', as they have been called by Nietzsche's followers, can partake of and benefit from the supremely beautiful (in their understanding) – that is, the loftiest pleasure of art. The rest, the crude herd, unable to experience these pleasures, must serve the lofty pleasures of this higher race of men. Those who voice such views at least do not pretend and do not want to combine the uncombinable, but admit directly what happens to be the case – namely, that our art is the art of the upper classes only. This, essentially, is how art has been and is understood by all people occupied with the arts in our society.

IX

The unbelief of the upper classes of the European world created a situation in which the activity of art, the aim of which was to convey the loftiest feelings mankind has attained to in its religious consciousness, was replaced by an activity the aim of which was to afford the greatest pleasure to a certain group of people. And from the whole vast area of art, that alone which affords pleasure to people of a certain circle has been singled out and has come to be called art.

Not to mention the moral consequences for European society of this singling out from the whole area of art and bestowing importance upon an art not deserving of such evaluation, this perversion of art weakened art itself and drove it almost to ruin. The first

consequence was that art lost the infinitely diverse and profound religious content proper to it. The second consequence was that, having only a small circle of people in mind, it lost beauty of form, became fanciful and unclear; and the third and chief consequence was that it ceased to be sincere and became artificial and cerebral.

The first consequence – impoverishment of content – occurred because the only true work of art is one that conveys a new feeling not experienced by people before. As a product of thinking is only a product of thinking when it conveys new observations and thoughts, and does not repeat what is already known, in exactly the same way a work of art is only a work of art when it introduces a new feeling (however insignificant) into the general usage of human life. The only reason why children and adolescents experience works of art so strongly is that they convey to them for the first time feelings that they have not experienced before.

A completely new feeling, never before expressed by anyone, has a similarly strong effect upon adults. The art of the upper classes, evaluating feelings not according to religious consciousness, but by the degree of pleasure they afford, deprived itself of the source of these feelings. There is nothing older or more hackneyed than pleasure; and there is nothing newer than the feelings that emerge from the religious consciousness of a particular time. And it could not be otherwise: a limit is set to man's pleasure by nature; but mankind's movement forward – which is expressed by religious consciousness – has no limits. With each step forward that mankind takes, and these steps are made through an ever-increasing clarification of religious consciousness – people experience more and more new feelings. And therefore it is only on the basis of religious consciousness, which reveals the highest degree of understanding of life attained by the people of a certain period, that there can emerge new feelings never before experienced by men. From ancient Greek religious consciousness there came truly new and infinitely diverse feelings, important for the Greeks, expressed by Homer and the tragedians. It was the same for the Jews, who attained to the religious consciousness of monotheism. This consciousness also produced all the new and important feelings expressed by the prophets.

It was the same for medieval man, who believed in the Church community and the heavenly hierarchy; and it is the same for the man of our time who has adopted the religious consciousness of true Christianity – the consciousness of the brotherhood of men.

The diversity of feelings produced by religious consciousness is infinite, and they are all new, because religious consciousness is nothing other than the indication of the new, creative attitude of man towards the world, while the feelings arising from the desire for pleasure are not only limited, but have long since been experienced and expressed. And therefore the unbelief of the European upper classes led them to an art most poor in content.

The impoverishment of the content of upper-class art was increased by the fact that, having ceased to be religious, it also ceased to be popular, thereby diminishing still further the range of feelings it conveyed, since the range of feelings experienced by the ruling, wealthy men, who do not know the labour that maintains life, is much smaller, poorer and more insignificant than the range of feelings of working people.

People of our circle, aestheticians, usually think and say the opposite. I remember the writer Goncharov, an intelligent, educated man, though a thorough city-dweller and an aesthetician, telling me that after the *Hunter's Notes* of Turgenev there was nothing left to write about the life of the people. It was all used up. The life of labouring people seemed so simple to him that after Turgenev's stories of the people there was nothing left to describe. But the life of the wealthy people, with its love affairs and self-dissatisfactions, seemed to him full of infinite content. One hero kissed his lady's palm, another her elbow, a third in some other way. One languishes from laziness, another because he is unloved. And it seemed to him there was no end of diversity in this area. And this opinion, that the life of labouring people is poor in content, while our life, the life of idle people, is full of interesting things, is shared by a great many people of our circle. The life of the labouring man, with its infinitely diverse forms of labour and the dangers connected with it on the sea or under the ground, with his travels, dealings with proprietors, superiors, comrades, with people of other confessions

and nationalities, his struggle with nature, wild animals, his relations with domestic animals, his labours in the forest, the steppe, the fields, the orchard, the kitchen garden, his relations with his wife and children, not only as close and dear people but as co-workers, helpers, replacements in his work, his relation to all economic questions, not as subjects of discussion or vanity, but as questions vital for himself and his family, with his pride in self-sufficiency and service to others, with his pleasure in time off, and all these interests pervaded by a religious attitude towards these phenomena – to us, who have no such interests and no religious understanding, this life seems monotonous compared with the small pleasures and insignificant cares of our life, not of labour and creativity, but of the use and destruction of what others have made for us. We think that the feelings experienced by people of our own time and circle are very significant and diverse, but in reality almost all the feelings of people of our circle come down to three very insignificant and uncomplicated feelings: the feelings of pride, sexual lust, and the tedium of living. And these three feelings, with their ramifications, make up almost exclusively the contents of the art of the wealthy classes.

Earlier, at the very beginning of the separation of upper-class art from popular art, the chief content of art was the feeling of pride. So it was during the time of the Renaissance and after, when the chief subject of works of art was praise of the powerful – popes, kings, dukes. Odes, madrigals, cantatas, hymns were written in their praise; their portraits were painted, their statues were sculpted, glorifying them in various ways. Later the element of sexual lust began to enter art more and more, becoming (with very few exceptions, and in novels and dramas with no exceptions) the necessary condition of every work of art of the wealthy classes.

Still later, the number of feelings conveyed by the new art was increased by the third feeling that makes up the content of the art of the wealthy classes – namely, the feeling of the tedium of living. This feeling was expressed at the beginning of the present century only by exceptional people – Byron, Leopardi and later Heine – but has recently become fashionable and is now expressed by the most

banal and ordinary people. The French critic Doumic says quite correctly of the main feature of the works of the new writers:

> . . . c'est la lassitude de vivre, le mépris de l'époque présente, le regret d'un autre temps aperçu à travers l'illusion de l'art, le goût du paradoxe, le besoin de se singulariser, une aspiration de raffinés vers la simplicité, l'adoration enfantine du merveilleux, la séduction maladive de la rêverie, l'ébranlement des nerfs, surtout l'appel exaspéré de la sensualité.[52]

And, indeed, of these three feelings, sensuality, being the lowest, accessible not only to all people but also to all animals, constitutes the chief subject of all works of art in modern times.

From Boccaccio to Marcel Prévost,[53] all novels, narrative poems and lyrics invariably convey feelings of sexual love in its various forms. Adultery is not just the favourite but the only theme of all novels. A performance is not a performance unless women bared above or below appear in it under some pretext. Ballads, songs – all these express lust with various degrees of poeticizing.

The majority of paintings by French artists portray female nakedness in various forms. There is hardly a page or a poem in the new French literature without a description of nakedness or the use here and there, appropriately or inappropriately, of the favourite word and notion *nu* ['nude']. There is a certain writer named Remy de Gourmont, who is published and considered talented. In order to form an idea of the new writers, I read his novel *Les chevaux de Diomède*.[54] This is an unbroken, detailed description of the sexual relations some gentleman had with various women. Not a page is without lust-arousing descriptions. It is the same with Pierre Louÿs's successful book *Aphrodite*, and the same with another book I recently came across, *Certains*, by Huysmans,[55] which is supposed to be a criticism of painters; it is the same, with the rarest exceptions, in all French novels. These are all works by people suffering from erotic mania. These people are apparently convinced that, since their entire life, as a result of their morbid condition, is concentrated on the smearing about of sexual abominations, it must mean that the

entire life of the world is concentrated on the same thing. And the entire artistic world of Europe and America imitates these people suffering from erotic mania.

And so, as a result of the unbelief and the exclusive life of the upper classes, the art of these classes became impoverished in content and was all reduced to the conveying of the feelings of vanity, the tedium of living and, above all, sexual lust.

X

As a result of the unbelief of people of the upper classes, the art of these people became poor in content. But, besides that, while becoming more and more exclusive, it became at the same time more and more complex, fanciful and unclear.

When an artist of the whole people – such as Greek artists or the Jewish prophets once were – created his works, he naturally strove to say what he had to say in such fashion that his work would be understood by all people. But when an artist created for a small circle of people who lived in exceptional conditions, or even for one person and his courtiers, for a pope, a cardinal, a king, a duke, a queen, a king's mistress, he naturally sought only to influence these people who were known to him and who lived in certain conditions with which he was familiar. And this easier way of calling up feelings pushed the artist involuntarily towards expressing himself in allusions unclear to everyone else and comprehensible only to the initiate. First of all, one could say more that way, and, secondly, this manner of expression contained within itself, even for the initiate, a certain special charm of obscurity. This manner of expression, consisting of euphemisms, mythological and historical allusions, came into use more and more, and seems to have reached its extreme limits recently in so-called decadent art. Recently, not only have vagueness, mysteriousness, obscurity and inaccessibility to the masses been considered a merit and a condition of the poeticality of

artistic works, but so, too, have imprecision, indefiniteness and ineloquence.

Théophile Gautier,[56] in his preface to the famous *Fleurs du Mal*, says that Baudelaire rid his poetry, as far as possible, of eloquence, passion, and a too exactly copied truth – '*l'éloquence, la passion, et la vérité calquée trop exactement*'.

And Baudelaire did not only say this, but also proved it in his poems, and still more so in the prose of his *Petits poèmes en prose*, the meaning of which must be puzzled out like a rebus, and the majority of which remain unriddled.

The poet Verlaine, following after Baudelaire, and also considered great, even wrote a whole *Art poétique*, in which he advises writing like this:

> De la musique avant toute chose,
> Et pour cela préfère l'Impair
> Plus vague et plus soluble dans l'air,
> Sans rien en lui qui pèse ou qui pose.
>
> Il faut aussi que tu n'ailles point
> Choisir tes mots sans quelque méprise:
> Rien de plus cher que la chanson grise
> Où l'Indécis au Précis se joint.

And further on:

> De la musique encore et toujours!
> Que ton vers soit la chose envolée
> Qu'on sent qui fuit d'une âme en allée
> Vers d'autres cieux à d'autres amours.
>
> Que ton vers soit la bonne aventure
> Éparse au vent crispé du matin
> Qui va fleurant la menthe et le thym . . .
> Et tout le reste est littérature.[57]

After these two come Mallarmé, regarded as the most important of the young poets, who says directly that the charm of a poem

consists in our having to guess its meaning, that there should always be some riddle in a poem:

Je pense qu'il faut qu'il n'y ait qu'allusion. La contemplation des objets, l'image s'envolant des rêveries suscitées par eux, sont le chant: les Parnassiens, eux, prennent la chose entièrement et la montrent; par là ils manquent de mystère; ils retirent aux esprits cette joie délicieuse de croire qu'ils créent. *Nommer* un objet, c'est supprimer les trois quarts de *la jouissance du poète qui est faite du bonheur de deviner peu à peu; le suggérer – voilà le rêve.* C'est le parfait usage de ce mystère qui constitue le symbole: évoquer petit à petit un objet et en dégager un état d'âme par une série de déchiffrements.

. . . Si un être d'une intelligence moyenne et d'une prépara-tion littéraire insuffisante ouvre par hasard un livre ainsi fait et prétend en jouir, il y a malentendu, il faut remettre les choses à leur place. *Il doit y avoir toujours énigme en poésie*, et c'est le but de la littérature; il n'y en a pas d'autre – d'évoquer les objets.[58]

Thus, among the new poets, obscurity is made a dogma, as the French critic Doumic, who has yet to recognize the truth of this dogma, quite correctly says: '*Il serait temps aussi de finir avec cette fameuse théorie de l'obscurité que la nouvelle école a élevée en effet à la hauteur d'un dogme.*'[59]

But it is not only French writers who think this way.

The poets of all other nationalities think and act in the same way: Germans, Scandinavians, Italians, Russians and Englishmen; all modern artists in all branches of art think in the same way: in painting, in sculpture and in music. Guided by Nietzsche and Wagner, artists of modern times think that there is no need for them to be understood by the crude masses, that it is enough for them to evoke poetic states in 'the best nurtured men', to use the expression of one English aesthetician.[60]

So that what I say may not seem unsubstantiated, I will cite at least a few examples here of French poets who are in the forefront of this movement. The name of these poets is legion.

I have chosen the new French writers because they express the new trend in art more clearly, and the majority of Europeans imitate them.

Besides those whose names are already regarded as famous, such as Baudelaire and Verlaine, the following are the names of some of these poets: Jean Moréas, Charles Morice, Henri de Régnier, Charles Vignier, Adrien Romaille, René Ghil, Maurice Maeterlinck, C. Albert Aurier, Remy de Gourmont, Saint-Pol-Roux le Magnifique, Georges Rodenbach, Comte Robert de Montesquiou-Fezensac. These are symbolists and decadents. Then come the Magi: Josephin Peladan, Paul Adam, Jules Bois, M. Papus *et al.*[61]

Besides these, there are one hundred and forty-one more writers enumerated by Doumic in his book.

Here are samples from those considered the best among these poets. I begin with the most famous, recognized as a great man deserving of a monument – Baudelaire. This, for instance, is a poem from his famous *Fleurs du Mal*:

> Je t'adore à l'égal de la voûte nocturne,
> O vase de tristesse, ô grande taciturne,
> Et t'aime d'autant plus, belle, que tu me fuis,
> Et que tu me parais, ornement de mes nuits,
> Plus ironiquement accumuler les lieues
> Qui séparent mes bras des immensités bleues.
>
> Je m'avance à l'attaque, et je grimpe aux assauts,
> Comme après un cadavre un chœur de vermisseaux,
> Et je chéris, ô bête implacable et cruelle!
> Jusqu'à cette froideur par où tu m'es plus belle![62]

Here is another by the same Baudelaire:

DUELLUM

> Deux guerriers ont couru l'un sur l'autre; leurs armes
> Ont éclaboussé l'air de lueurs et de sang.
> Ces jeux, ces cliquetis du fer sont les vacarmes
> D'une jeunesse en proie à l'amour vagissant.

Les glaives sont brisés! comme notre jeunesse,
Ma chère! Mais les dents, les ongles acérés,
Vengent bientôt l'épée et la dague traîtresse.
—O fureur des cœurs mûrs par l'amour ulcérés!

Dans le ravin hanté des chats-pards et des onces
Nos héros, s'étreignant méchamment, ont roulé,
Et leur peau fleurira l'aridité des ronces.

—Ce gouffre, c'est l'enfer, de nos amis peuplé!
Roulons-y sans remords, amazone inhumaine,
Afin d'éterniser l'ardeur de notre haine![63]

To be precise, I must say that there are less incomprehensible poems in the collection, but there is not one that is simple and can be understood without some effort – an effort seldom rewarded, because the feelings conveyed by the poet are not good ones, and are quite base.

And these feelings are always expressed with deliberate originality and absurdity. This intentional obscurity is particularly noticeable in prose, where the author could speak simply if he wished to.

Here is an example from his *Petits poèmes en prose*. The first piece is *L'Étranger*.

Qui aimes-tu le mieux, homme énigmatique, dis? ton père, ta mère, ta sœur ou ton frère?
—Je n'ai ni père, ni mère, ni sœur, ni frère.
—Tes amis?
—Vous vous servez là d'une parole dont le sens m'est resté jusqu'à ce jour inconnu.
—Ta patrie?
—J'ignore sous quelle latitude elle est située.
—La beauté?
—Je l'aimerais volontiers, déesse et imortelle.
—L'or?
—Je le hais comme vous haïssez Dieu.
—Eh! qu'aimes-tu donc, extraordinaire étranger?

—J'aime les nuages . . . les nuages qui passent . . . là-bas . . .
là-bas . . . les merveilleux nuages![64]

The piece entitled *La soupe et les nuages* probably portrays the
poet being misunderstood even by the woman he loves. Here is this
piece:

Ma petite folle bien-aimée me donnait à dîner, et par la fenêtre
ouverte de la salle à manger, je contemplais les mouvantes
architectures que Dieu fait avec les vapeurs, les merveilleuses
constructions de l'impalpable. Et je me disais, à travers ma
contemplation: 'Toutes ces fantasmagories sont presque aussi
belles que les yeux de ma belle bien-aimée, la petite folle
monstrueuse aux yeux verts.'

Et tout à coup je reçus un violent coup de poing dans le dos,
et j'entendis une voix rauque et charmante, une voix hystérique
et comme enrouée par l'eau-de-vie, la voix de ma chère petite
bien-aimée, qui disait: 'Allez-vous bientôt manger votre soupe,
s . . . b . . . de marchand de nuages?'[65]

However artificial this work is, with some effort one can guess
what the author wished to say, but there are pieces that are entirely
incomprehensible, to me at least.

Here, for instance, is *Le Galant tireur*, the meaning of which I
entirely fail to grasp:

Comme la voiture traversait le bois, il la fit arrêter dans le voisin-
age d'un tir, disant qu'il lui serait agréable de tirer quelques balles
pour *tuer* le Temps. Tuer ce monstre-là, n'est-ce pas l'occupa-
tion la plus ordinaire et la plus légitime de chacun? – Et il offrit
galamment la main à sa chère, délicieuse et exécrable femme, à
cette mystérieuse femme à laquelle il doit tant de plaisirs, tant de
douleurs, et peut-être aussi une grande partie de son génie.

Plusieurs balles frappèrent loin du but proposé; l'une d'elles
s'enfonça même dans le plafond; et comme la charmante
créature riait follement, se moquant de la maladresse de son

époux, celui-ci se tourna brusquement vers elle, et lui dit: 'Observez cette poupée, là-bas, à droite, qui porte le nez en l'air et qui a la mine si hautaine. Eh bien! cher ange, je me figure que c'est vous.' Et il ferma les yeux et il lâcha la détente. La poupée fut nettement décapitée.

Alors s'inclinant vers sa chère, sa délicieuse, son exécrable femme, son inévitable et impitoyable Muse, et lui baisant respectueusement la main, il ajouta: 'Ah, mon cher ange, combien je vous remercie de mon adresse!'[66]

The works of Verlaine, another celebrity, are no less fanciful and no less incomprehensible. Here, for instance, is the first of his *Ariettes oubliées*:

> Le vent dans la plaine
> Suspend son haleine.
> —Favart

C'est l'extase langoureuse,
C'est la fatigue amoureuse,
C'est tous les frissons des bois
Parmi l'étreinte des brises,
C'est vers les ramures grises
Le chœur des petites voix.

O le frêle et frais murmure!
Cela gazouille et susure,
Cela ressemble au cri doux
Que l'herbe agitée expire . . .
Tu dirais, sous l'eau qui vire,
Le roulis sourd de cailloux.

Cette âme qui se lamente
En cette plainte dormante,
C'est la nôtre, n'est-ce pas?
La mienne, dis, et la tienne,
Dont s'exhale l'humble antienne
Par ce tiède soir, tout bas.[67]

What is this *chœur des petites voix*, and this *cri doux que l'herbe agitée expire*? And what is the meaning of the whole thing? For me it remains entirely incomprehensible.

Here is another *ariette*:

> Dans l'interminable
> Ennui de la plaine
> La neige incertaine
> Luit comme du sable.
>
> Le ciel est de cuivre
> Sans lueur aucune,
> On croirait voir vivre
> Et mourir la lune.
>
> Comme des nuées
> Flotte gris les chênes
> Des forêts prochaines
> Parmi les buées.
>
> Le ciel est de cuivre
> Sans lueur aucune.
> On croirait voir vivre
> Et mourir la lune.
>
> Corneille poussive
> Et vous les loups maigres,
> Par ces bises aigres
> Quoi donc vous arrive?
>
> Dans l'interminable
> Ennui de la plaine,
> La neige incertaine
> Luit comme du sable.[68]

How is it that the moon lives and dies in a sky of brass, and how is it that snow shines like sand? All this is not only incomprehensible, but, under the pretext of conveying a mood, is a series of false comparisons and words.

Besides these artificial and obscure poems, there are others which are intelligible but quite bad both in form and content. Such are all the poems entitled *La Sagesse*. The greatest place in these poems is taken up by very bad manifestations of the most banal Catholic and patriotic feelings. There are, for instance, such stanzas as this:

> Je ne veux plus penser qu'à ma mère Marie,
> Siège de la sagesse et source de pardons,
> Mère de France aussi *de qui nous attendons*
> *Inébranlablement l'honneur de la patrie.*[69]

Before giving examples from other poets, I cannot help dwelling upon the remarkable celebrity of these two versifiers, Baudelaire and Verlaine, now recognized as great poets. How could the French, who had Chénier, Musset, Lamartine and, above all, Victor Hugo, who still recently had the so-called Parnassians: Leconte de Lisle, Sully-Prudhomme, *et al.*, ascribe such significance to these two versifiers and consider them great, when they are so unskilful in form and quite base and banal in content? One of them, Baudelaire, had a world outlook that consisted of crude egoism erected into a theory and the supplanting of morality by the concept of beauty, indefinite as the clouds and invariably artificial. Baudelaire preferred a woman's face painted rather than natural, and metal trees and a mineral simulacrum of water to the real things.

The world outlook of the other poet, Verlaine, consists of flabby licentiousness, the confession of his own moral impotence, and, as salvation from this impotence, the crudest Catholic idolatry. For all that, they are both not only totally devoid of naïvety, sincerity and simplicity, but are filled with artificiality, forced originality and self-conceit. So that in the least bad of their works one sees more of Messrs Baudelaire and Verlaine than of what they are portraying. And these two bad versifiers form a school and lead hundreds of followers after them.

There is only one explanation of this phenomenon: that art for the society in which these two versifiers are active is not a serious,

important matter of life, but is merely an amusement. And any amusement becomes boring with repetition. In order to make the boring amusement possible again, it must be renewed in some way: when Boston gets boring, whist is invented; when whist gets boring, preference is invented; when preference gets boring, some other new thing is invented, and so on. The essence of the matter remains the same, only the forms change. So it is with this art: its content, becoming more and more limited, finally reaches the point where artists of the exclusive classes think that everything has already been said, and it is no longer possible to say anything new. And so, to renew this art, they seek new forms.

Baudelaire and Verlaine, while inventing a new form, have also enhanced it with previously unused pornographic details. And the critics and public recognize them as great writers.

This alone explains the success not only of Baudelaire and Verlaine, but of the entire decadent movement.

There are, for instance, poems by Mallarmé and Maeterlinck that have no meaning, and in spite of that, or perhaps because of it, they are published not only in separate editions numbering tens of thousands, but in collections of the best works of the younger poets.

Here, for example, is a sonnet by Mallarmé, published in the review *Pan* (1895, No. 1):

> À la nue accablante tu
> Basse de basalte et de laves
> À même les échos esclaves
> Par une trompe sans vertu
>
> Quel sépulcral naufrage (tu
> Le sais, écume, mais y baves)
> Suprême une entre les épaves
> Abolit le mât dévêtu
>
> Ou cela que furibond faute
> De quelque perdition haute
> Tout l'abîme vain éployé

Dans le si blanc cheveu qui traîne
Avarement aura noyé
Le flanc enfant d'une sirène.[70]

This poem is not exceptional in its incomprehensibility. I have read several poems by Mallarmé. They are all similarly devoid of meaning.

And here is an example from another famous contemporary poet – three songs by Maeterlinck. This, too, I have taken from *Pan* (1895, No. 2):

Quand il est sorti
(J'entendis la porte)
Quand il est sorti
Elle avait souri . . .

Mais quand il rentra
(J'entendis la lampe)
Mais quand il rentra
Une autre était là . . .

Et j'ai vu la mort
(J'entendis son âme)
Et j'ai vu la mort
Qui l'attend encore . . .

On est venu dire
(Mon enfant, j'ai peur)
On est venu dire
Qu'il allait partir . . .

Ma lampe allumée
(Mon enfant, j'ai peur)
Ma lampe allumée
Me suis approchée . . .

À la première porte
(Mon enfant, j'ai peur)

À la première porte
La flamme a tremblé . . .

À la seconde porte
(Mon enfant, j'ai peur)
À la seconde porte,
La flamme a parlé . . .

À la troisième porte
(Mon enfant, j'ai peur)
À la troisième porte
La lumière est morte . . .

Et s'il revenait un jour
Que faut-il lui dire?
Dites-lui qu'on l'attendit
Jusqu'à s'en mourir . . .

Et s'il interroge encore
Sans me reconnaître,
Parlez-lui comme une sœur,
Il souffre peut-être . . .

Et s'il demande où vous êtes
Que faut-il répondre?
Donnez-lui mon anneau d'or
Sans rien lui répondre . . .

Et s'il veut savoir pourquoi
La salle est déserte?
Montrez-lui la lampe éteinte
Et la porte ouverte . . .

Et s'il m'interroge alors
Sur la dernière heure?
Dites-lui que j'ai souri
De peur qu'il ne pleure . . .[71]

Who went out? Who came in? Who is talking? Who died?

I ask the reader not to be lazy about reading the examples I cite in the first appendix from the better-known and esteemed young poets – Griffin,[72] Régnier, Moréas and Montesquiou. It is necessary in order to form a clear idea of the true state of art, and not to think, as many do, that decadence is an accidental, temporary phenomenon.

To avoid the reproach of having picked out the worst poems, I have cited from each book the poem that happened to appear on the twenty-eighth page.

All the poems of these poets are equally incomprehensible, or comprehensible only with great effort and then not fully.

All the works of these hundreds of poets, of whom I have named only a few, are the same. And the same sort of poems are published by Germans, Scandinavians, Italians and us Russians. If not millions, at least hundreds of thousands of copies are typeset and printed (some sell in tens of thousands). To typeset, print, compose and bind these books, millions and millions of working days are spent – no less, I think, than for the building of a big pyramid. But not only that: the same thing goes on in all the other arts, and millions of working days are spent to produce objects just as incomprehensible in painting, music, drama.

Painting not only does not lag behind poetry in this, but even outstrips it. Here is a passage from the diary of an amateur of painting who visited the Paris exhibitions in 1894:[73]

Today I attended three exhibitions: symbolists, impressionists and neo-impressionists. I looked at the paintings conscientiously and diligently – but again the same perplexity and, in the end, indignation. The first exhibition, of Camille Pissarro, is still the most comprehensible, though there is no drawing, no content, and the colours are most incredible. The drawing is so indefinite that one sometimes cannot tell which way a hand or head is turned. The content is mostly *effets – effet de brouillard, effet du soir, soleil couchant*.[74] Several paintings with figures, but without subject.

In colouring there is a predominance of bright blue and

bright green. And each painting has its basic tone, with which the painting is as if spattered. For example, the goose-girl has a basic tone of vert-de-gris, and there are spots of this colour everywhere: on her face, hair, arms, dress. In the same Durand-Ruel gallery, other paintings by Puvis de Chavannes, Manet, Monet, Renoir, Sisley – these are all impressionists. One of them – I could not make out his name, something like Redon – painted a blue face in profile. The whole face is just this blue tone, with some white. In Pissarro there is one watercolour done entirely in dots. In the foreground a cow, all painted in multicoloured dots. One cannot catch the general tone, whether one stands back or steps close. From there I went to look at the symbolists. I looked for a long time without asking anyone, trying to guess for myself what the point was – but it is beyond human comprehension. One of the first things that struck my eye was a wooden haut-relief, of ugly execution, portraying a woman (naked) who with her two hands is squeezing streams of blood from her nipples. The blood flows down and becomes purple flowers. The hair first hangs down, then is pulled up, turning into trees. The figure is painted yellow all over, the hair is brown.

Then a painting: a yellow sea, and floating in it what might be a ship or might be a heart; on the horizon a profile with a halo and yellow hair that becomes the sea and gets lost in it. The paint in some paintings is applied so thickly that it comes out as something between painting and sculpture. A third work, still less comprehensible: a male profile, before it a flame and black stripes – leeches, it was later explained to me. I finally asked a gentleman who was there what it all means, and he explained to me that the statue was a symbol, that it represented *La Terre*, that the heart floating in the yellow sea was *Illusion*, and the gentleman with the leeches was *Le Mal*. There were several impressionist paintings among them: primitive profiles with some flower in their hand. Monochrome, no drawing, and either completely indefinite or else outlined with a broad black contour.

That was in the year 1894; now this tendency is still more strongly defined: Böcklin, Stuck, Klinger, Sasha Schneider and others.[75]

The same thing is also happening in the drama. We are shown an architect who for some reason has not fulfilled his earlier lofty intentions and consequently climbs on to the roof of a house he has built and throws himself off it head first; or some incomprehensible old woman who exterminates rats and who, for no apparent reason, takes a poetical child to the sea and drowns him there; or some blind men who sit on the seashore and for some reason keep repeating the same thing over and over again; or some bell that falls into a lake and rings there.[76]

The same thing is also happening in music − an art which, it seems, ought to be understood in the same way by everyone.

A well-known musician of your acquaintance sits down to the piano and plays for you what he says is a new work of his or of one of the new composers. You listen to the strange, loud noises, marvel at the gymnastic exercises of the fingers, and see clearly that the composer wishes to suggest to you that the sounds he is producing are poetic yearnings of the soul. You see his intention, but no other feeling is communicated to you except boredom. The performance goes on for a long time, or so at least it seems to you, a very long time, because without perceiving anything clearly, you involuntarily recall the words of Alphonse Karr: '*Plus ça va vite, plus ça dure longtemps.*'[77] And it occurs to you that it is perhaps a mystification, that the performer is testing you, throwing his hands and fingers randomly on the keys, hoping you will get caught in the trap and start praising him, at which point he will laugh and confess that he was merely testing you. But when it is finally over, and the musician rises, sweaty and excited, from the piano, obviously expecting to be praised, you see that it was all very serious.

The same thing happens at all concerts with performances of Liszt, Wagner, Berlioz, Brahms and − the latest − Richard Strauss, and countless others who ceaselessly compose opera after opera, symphony after symphony, piece after piece.

The same thing happens in that area where it would seem difficult

to be incomprehensible – the area of the novel and the short story.

You read *Là-bas* by Huysmans, or short stories by Kipling, or *L'Annonciateur* from the *Contes cruels* of Villiers de l'Isle Adam,[78] etc., and all this is for you not only *abscons*[79] (a new word of the new writers), but utterly incomprehensible both in form and in content. Such, for instance, is the novel *Terre promise* by E. Morel, now appearing in the *Revue Blanche*,[80] as well as the majority of new novels: the style is quite bold, the feelings seem to be lofty, but one simply cannot understand what is happening where and to whom.

And all the young art of our time is like that.

People of the first half of our century – admirers of Goethe, Schiller, Musset, Hugo, Dickens, Beethoven, Chopin, Raphael, da Vinci, Michelangelo, Delaroche[81] – understanding nothing of this new art, often simply regard its works as tasteless madness and wish to ignore them. But this attitude towards the new art is completely unfounded, because, first of all, this art is spreading more and more, and has already won itself a firm position in society – just as romanticism did in the 'thirties; second, and above all, because if we are able to judge the works of the latest, so-called decadent art in this way simply because we do not understand them, then there is an enormous number of people – including all working people and many non-workers – who in exactly the same way do not understand those works of art which we consider beautiful: the poems of our own favourite artists – Goethe, Schiller, Hugo; the novels of Dickens; the music of Beethoven and Chopin; the paintings of Raphael, Michelangelo, da Vinci, *et al.*

If I have the right to think that large masses of people neither understand nor love what I recognize as unquestionably good, because they are not sufficiently developed, then I have no right to deny that it is possible for me not to understand or love the new works of art because I am insufficiently developed to understand them. And if I have the right to say that I, along with the majority of like-minded people, do not understand the works of the new art simply because there is nothing to understand and because it is bad

art, then a still greater majority, the entire mass of working people who do not understand what I regard as beautiful art, have the same right to say that what I regard as good art is bad art and there is nothing in it to understand.

I once saw especially clearly how wrong it is to condemn the new art when, in my presence, a poet who writes incomprehensible verses laughed with merry self-confidence at incomprehensible music, and soon afterwards a musician who composes incomprehensible symphonies laughed with the same self-confidence at incomprehensible poetry. I cannot condemn the new art and have no right to condemn it simply because, as a man brought up in the first half of the century, I do not understand it; I can only say that I am unable to understand it. The one advantage of the art which I recognize over the art of the decadents is that the art which I recognize is understood by a slightly larger number of people than present-day art.

From the fact that I am accustomed to a certain exclusive art and understand it, while I do not understand a still more exclusive art, I have no right to conclude that this art, my art, is the most true art, and that the art I do not understand is not true and is bad; I can only conclude from it that art, as it has become more and more exclusive, has become more and more incomprehensible for a larger and larger number of people, and in this movement towards greater and greater incomprehensibility, one step of which I occupy with my accustomed art, it has reached a point where it is understood by a very small number of the elect, and that this number of the elect keeps getting smaller and smaller.

As soon as the art of the upper classes became separated from the art of the whole people, there arose the conviction that art can be art and yet be incomprehensible to the masses. As soon as this thesis was allowed, it inevitably became necessary to allow that art may be comprehensible only to a small number of the elect, and, finally, only for two, or one – a best friend, one's own self. This is what modern artists say straight out: 'I create and I understand myself; if others do not understand me, so much the worse for them.'

The assertion that art can be good art and yet be incomprehensible

to a large number of people is so wrong, its consequences are so pernicious for art, and it is at the same time so widespread, so embedded in our notions, that no explanation of its utter incongruity can suffice.

Nothing is more common than to hear said of alleged works of art that they are very good but very difficult to understand. We are used to the assertion, and yet to say that a work of art is good but incomprehensible is the same as saying of some kind of food that it is very good but people cannot eat it. People may not like rotten cheese, putrid grouse and other such dishes appreciated by gastronomes with perverted taste, but bread and fruit are only good when people like them. It is the same with art: perverted art may be incomprehensible to people, but good art is always understood by everyone.

It is said that the best works of art are such that they cannot be understood by the majority and are accessible only to the elect, who are prepared to understand these great works. But if the majority do not understand, they must be given an explanation, the knowledge necessary for understanding. But it turns out that this knowledge does not exist, that the works cannot be explained, and therefore those who say that the majority do not understand good works of art give no explanations, but say that in order to understand one must read, look at, or listen to the same work over and over again. But this is not to explain, it is to make accustomed. And one can get accustomed to anything, even the worst. As it is possible to get people accustomed to rotten food, vodka, tobacco, opium, so it is possible to get them accustomed to bad art, which in fact is being done.

Besides, it cannot be said that the majority of people lack the taste to appreciate the highest works of art. The majority understand and have always understood what we, too, consider the highest art: the artistically simple narratives of the Bible, the Gospel parables, folk legends, fairy tales, folk songs are understood by everyone. Why is it that the majority suddenly lost the ability to understand the highest of our art?

One can say of speech that it is beautiful but incomprehensible to

those who do not understand the language in which it is uttered. Speech uttered in Chinese may be beautiful and yet remain incomprehensible to me if I do not know Chinese, but a work of art is distinguished from all other spiritual activity in that its language is understandable to everyone, that it infects everyone without distinction. The tears, the laughter of a Chinese will infect me in just the same way as the tears and laughter of a Russian, as will painting and music, or a work of poetry if it is translated into a language I understand. The song of a Kirghiz or a Japanese moves me, though not as much as it moves the Kirghiz or the Japanese themselves. So, too, I am moved by Japanese painting and Indian architecture and Arabian tales. If I am little moved by a Japanese song or a Chinese novel, it is not because I do not understand these works, but because I know and am accustomed to higher works of art, and by no means because this art is above me. Great works of art are great only because they are accessible and comprehensible to everyone. The story of Joseph, translated into Chinese, moves the Chinese. The story of Shakya-muni moves us.[82] The same is true of buildings, paintings, statues, music. And therefore, if art does not move us, one must not say that the cause is the spectator's or listener's incomprehension, but one can and must conclude that it is either bad art or not art at all.

The difference between art and mental activity, which requires preparation and a certain sequence of learning (so that one cannot teach trigonometry to someone who does not know geometry), is precisely that art affects people independently of their degree of development and education, that the charm of a picture, of sounds, of images infects any man, on whatever level of development he may stand.

The business of art consists precisely in making understandable and accessible that which might be incomprehensible and inaccessible in the form of reasoning. Usually, when a person receives a truly artistic impression, it seems to him that he knew it all along, only he was unable to express it.

And the best, the highest art has always been so: the *Iliad*, the *Odyssey*, the stories of Jacob, Isaac, and Joseph, the Hebrew prophets,

the Psalms, the Gospel parables, and the story of Shakya-muni, and the Vedic hymns[83] – all convey very lofty feelings, and in spite of that are fully understandable to us now, to the educated and the uneducated, and were understood by people of their own time, who were still less educated than our own working people. They talk of incomprehensibility. But if art is the conveying of feelings that arise from a people's religious consciousness, how can a feeling based on religion – that is, on man's relation to God – be incomprehensible? Such art must be, and indeed has always been, understandable to everyone, because each man's relation to God is always the same. And therefore temples, and the images and singing in them, have always been understandable to everyone. The obstacle to understanding the best and highest feelings, as is also said in the Gospel, by no means lies in an absence of development and education, but, on the contrary, in false development and false education. A good and lofty artistic work may indeed be incomprehensible, only not to simple, unperverted working people (they understand all that is lofty) – no, but a true artistic work may be and often is incomprehensible to highly educated, perverted, religion-deprived people, as constantly occurs in our society, where people find the highest religious feelings simply incomprehensible. I know people, for example, who consider themselves most refined, and who say that they do not understand the poetry of love for one's neighbour and of self-denial, or the poetry of chastity.

Thus, good, great, universal, religious art may be incomprehensible only for a small circle of perverted people, but not otherwise.

It is impossible that art can be incomprehensible to the great masses only because it is very good, as artists of our time like to say. One should rather suppose that the great masses do not understand art only because this art is very bad, or even is not art at all. So that the most beloved argument naïvely accepted by the cultivated mob, according to which, in order to feel art, one must understand it (which, in fact, merely means get accustomed to it), is the surest sign that what is offered to our understanding in this way is either very bad, exclusive art, or is not art at all.

They say the people do not like works of art because they are

unable to understand them. But if the work of art has the aim of infecting people with the feeling experienced by the artist, how then can we speak of incomprehension?

A man of the people reads a book, looks at a painting, listens to a drama or a symphony, and feels nothing. He is told that that is because he does not know how to understand it. They promise to show a man a certain spectacle – he comes in and sees nothing. He is told that that is because his sight has not been prepared for this spectacle. But the man knows that he can see everything perfectly well. And if he does not see what they promised to show him, he merely concludes (quite correctly) that those who undertook to show him the spectacle did not fulfil their undertaking. In the same way, and quite correctly, a man of the people draws conclusions about the works of art of our society, which do not call up any feelings in him. And therefore, to say that a man is not moved by my art because he is still very stupid, which is both very presumptuous and very brazen, is to pervert the roles and shift the blame from the sick head to the sound.

Voltaire said, '*Tous les genres sont bons, hors le genre ennuyeux.*' With still greater right one may say about art, '*Tous les genres sont bons, hors celui qu'on ne comprend pas*', or '*qui ne produit pas son effet*',[84] for what virtue is there in an object that does not do what it is meant to do?

But the main thing is that, once we allow that art can be art while being incomprehensible to certain people of sound mind, there is then no reason why some circle of perverted people should not create works that titillate their perverted feelings and are incomprehensible to anyone except themselves, and call these works art, which in fact is now being done by the so-called decadents.

The course art has been taking may be likened to placing on a circle of large diameter circles of smaller and smaller diameters, thus forming a cone the tip of which ceases to be a circle at all. This very thing has happened with the art of our time.

XI

Becoming ever poorer in content and ever more incomprehensible in form, art in its latest manifestations has even lost all the properties of art and has been replaced by simulacra of art.

As if it were not enough that, owing to its separation from the art of the whole people, the art of the upper classes became poor in content and bad in form – that is, more and more incomprehensible – this art has in the course of time even ceased to be art and has come to be replaced by counterfeits of art.

This has happened for the following reasons. Art of the whole people emerges only when a man of the people, having experienced a strong feeling, has need of conveying it to others. Art of the wealthy classes emerges, not because of any need in the artist, but mostly because people of the upper classes demand amusements, which are very well remunerated. People of the wealthy classes demand that art convey feelings pleasing to them, and artists try to satisfy these demands. But to satisfy these demands is very difficult, since the people of the wealthy classes, leading a life of idleness and luxury, demand continuous amusement from art, while it is imposs- ible to produce art at will, even of the lowest sort – it must be born of itself in the artist. And therefore, in order to satisfy the demands of upper-class people, artists had to develop methods by which they could produce objects simulating art. And these methods were developed.

These methods are: (1) borrowing, (2) imitation, (3) effectfulness, and (4) diversion.

The first consists in borrowing either whole subjects or only separate features from earlier, well-known poetic works and so reworking them that, with some additions, they represent something new. Such works of art, evoking memories of previously experi- enced artistic feelings in people belonging to a certain circle, produce an impression similar to that of art, and pass for art among those who seek pleasure from art, if some other necessary conditions are satisfied at the same time. Subjects borrowed from earlier works of

art are usually called poetic subjects. Objects and characters borrowed from earlier works of art are called poetic objects. Thus, in our circle, all sorts of legends, sagas and old tales are regarded as poetic subjects. Poetic characters and objects include maidens, warriors, shepherds, hermits, angels, devils in all forms, moonlight, thunderstorms, mountains, the sea, precipices, flowers, long hair, lions, the lamb, the dove, the nightingale; all objects used by earlier artists in their works are generally considered poetic.

About forty years ago a lady (since deceased), not very intelligent but highly civilized, *ayant beaucoup d'acquis*,[85] invited me to listen to a novel she had written. The action began with the heroine in a poetic forest, by the waterside, in a poetic white dress, with poetically loose hair, reading poetry. It was set in Russia, and suddenly from behind the bushes the hero appeared in a hat with a feather *à la Guillaume Tell* (so it was written), and with two poetic white dogs accompanying him. It seemed to the author that this was all very poetic. Everything would have been well, however, if the hero had not needed to speak: but as soon as the gentleman in the hat *à la Guillaume Tell* started talking with the girl in the white dress, it became obvious that the author had nothing to say, that she was moved by poetic memories of earlier works and thought that by rummaging through these memories she could produce an artistic impression. But an artistic impression is an infection, it works only when the author has himself experienced some feeling and conveys it in his own way, not when he conveys someone else's feeling as it was conveyed to him. This sort of poetry out of poetry cannot infect people, and only produces the simulacrum of a work of art, and that only for people with perverted aesthetic taste. The lady was very stupid and untalented, and therefore one could see at once how things were; but when such borrowings are undertaken by well-read and talented people, with a developed artistic technique besides, the results are those borrowings from the Greek, the antique, the Christian, and the mythological world, which have multiplied so greatly and, especially now, continue to appear in large numbers, and which the public takes for works of art, if the borrowings are nicely presented by means of the technique of the art to which they belong.

Rostand's play *Princesse Lointaine* ('Princess Faraway'),[86] in which there is not a scintilla of art, but which seems to many, probably including its author, to be very poetic, may serve as a typical example of such artistic counterfeits.

The second method of producing a simulacrum of art is what I have called imitation. The essence of this method consists in conveying the details that accompany what is being described or portrayed. In verbal art, this method consists in describing in minute detail the external appearance, faces, clothing, gestures, sounds and positions of the characters with all the accidents that occur in life. Thus, in novels and stories, each time a character speaks, we are told what sort of voice he spoke in and what he was doing at the same time. And the speeches themselves are given not so as to have the greatest meaning, but in a lifelike manner, poorly put together, with interruptions and omissions. In dramatic art, this method consists in presenting, together with imitative speech, the whole situation and all the actions of the characters as they would be in real life. In painting, this method reduces painting to photography, and abolishes the difference between photography and painting. Strange as it may seem, this method is also employed in music, when it tries to imitate, not only with rhythm but with sounds themselves, the very sounds which in real life accompany that which it wishes to portray.

The third method consists in affecting external sensations, often in a purely physical way, by what is called strikingness or effectfulness. These effects, in all the arts, consist mainly in contrasts – in a juxtaposing of horrible and tender, beautiful and ugly, loud and soft, dark and light, the most ordinary and the most extraordinary. In verbal art, besides effects of contrast, there are also effects consisting in the description or portrayal of something that has never been described or portrayed before, predominantly in the description or portrayal of details that arouse sexual lust, or details of suffering and death that evoke the feeling of horror – for example, in describing a murder, to give a minute description of the torn tissues, the swellings, the smell, the quantity and appearance of the blood. So, too, in painting: together with contrasts of various

sorts, another contrast is becoming widely used, consisting in the thorough finishing of one object and the sketchy treatment of the rest. The main effects used in painting are the effects of light and the portrayal of the horrible. In the drama, the most ordinary effects, apart from contrasts, are tempests, thunderstorms, moonlight, action on the sea or near the sea, changes of costume, the baring of the female body, madness, murders, and deaths in general, when the dying people convey in detail all the phases of their agony. In music, the most commonly used effects consist in following very weak and monotonous sounds with a crescendo and complication, culminating in the strongest and most complex sounds of the whole orchestra, or else in repeating the same sounds *arpeggio* in all octaves and on all instruments, or else in having a harmony, tempo, or rhythm utterly different from what would naturally flow from the course of the musical idea, but striking in their unexpectedness.

These are some of the most commonly used effects in the various arts, but there is one more besides, which is common to all the arts, and that is the portrayal by one art of what is usually portrayed by another, so that music should 'describe', as all programme music does, both that of Wagner and that of his followers, while painting, drama and poetry should 'create a mood', as is done in all decadent art.

The fourth method is diversion, that is, an intellectual interest added to the work of art. Diversion may consist in an entangled plot – a method still very much in use in recent English novels and French comedies and dramas, but which is now going out of fashion and is being replaced by documentary methods, that is, by the detailed description either of some historical period or of some particular sphere of contemporary life. Thus, for instance, the diversion consists in describing Egyptian or Roman life in a novel, or the life of miners, or of salesmen in a department store; the reader becomes interested, and he mistakes this interest for an artistic impression. The diversion may also consist in the methods of expression themselves. This sort of diversion is now very much in use. Poetry and prose, as well as paintings, dramas and musical pieces, are now written in such a way that they must be puzzled out

like rebuses, and this process of puzzling out also affords pleasure and gives a semblance of the impression produced by art.

It is very often said that a work of art is very good because it is poetic, or realistic, or effectual, or interesting, whereas not only can neither the one, nor the other, nor the third, nor the fourth be a standard of worth in art, but they do not even have anything in common with it.

Poetic means borrowed. And any borrowing only suggests to readers, spectators or listeners some vague memories of the artistic impressions they received from earlier works of art, and does not infect them with a feeling that the artist himself has experienced. A work based on borrowing – Goethe's *Faust*, for example – may be very well executed, full of intelligence and every beauty, but it cannot produce a true artistic impression, because it lacks the chief property of a work of art – wholeness, organicness, in which form and content constitute an inseparable whole expressing the feeling experienced by the artist. In borrowing, the artist conveys only the feeling that was conveyed to him by an earlier work of art, and therefore any borrowing of entire themes or various scenes, situations, descriptions is only a reflection of art, its simulacrum, and not art itself. And therefore, to say of such a work that it is good because it is poetic – meaning that it resembles a work of art – is the same as to say of a coin that it is good because it resembles a real one. Just as little can imitation, realism, contrary to what many think, be a standard of the worth of art. Imitation cannot be a standard of the worth of art because, if the chief property of art is to infect others with the feeling experienced by the artist, this infecting not only does not go together with a detailed description of what is conveyed, but is largely disrupted by the superfluity of details. The attention of the one receiving the artistic impression is distracted by all these well-observed details, and this prevents the author's feeling, if indeed there is any, from being conveyed.

To evaluate a work of art by the degree of its realism, by the truthfulness of the details conveyed, is as strange as to judge the nutritional qualities of food by its appearance. When we define the value of a work of art by its realism, we merely show thereby that we are talking, not of a work of art, but of a counterfeit.

The third method of counterfeiting art – by strikingness, or effectfulness – goes together no more than the first two with the concept of genuine art, because the strikingness, the effects of novelty, unexpected contrasts, horrors, do not convey any feeling, but only affect the nerves. If an artist makes an excellent portrayal of a bloody wound, the sight of the wound will strike me, but there will be no art in it. One drawn-out note on a powerful organ will produce a striking impression, will even call up tears, but there will be no music in it, because it conveys no feeling. And yet physiological effects of this sort are constantly mistaken for art by people of our circle, not only in music, but in poetry, painting and the drama. It is said that art has become refined in our time. On the contrary, owing to the pursuit of effects, it has become extremely crude. Take a performance of the new play *Hannele*,[87] which is showing in theatres all over Europe, and in which the author wishes to convey to the public his compassion for a girl tormented to death. To call up this emotion in the spectators by means of art, the author ought to have made one of his characters express this compassion in such a way as to infect everyone, or to have given a true description of the girl's sensations. But he cannot or will not do this, and chooses another way, more complicated for stage technicians but easier for artists. He has the girl die onstage; and furthermore, to enhance the psychological effect on the public, he puts out the lights in the theatre, leaving the audience in darkness, and, to the sounds of pitiful music, shows the girl's drunken father pursuing her and beating her. The girl writhes, squeals, moans, falls. Angels appear and carry her away. And the audience, experiencing a certain excitement, is quite sure that this is an aesthetic feeling. But there is nothing aesthetic in this excitement, because it is not one man infecting another, but is only a mixed feeling of suffering for another and gladness for oneself, that it is not I who am suffering – like what we experience in viewing an execution, or what the Romans experienced in their circuses.

The substitution of effects for aesthetic feeling is especially noticeable in musical art – an art peculiar in its direct physiological impact on the nerves. Instead of using melody to convey the feelings

experienced by the composer, the new musician accumulates and interweaves sounds, and by alternately intensifying and weakening them, produces a physiological effect on the public, which can be measured by an apparatus specially designed for that purpose.[88] And the public mistakes this physiological effect for the effect of art.

As for the fourth method, diversion, though it is more foreign to art than the others, it is more often confused with it. Not to mention an author's deliberate concealment of something in a novel or story which the reader must then guess, one often hears it said that a painting or a musical composition is interesting. What does 'interesting' mean? An interesting work of art is either one that provokes unsatisfied curiosity, or one which, as we contemplate it, gives us information that is new to us, or else it is a work that is not entirely comprehensible, the meaning of which we figure out gradually and with effort, finding a certain pleasure in this guessing process. In none of these cases does the diversion have anything to do with an artistic impression. The aim of art is to infect people with a feeling experienced by the artist. But the mental effort required of a spectator, listener or reader to satisfy their aroused curiosity, or to master the new information imparted by the work, or to grasp its meaning, absorbs the reader's, spectator's or listener's attention, thereby interfering with the infection. And therefore what is diverting in the work not only has nothing to do with its artistic worth, but hinders rather than helps the artistic impression.

A work of art may be poetic, imitative, striking or diverting, but none of these qualities can replace the chief property of art – the feeling experienced by the artist. Lately, however, in the art of the upper classes, the majority of objects that pass for objects of art are precisely the sort that only resemble art, and do not have as their basis the chief property of art – the feeling experienced by the artist.

There are many conditions necessary for a man to create a true object of art. It is necessary that the man stand on the level of the highest world outlook of his time, that he have experienced a feeling and have the wish and opportunity to transmit it, and that he have, with all that, a talent for some kind of art. It is very seldom that all these conditions necessary for the production of true

art come together. But to produce, with the help of the developed methods of borrowing, imitation, effectfulness and diversion, that simulacrum of art which is so well remunerated in our society, one need only have a talent for some kind of art, which occurs quite often. I call talent the ability, in verbal art, to express one's thoughts and impressions with ease, and to observe and remember characteristic details; in plastic art, to distinguish, remember and convey lines, forms and colours; in music, to distinguish intervals, to remember and convey a sequence of sounds. In our time, a man with such talent, once he has learned the techniques and methods of counterfeiting his art, if he is patient, and if his aesthetic sense, which would make such works loathsome to him, has atrophied, can ceaselessly produce, to the end of his days, works which in our society are regarded as art.

To produce such counterfeits, there exist certain rules or recipes in every kind of art, so that a talented man, having learned them, can produce such objects *à froid*, coldly, without the least feeling. To write poetry, a man with verbal talent need only accustom himself to using, in place of each single, real, necessary word, depending on the demands of metre and rhyme, another ten words of approximately the same meaning, and then accustom himself to saying each sentence, which to be clear must have its own particular word-order, in every other possible verbal combination, so long as there is some semblance of meaning; and then, too, depending on words that happen to rhyme, to accustom himself to inventing simulacra of thoughts, feelings or pictures to go with these words, and then the man can proceed ceaselessly to turn out verses, short or long, religious, amatory, or civic, depending on the need.

If a man talented in verbal art wishes to write stories or novels, all he need do is develop a style – that is, learn to describe everything he sees and accustom himself to remembering or noting down details. Once he has mastered that, he can ceaselessly write novels or stories, depending on the demand or his own desire – historical, naturalistic, social, erotic, psychological, or even religious, a fashion and demand for which is beginning to appear. He can take plots from his reading or from events he has experienced and copy the characters of the protagonists from his own acquaintances.

And such novels and stories, if they are garnished with well-observed and recorded details, best of all erotic ones, will be regarded as works of art, though they lack even a scintilla of experienced feeling.

To produce art in dramatic form, a talented man, along with everything needed for writing a novel or story, must also learn to put into the mouths of his characters as many apt and witty words as possible, to use theatrical effects, and manage so to interweave the actions of the heroes that there is not a single long conversation on the stage, but as much bustle and movement as possible. If a writer knows how to do that, he can write dramatic works ceaselessly, one after the other, choosing his plots from criminal records, or from the latest question that society is taken up with, such as hypnotism, heredity, and so on, or from the most ancient and even fantastic realms.

For a man talented in painting or sculpture, it is still easier to produce objects that resemble art. All he needs is to learn to draw, paint or sculpt – especially naked bodies. Once he has learned that, he can ceaselessly paint one painting after another or sculpt one statue after another, choosing, according to his inclination, mythological, religious, fantastic or symbolic subjects, or portraying what is written about in the newspapers – a coronation, a strike, the Graeco-Turkish War, the disasters of famine; or, most commonly, portraying all that seems beautiful, from naked women to copper basins.

To produce musical art, a talented man needs still less of what constitutes the essence of art – that is, a feeling which will infect others; but, on the other hand, he needs more physical, gymnastic labour than for any other art, with the possible exception of dancing. To produce works of musical art, one needs first of all to learn to move one's fingers on some instrument as quickly as those who have reached the highest degree of perfection in it; then, one must learn how polyphonic music was written in the old days – that is, learn what are known as counterpoint and fugue; and then master orchestration – that is, the use of instrumental effects. Once he has learned all that, the musician can then ceaselessly write one

work after another: programme music, operas, songs, devising sounds that more or less correspond to the words; or else chamber music – that is, taking other people's themes and reworking them by means of counterpoint and fugue within defined forms; or, most commonly, a fantastic music, taking combinations of sounds that accidentally come to hand and piling all sorts of complications and adornments on top of these accidental sounds.

Thus, in all areas of art, counterfeit works are produced by a ready-made, worked-out recipe, which our upper-class public takes for genuine art.

And this replacement of works of art by counterfeits is the third and most important consequence of the separation of upper-class art from the art of the whole people.

XII

Three conditions contribute to the production in our society of objects of counterfeit art. These conditions are: (1) the considerable remuneration of artists for their works and the resultant establishing of the artist as a professional, (2) art criticism, and (3) art schools.

As long as art was undivided, and only religious art was appreciated and encouraged, while indifferent art was not, there were no counterfeit works of art; or, if there were, being subject to the judgement of the whole people, they would drop away at once. But as soon as the division had been accomplished, and people of the wealthy classes recognized any art as good so long as it afforded pleasure, and this pleasure-affording art began to be remunerated more highly than any other public activity, then at once a great number of people devoted themselves to this activity, and it acquired a totally different character than formerly and became a profession.

And as soon as art became a profession, the chief and most precious property of art – its sincerity – became significantly weakened and was partly destroyed.

The professional artist lives by his art, and must therefore constantly invent subjects for his works, and invent them he does. It is clear what difference must exist between works of art when created by people such as the Hebrew prophets, the authors of the Psalms, Francis of Assisi, the author of the *Iliad* and *Odyssey*, of all folk tales, legends, and songs, who not only received no remuneration for their works, but did not even connect their names with them, and when art was first produced by court poets, playwrights, musicians, who received honour and remuneration for it, and then by official artists, who lived by their craft and received remuneration from journalists, publishers, impresarios and middlemen in general, who stand between the artists and the urban public – the consumers of art.

This professionalism is the first condition for the spread of counterfeit, false art.

The second condition is the recently emerged art criticism – that is, the evaluation of art, not by everyone, and above all not by ordinary people, but by learned, and therefore perverted and at the same time self-assured, individuals.

A friend of mine, speaking of the attitude of critics towards artists, defined it half jokingly like this: critics are the stupid discussing the clever. This definition, however one-sided, imprecise and crude, still contains a partial truth, and is incomparably more correct than the one according to which critics are supposed to explain works of art.

'Critics explain.' But what do they explain?

An artist, if he is a true artist, has in his work conveyed to others the feeling he has experienced: what is there to explain?

If the work is good as art, then the feeling expressed by the artist is conveyed to others, regardless of whether the work is moral or immoral. If it is conveyed to others, they experience it, and experience it, moreover, each in his own way, and all interpretation is superfluous. If the work does not infect others, then no interpretation is going to make it infectious. Artistic works cannot be interpreted. If it had been possible for the artist to explain in words what he wished to say, he would have said it in words. But he has

94

said it with his art, because it was impossible to convey the feeling he experienced in any other way. The interpretation of a work of art in words proves only that the interpreter is incapable of being infected by art. That is indeed so, and, strange as it may seem, it is the people least capable of being infected by art who have always been critics. For the most part they are people with a ready pen, well educated, intelligent, but with a completely perverted or atrophied capacity for being infected by art. And therefore, with their writings, these people have always contributed significantly and still contribute to perverting the taste of the public that reads them and believes them.

Art criticism did not and could not and cannot exist in any society in which art is not divided in two and is therefore evaluated by the religious world view of the whole people. Art criticism emerged and could emerge only in the art of the upper classes who do not recognize the religious consciousness of their time.

Art of the whole people has a definite and indisputable inner criterion – religious consciousness; the art of the upper classes does not have this, and therefore the lovers of this art must inevitably hold to some external criterion. For them, this criterion is, as was said by an English aesthetician, the taste of 'the best nurtured men', the best educated men – that is, the authority of people regarded as educated, and not only their authority but also the tradition of their authority. This tradition, however, is a quite mistaken one, both because the judgements of 'the best nurtured men'[89] are often mistaken, and because judgements that were once correct cease to be so in time. Yet the critics, having no grounds for their judgements, never cease repeating them. The ancient tragedians were once considered good, and the critics consider them so still. Dante was considered a great poet, Raphael a great painter, Bach a great musician, and the critics, having no standard by which to distinguish good art from bad, not only consider these artists still great, but also consider *all* the works of these artists great and worthy of imitation. Nothing has contributed and still contributes so much to the perversion of art as these authorities set up by criticism. A young man produces a work of art, expressing in it in his own particular

fashion, as any artist does, the feelings he has experienced. The majority of people are infected by the artist's feeling, and his work becomes known. And then the critics, discussing the artist, start saying that his work is not bad, but still he is no Dante, no Shakespeare, no Goethe, no Beethoven of the late period, no Raphael. And the young artist, listening to these opinions, starts to imitate those set up as examples for him, and produces not only weak, but counterfeit, false works.

So, for instance, our Pushkin writes his short poems, his *Evgeniy Onegin*, his *Gypsies*, his tales – all works of varying merit, but all works of true art. But then, influenced by false criticism extolling Shakespeare, he writes *Boris Godunov*, a cold, cerebral work, and the critics extol this work, call it exemplary, and imitations of the imitation begin to appear: *Minin*, by Ostrovsky, *Tsar Boris*, by Tolstoy, and others.[90] Such imitations of imitations fill all literatures with the most worthless, utterly unnecessary works. The chief harm of critics is that, as men lacking the capacity to be infected by art (and all critics are that way: if they did not lack this capacity, they would not be able to undertake the impossible interpretation of artistic works), critics give most attention and praise to cerebral, contrived works, and hold up such works as models worthy of imitation. That is why they so confidently praise the Greek tragedians, Dante, Tasso, Milton, Shakespeare, Goethe (almost everything), and, among the new ones, Zola, Ibsen, the music of Beethoven's late period, Wagner. To justify their praise of these cerebral, contrived works, they invent whole theories (the famous theory of beauty is one), and not only do dull but talented people create their works strictly in accordance with these theories, but often even true artists force themselves to comply with them.

Every false work praised by the critics is a doorway through which burst the hypocrites of art.

It is only thanks to the critics who, in our time, praise the crude, savage, and for us often meaningless works of the ancient Greeks: Sophocles, Euripides, Aeschylus, and especially Aristophanes; or the moderns: Dante, Tasso, Milton, Shakespeare; in painting, all of Raphael, all of Michelangelo, with his absurd *Last Judgement*; in

music, all of Bach and all of Beethoven, including his late period – it is only thanks to these critics that in our time, too, the Ibsens, Maeterlincks, Verlaines, Mallarmés, Puvis de Chavannes, Klingers, Böcklins, Stucks, Schneiders, and, in music, the Wagners, Liszts, Berliozes, Brahmses, Richard Strausses, *et al.*, and the whole enormous mass of imitators of these imitators became possible.

The best illustration of the harmful influence of criticism may be its attitude towards Beethoven. Among his countless works, often written hastily, on commission, there are some artistic works as well, despite their artificiality of form; but he is growing deaf, he cannot hear and is beginning to write totally contrived, unfinished and therefore often meaningless, musically incomprehensible works. I know that musicians can imagine sounds quite vividly and almost hear what they read; but imaginary sounds can never replace real ones, and every composer must hear his work in order to put the finishing touch to it. Beethoven could not hear and could not put the finishing touch to his works, and so he released into the world what amounts to artistic gibberish. Yet criticism, having once recognized him as a great composer, finds particular joy in latching on precisely to these ugly works, seeking extraordinary beauties in them. And to justify its own praises, it perverts the very idea of musical art by ascribing to it the property of portraying what it cannot portray; and imitators appear, a numberless host of imitators of these ugly attempts at works of art created by the deaf Beethoven.

And so Wagner appears, who first of all praises Beethoven in his critical articles, precisely the Beethoven of the late period, and establishes a connection between his music and the mystical theory of Schopenhauer (as absurd as Beethoven's music itself) that music is the expression of the will – not particular expressions of the will at various stages of objectivization, but of its very essence – and then, following this theory, he writes his own music, in connection with the still more false system of the unity of all the arts. And after Wagner there appear more new imitators, still further removed from art: the Brahmses, the Richard Strausses and others.

Such are the consequences of criticism. But the third condition of the perversion of art – schools that teach art – is hardly less harmful.

97

As soon as art became art not for the whole people but for the wealthy class, it became a profession, and as soon as it became a profession, methods were developed for teaching this profession, and those who chose art as their profession began to study these methods, and so professional schools appeared: classes of rhetoric or literature in public schools, academies of painting, conservatories of music, schools of dramatic art.

In these schools art is being taught. But art consists of conveying to others the special feeling experienced by an artist. How can this be taught in schools?

No school can call up feelings in a man, and still less can it teach a man what is the essence of art: the manifestation of feeling in his own peculiar fashion.

The one thing a school can teach is how to convey feelings experienced by other artists in the way that these other artists conveyed them. Precisely this is what is taught in art schools, and this education not only does not contribute to the spread of true art, but, on the contrary, by spreading artistic counterfeits, more than anything else it deprives people of the ability to understand true art.

In literary art, people who have no wish to say anything are taught the skill of writing a many-paged composition on a topic they have never thought about, and of writing it so that it resembles the writing of authors recognized as famous. This is taught in the public schools.

In painting, the main education consists of drawing and painting from life and nature, mainly the naked body – precisely what one never sees and what a man occupied with real art hardly ever has to portray – and of drawing and painting it in the same way as earlier masters did; the composition of paintings is taught by giving subjects similar to those treated by earlier recognized celebrities. So, too, in the schools of dramatic art, the students are taught to deliver monologues in exactly the same way they were delivered by tragic actors considered famous. So, too, in music. The whole theory of music is nothing but an incoherent repetition of the methods that recognized masters of composition used to create their own music.

I have already quoted elsewhere a profound saying on art from

the Russian painter Briullov,[91] but I cannot refrain from quoting it again, because it shows best of all what can and cannot be taught in schools. Correcting a student's sketch, Briullov touched it up a little here and there, and the poor, dead sketch suddenly came to life. 'Why, you just touched it up a *little bit*, and everything changed,' said one of the students. 'Art begins where that *little bit* begins,' said Briullov, expressing in these words the most characteristic feature of art. This observation holds for all the arts, but its correctness is especially noticeable in musical performances. For a musical performance to be artistic, to be art – that is, to produce infection – three main conditions must be observed (besides which there are many other conditions necessary for musical perfection: that the transition from sound to sound be abrupt or blended, that the sound increase or diminish gradually, that it combine with one sound and not with another, that the sound have this and not that timbre, and many more things). But let us take three main conditions: the pitch, the duration and the intensity of the sound. A musical performance is art and can infect only when the sound is neither higher nor lower than it ought to be – that is, the infinitely small centre of the required note must be played – and it must have exactly the necessary duration, and the intensity of the sound must be neither stronger nor weaker than is necessary. The least deviation in the pitch of the sound one way or the other, the least lengthening or shortening of the duration, and the least strengthening or weakening of the sound as compared with what is required, destroys the perfection of the performance and, consequently, the infectiousness of the work. So that we can be infected by the art of music, something that would seem so simply and easily achieved, only if the performer finds those infinitely small moments required for musical perfection. It is the same in all the arts: a little bit lighter, a little bit darker, a little bit higher, lower, to the right, to the left – in painting; a little bit weaker or stronger in intonation, a little bit too early or too late – in dramatic art; in poetry – a little bit too much said, or not said, or exaggerated, and there is no infection. Infection is achieved only when and in so far as the artist finds those infinitely small moments of which the work of art is composed.

And it is absolutely impossible to teach someone in any external fashion how to find these infinitely small moments: they are found only when a man gives himself to his feeling. No education can bring a dancer to follow the exact beat of the music, or a singer or violinist to strike the infinitely small centre of a note, or a draughtsman to draw the only necessary line out of all possible lines, or a poet to find the only necessary arrangement of the only necessary words. Feeling alone can do that. And therefore schools can teach what is required for creating something resembling art, but never art itself.

School education stops where the *little bit* begins – and therefore where art begins.

Accustoming people to what resembles art makes them unaccustomed to understanding true art. As a result, there are no people duller with regard to art than those who have gone through professional schools of art and have been most successful in them. These professional schools produce a hypocrisy of art of exactly the same sort as the religious hypocrisy produced by schools that educate pastors and various kinds of religious teachers. As it is impossible to educate a man at school to be a religious teacher of men, so it is impossible to teach a man to be an artist.

Thus art schools are doubly pernicious for art: first, by destroying the capacity to produce real art in people who have the misfortune of attending these schools for seven or eight years of study; secondly, because they multiply by enormous quantities that counterfeit art which perverts the taste of the masses and with which our world is filled to overflowing. For people who are born artists to learn the methods of the various kinds of art which have been developed by earlier artists, there should exist classes of drawing, music and singing in all primary schools, after the completion of which every gifted student, by making use of existing and generally available models, could perfect himself independently in his art.

These three conditions – the professionalism of artists, criticism, and schools of art – are what have led to the present situation when the majority of people have absolutely no understanding of what art even is, and mistake for art the most crude counterfeits of it.

XIII

The extent to which people of our circle and time have lost the ability to perceive genuine art, and have become used to taking as art objects that have nothing in common with it, can best be seen in the works of Richard Wagner, more and more appreciated and recognized of late, not only by the Germans but also by the French and the English, as the highest art, opening new horizons.

The peculiarity of Wagner's music, as is known, consists in this, that music must serve poetry, expressing all the nuances of the poetic work.

The combination of drama and music, invented in fifteenth-century Italy to restore what was imagined to be Greek musical drama, is an artificial form which was and is successful only among the upper classes, and then only when gifted musicians like Mozart, Weber, Rossini and others, inspired by the dramatic subject, have given themselves freely to their inspiration, subordinating the text to the music, with the result that in their operas only the music to a certain text was important for the listener, and not the text itself, which, even when quite meaningless, as, for example, in the *Magic Flute*, still did not detract from the artistic impression of the music.

Wagner wants to correct opera by making music subserve the demands of poetry and merge with it. But each art has its own definite sphere, not coinciding with but only touching upon other arts, and therefore if the expressions, not of many, but even only of two arts, the dramatic and the musical, are joined into a single whole, the demands of one art will make it impossible to fulfil the demands of the other, as always used to happen in ordinary opera, where dramatic art subserved, or rather yielded place to, musical art. But Wagner wants musical art to subserve dramatic art and both to be manifest with full power. But this is impossible, because every work of art, if it is a true work of art, is the expression of the artist's innermost feelings, completely exceptional, unlike anything else. Such is the work of music, and such is the work of dramatic art, if they are true art. And therefore, in order that the work of one

art should coincide with the work of the other, an impossible thing must occur: that two works of art from different spheres be completely and exceptionally unlike anything that has been before, and at the same time coincide and be completely like each other.

And this cannot be, just as there cannot be, not only two people, but even two leaves on a tree that are completely the same. Still less can two works from different spheres of art – the musical and the verbal – be completely the same. If they do coincide, then either one is a work of art and the other a counterfeit, or both are counterfeits. Two living leaves cannot be completely like each other, but two artificial leaves can be alike. It is the same with works of art. They can coincide fully only when neither the one nor the other is art, but only a contrived simulacrum of art.

If poetry and music can more or less combine in hymns, songs and ballads (not in such a way that music follows each verse of the text, as Wagner wants, but so that the one and the other produce the same mood), that happens only because lyrical poetry and music have in part the same goal – to produce a mood; and the moods produced by lyrical poetry and music may more or less coincide. Yet in these combinations the centre of gravity is always in one of the two productions, so that only one of them produces an artistic impression, while the other goes unnoticed. Still less can there be such a combination of epic or dramatic poetry and music.

Besides that, one of the main conditions of artistic creativity is the total freedom of the artist from any sort of preconceived demands. Yet the necessity of adjusting one's musical work to a poetic work, or vice versa, is just such a preconceived demand, which destroys any possibility of creative work, and therefore productions of this kind, adjusted to each other, have always been and can only be, not works of art, but simulacra of it, like the music in melodramas, captions under pictures, illustrations, opera librettos.

Such, too, are Wagner's productions. A confirmation of this can be seen in the fact that the chief feature of every true work of art – wholeness, organicness, when the least change in form disturbs the meaning of the entire work – is absent from the new music of Wagner. In a true work of art – poem, drama, painting, song,

symphony – one cannot take one line, one scene, one figure, one measure from its place and put it in some other place without disturbing the meaning of the whole, just as one cannot but disturb the life of an organic being by taking an organ from its place and putting it somewhere else. But in Wagner's music of the latest period, with the exception of certain insignificant passages that have independent musical meaning, one can make all sorts of replacements, putting what came earlier into a later part, and vice versa, without thereby changing the musical meaning. The meaning of Wagner's music is not changed, because it is contained in the words and not in the music.

The musical text of Wagner's operas may be likened to what a poet of a now numerous sort – having crippled his language so as to be able to write verses on any subject, in any rhymes, in any metre, and have them come out resembling verses with meaning – would do if he made up his mind to illustrate some symphony or sonata of Beethoven, or a ballade of Chopin, with his verses, so that, for the first few measures of a certain character, he would write verses which, in his opinion, correspond to those first few measures. Then, to the next few measures of a different character he would write what were, in his opinion, corresponding verses, with no inner connection to the first verses and, moreover, with no rhyme or metre. Such a work, without the music, would in a poetic sense be exactly like Wagner's operas in a musical sense, if they were listened to without the text.

But Wagner is not only a musician, he is also a poet, or both at once, and therefore, in order to judge Wagner, one must also know his text, that very text which the music must serve. The chief poetic production of Wagner is the poetic rendition of the *Nibelungen*. This work has acquired such great significance in our time, it has so much influence over everything that nowadays passes for art, that every man of our time must have some idea of it. I have read very attentively the four little books in which this work has been published, and have composed a brief abstract which I have put in the second Appendix, and I strongly advise the reader, if he has not read the text itself, which would be best of all, at least to read my

summary, in order to form an idea of this extraordinary work. It is an example of a poetic counterfeit crude to the point of being ridiculous.

But it is said that one cannot judge the works of Wagner without having seen them staged. This winter in Moscow there was a performance of the second day, or second act, of this drama – the best of all, I was told – and I went to see it.

When I arrived, the enormous theatre was already filled from top to bottom. There were grand dukes and the flower of the aristocracy, and merchants, and scholars, and middle-class clerkdom. Most of them were holding the libretto, trying to understand its meaning. Musicians – some of them elderly, grey-haired men – followed the music with score in hand. Obviously, the performance of this work was an event of sorts.

I came a bit late, but I was told that the short prelude that begins the play was of little significance and that I had missed nothing important. On stage, amid scenery supposedly representing a cave in the rocks, in front of some object supposedly representing a blacksmith's apparatus, sat an actor dressed in tights and a cloak of skins, wearing a wig and a false beard, with weak, white, non-labouring hands (from his slack movements, and above all from his belly and lack of muscle, one could see that he was an actor), beating with a hammer such as never was upon a sword such as never could be, and beating in such a way as no one ever beats with a hammer, all the while opening his mouth strangely and singing something that could not be understood. Music from various instruments accompanied the strange sounds he produced. From the libretto one learned that this actor was supposed to portray a mighty dwarf who lived in the grotto and was forging a sword for Siegfried, whom he had brought up. One could tell he was a dwarf by the fact that the actor walked about all the time with his tight-clad legs bent at the knees. For a long time the actor sang or shouted something, opening his mouth in the same strange way. The music meanwhile ran through something strange, some beginnings of something that had no sequel and did not end with anything. From the libretto one learned that the dwarf was telling

himself about a ring which had come into the possession of a giant, and which he wanted to acquire by means of Siegfried; so Siegfried needed a good sword; it was with the forging of this sword that the dwarf was occupied. After this rather lengthy conversation with or singing to himself, different sounds suddenly come from the orchestra, again something that begins and does not end, and another actor appears with a horn slung over his shoulder, accompanied by a man running on all fours and dressed up as a bear, and he sicks this bear on the dwarf blacksmith, who runs about without unbending his tight-clad legs. This other actor must represent Siegfried himself. The sounds produced by the orchestra at this actor's entrance are supposed to portray Siegfried's character and are called Siegfried's leitmotiv. And these sounds are repeated each time Siegfried appears. For each character there is one such specific combination of sounds as a leitmotiv. So that this leitmotiv is repeated each time the character it represents appears; even at the mention of some character, the motiv corresponding to this character is heard. Moreover, each object has its own leitmotiv or chord. There is a motiv of the ring, a motiv of the helmet, a motiv of the apple, fire, spear, sword, water and so on, and as soon as ring, helmet or apple is mentioned – there comes the motiv or chord of the helmet, the apple or whatever. The actor with the horn opens his mouth up as unnaturally as the dwarf and for a long time shouts some words in sing-song and receives sing-song answers from Mime. That is the dwarf's name. The gist of this conversation, which can be learned only from the libretto, is that Siegfried was brought up by the dwarf, and for some reason hates him on account of that, and keeps wanting to kill him. The dwarf has forged the sword for Siegfried, but Siegfried is not pleased with the sword. From this ten-page (going by the libretto) sing-song conversation, conducted for about half an hour with the same strange opening of mouths, one learns that Siegfried's mother gave birth to him in the forest, and all that is known of the father is that he had a sword that was broken, and Mime has the pieces, and that Siegfried knew no fear and wanted to leave the forest, but Mime did not want to let him go. In this conversation to music, at each mention of the father,

the sword, etc., the motivs of these characters and objects are never omitted. After these conversations, new sounds are heard on stage, those of the god Wotan, and a wanderer appears. This wanderer is the god Wotan. Also in a wig, also in tights, this god Wotan, standing in a silly pose with a spear, for some reason tells all sorts of things that Mime must already know, but that the spectators need to be told anyway. He tells all this not simply, but in the form of riddles which he orders them to ask him, betting his head, God knows why, that he will unriddle them. Each time the wanderer strikes the ground with his spear, fire comes from the ground, and the orchestra produces the sounds of the spear and the sounds of the fire. The conversation is accompanied by the orchestra, with a constant artificial interweaving of the motivs of the characters and objects being talked about. Besides that, feelings are expressed – musically – in the most naïve way: the fearsome by bass sounds, the light-hearted by a quick running over the treble, and so on.

The riddles have no other purpose than to tell the spectators who the Nibelungs are, who the giants are, who the gods are, and what happened earlier. This conversation, also with mouths strangely gaped open, is done in sing-song and continues for eight libretto pages, and for a correspondingly long time on the stage. After that the wanderer exits, Siegfried enters again and talks with Mime for another thirteen pages. There is not a single melody, but all the while the interweaving of the leitmotivs of the characters and objects being talked about. The talk is about Mime wanting to teach Siegfried fear, and Siegfried not knowing what fear is. Having finished this conversation, Siegfried seizes a piece of what must represent the pieces of the sword, saws it up, puts it on what must represent the forge, welds it together, then hammers on it, singing: 'Heaho, heaho, hoho! Hoho, hoho, hoho, hoho; hoheo, haho, haheo, hoho,' and the first act is over.

The question with which I had come to the theatre was for me indisputably resolved, as indisputably as the question of the merits of the story by the lady of my acquaintance, when she read me the scene between the loose-haired girl in the white dress and the hero with two white dogs and a hat with a feather à la Guillaume Tell.

There is nothing to be expected from an author who can compose such false scenes, cutting like knives at the aesthetic sense, as those I had seen: one can boldly decide that everything this author writes will be bad, because this author obviously does not know what a true work of art is. I wanted to leave, but the friends with whom I had come begged me to stay, insisting that one could not form a decision by this one act, that it would get better in the second – and so I stayed for the second act.

Second act – night. Then dawn breaks. Generally, the whole play is filled with dawns, fogs, moonlights, darknesses, magic fires, thunderstorms and so on.

The stage represents a forest and a cave in the forest. By the cave sits a third actor in tights, representing yet another dwarf. Dawn breaks. Again the god Wotan enters with his spear, again in the guise of a wanderer. Again his sounds are heard, then new sounds, as bass as can be produced. These sounds signify that a dragon is speaking. Wotan awakens the dragon. The same bass sounds are repeated, getting more and more bass. The dragon first says, 'I want to sleep,' then he crawls out of the cave. The dragon is played by two men dressed in a sort of green scaly skin, who swing the tail at one end and at the other end open a stuck-on crocodile-like maw, from which comes the light of an electric bulb. The dragon, who is meant to be frightening, and might possibly seem so to five-year-old children, utters some words in a bellowing basso. This is all so stupid, so farcical, that one wonders how people older than seven can seriously attend it; yet thousands of quasi-educated people sit there, listening and watching attentively, admiring it.

Siegfried enters with his horn and Mime. The orchestra plays the sounds signifying them, and Siegfried and Mime talk about whether Siegfried does or does not know what fear is. Then Mime exits and there begins a scene that is meant to be most poetic. Siegfried in his tights lies down in what is supposed to be a beautiful pose, now silent, now talking to himself. He dreams, he listens to the birds singing and wants to imitate them. To that end, he cuts a reed with his sword and makes a pipe. Day dawns more and more; the birds sing. Siegfried tries to imitate the birds. From the orchestra comes

an imitation of birds mixed with the sounds corresponding to the words he speaks. But Siegfried does not succeed in playing the pipe, so he plays his horn. This scene is unbearable. There is no trace of music in it – that is, of art serving as a means of conveying the mood experienced by the author. There is something completely incomprehensible in a musical sense. In a musical sense there is always hope, followed immediately by disappointment, as if a musical thought were begun and at once broken off. If there is anything resembling the beginnings of music, these beginnings are so brief, so encumbered with complicated harmony, orchestration, effects of contrast, they are so obscure, so unfinished, and with all that the falsity of what takes place on stage is so repulsive, that they are hard to notice, to say nothing of being infected by them. And the main thing is that the author's intentions are heard and seen from the very beginning to the end, and in every note, so much so that one sees and hears not Siegfried or the birds, but only the limited, self-confident bad tone and bad taste of a German, whose ideas of poetry are absolutely false, and who wants, in the most crude and primitive fashion, to convey these false notions of poetry to me.

Everyone knows the feeling of distrust and resistance evoked by the obviousness of an author's intentions. A narrator need only tell you beforehand to get ready to weep or laugh, and you are certain not to weep or laugh; but when you see that the author not only prescribes that we be moved by something that not only is not moving but is ludicrous or repulsive, and when you see, furthermore, that the author is unquestionably certain that he has captivated you, the result is a heavy, tormenting feeling, similar to what anyone would experience if an ugly old woman, dressed up in a ballgown and smiling, twirled in front of you, certain of your sympathy. This impression was reinforced because I saw around me a crowd of three thousand people who not only listened obediently to this totally incoherent gibberish, but considered it their duty to admire it.

Somehow I managed to sit through the next scene with the entrance of the monster, accompanied by bass notes interwoven with Siegfried's motiv, the fight with the monster, all the roaring,

the flames, the brandishings of the sword, but more I could not endure, and I rushed from the theatre with a feeling of revulsion that I still cannot forget.

Listening to this opera, I could not help thinking of a respectable, intelligent, literate village labourer – one of those intelligent, truly religious men whom I know among the people – and imagining the terrible perplexity of such a man if he were to be shown what I had seen that evening.

What would he think if he knew of all the effort expended on this performance, and saw that audience, the mighty of this world, whom he is accustomed to respect, these old, bald-headed, grey-bearded men, sitting for a good six hours in silence, attentively listening to and watching all this stupidity? But, to say nothing of an adult labourer, it is hard to imagine even a child of more than seven who could be amused by this stupid, incoherent tale.

And yet a huge audience, the flower of the educated upper class, sits through these six hours of mad performance and leaves imagining that, having given this stupidity its due, it has acquired a fresh right to regard itself as progressive and enlightened.

I am speaking of the Moscow public. But what is the Moscow public? It is one hundredth part of that public which regards itself as most enlightened and counts it to its credit that it has lost the ability to be infected by art to such a degree that it is capable not only of being present at this stupid falseness, but even of admiring it.

In Bayreuth, where these performances began,[92] people who regarded themselves as refinedly educated came from all over the world, spending about a thousand roubles per person, just to see the performance, and for four days in a row, sitting it out for six hours a day, they went to watch and listen to this absurdity and falseness.

But why did and why do people still go to these performances, and why do they admire them? The question involuntarily arises: how is the success of Wagner's works to be explained?

I explain this success to myself by the fact that, thanks to the exclusive position he occupied, having a king's resources at his disposal, Wagner very skilfully employed all the methods of falsification worked out in the long practice of counterfeiting art and

composed an exemplary counterfeit of an artistic production. I have taken this work as an example precisely because in no other artistic counterfeit known to me are all the methods of counterfeiting art – namely, borrowing, imitation, effectfulness and diversion – combined with such mastery and power.

Starting with a theme from antiquity and ending with fogs and moon- and sunrises, Wagner employs all that is considered poetic in this work. Here we have a sleeping beauty, and river nymphs, and subterranean fires, and gnomes, and battles, and swords, and love, and incest, and a monster, and singing birds – the whole arsenal of poeticality is put to use.

Furthermore, it is all imitative: both sets and costumes are imitative. Everything is done as it must have been in antiquity, according to archaeological data. The very sounds are imitative. Wagner, who was not without musical talent, invented precisely the sounds to imitate the strokes of a hammer, the hiss of red-hot iron, the singing of birds and so on.

Besides that, everything in this work is strikingly effectful in the highest degree – striking both in its details (monsters and magic fires) and in actions that take place in the water, and in the darkness in which the audience sits, and in the invisibility of the orchestra, and in the new, never-before-employed harmonic combinations.

And, moreover, everything is diverting. The diversion lies not only in who will kill whom, and who will marry whom, and who is whose son, and what will happen after what – there is also diversion in the relation of music and text: waves are flowing on the Rhine – how will that be expressed in music? A wicked dwarf enters – how will music express the wicked dwarf? How will music express the sensuality of this dwarf? How will courage, fire, apples be expressed in music? How does the leitmotiv of a person speaking interweave with the leitmotivs of the characters and objects of which he speaks? Besides, the music itself is diverting. This music departs from all previously accepted laws; the most unexpected and completely new modulations appear in it (which is very easy and quite possible in music that has no inner structure). The dissonances are new and are resolved in a new way, and this is diverting.

These poetical, imitative, striking and diverting qualities, owing both to Wagner's peculiar talent and to his advantageous position, are brought to the highest degree of perfection in these works, and affect the spectator by hypnotizing him, as a man who listens for several hours to the ravings of a madman uttered with great oratorical skill will also become hypnotized.

They say you cannot judge without having seen Wagner's productions in Bayreuth, in the darkness, where the music is not seen, being placed under the stage, and the performance is brought to the highest degree of perfection. But this precisely proves that it is a matter, not of art, but of hypnosis. The spiritualists say the same thing. In order to convince people of the genuineness of their visions, they usually say that you cannot judge, you must experience it – that is, spend several hours in a row sitting silently in the company of half-mad people, and repeat this about ten times – and then you will see everything that we see.

How could one not see it? Only put yourself in such conditions, and you will see whatever you like. This can be achieved in a still quicker way by drinking wine or smoking opium. It is the same when listening to Wagner's operas. Try sitting in the dark for four days in the company of not quite normal people, subjecting your brain to the strongest influence of sounds calculated to excite the brain by strongly affecting the nerves of hearing, and you are certain to arrive at an abnormal state and come to admire the absurdity. That does not even take four days; the five hours of a single day's performance, as in Moscow, are enough. Not five hours, but even one hour is enough for people who have no clear idea of what art ought to be, and who have formed the opinion for themselves beforehand that what they are going to see is wonderful and that indifference to or dissatisfaction with this work will be proof of their ignorance and backwardness.

I watched the audience at the performance I attended. The people who guided the whole audience and set the tone for them were people who had already been hypnotized and had fallen once again into the familiar hypnosis. These hypnotized people, being in an abnormal state, were completely enraptured. Besides, all the art

critics, who lack the capacity for being infected by art, and therefore especially appreciate works like Wagner's operas in which everything is a cerebral matter, with an air of great profundity also approved this work, which gives abundant food for philosophizing. And these two groups of people were followed by the big city mob, indifferent to art, their capacity for being infected by it perverted and partly atrophied, with princes, rich men and Maecenases at their head, who, like bad hounds, always join those who express the loudest and most resolute opinion.

'Oh, yes, of course, what poetry! Remarkable! The birds especially!' 'Yes, yes, I'm quite won over!' These people repeat, each in his own way, the same thing they have just heard from those whose opinion seems trustworthy to them.

Even if there are people who are insulted by the senselessness and falseness, they keep timidly silent, as sober people keep timidly silent among the drunk.

And so, owing to its masterful counterfeiting of art, a senseless, crude, false work, which has nothing to do with art, goes around the world, its production costing millions, and perverts more and more the tastes of upper-class people and their notion of what art is.

XIV

I know that the majority of people who are not only regarded as intelligent but are indeed intelligent, capable of understanding the most difficult scientific, mathematical and philosophical reasonings, are very rarely capable of understanding a most simple and obvious truth, if it is such as requires that they admit that a judgement they have formed about something, sometimes with great effort, a judgement they are proud of, which they have taught to others, on the basis of which they have arranged their entire life – that this judgement may be wrong. And therefore I have little hope that the arguments I am presenting about the perversion of art and taste in

our society will be, not accepted, but even seriously discussed, and yet I must speak out to the end what I have been ineluctably brought to by my study of the question of art. This study has brought me to the conviction that almost everything regarded as art, and good art, and the whole of art in our society, is not only not true and good art, nor the whole of art, it is not even art at all, but only a counterfeit of it. This statement, I know, is very strange, and seems paradoxical, and yet if we once recognize as true that art is a human activity by means of which some people convey their feelings to others, and is not the service of beauty, the manifestation of an idea, and so on, then it must needs be admitted. If it is true that art is an activity by means of which one man, having experienced a feeling, conveys it consciously to others, then we must inevitably admit that of all that among us is called the art of the upper classes — all these novels, stories, dramas, comedies, paintings, sculptures, symphonies, operas, operettas, ballets, etc., which pass for works of art — there is hardly one in a hundred thousand that originated in a feeling experienced by its author; the rest are manufactured works, artistic counterfeits, in which borrowing, imitation, effectfulness and diversion replace infection by feeling. That the proportion of true works of art to the number of these counterfeits is one to hundreds of thousands, or even less, can be proved by the following calculation. I read somewhere that there are 30,000 artist-painters in Paris alone. There must be the same number in England, the same in Germany, the same in Russia, Italy and some smaller countries combined. So that there should be altogether about 120,000 artist-painters in Europe, and as many musicians, and as many artistic writers. If these 300,000 people produce at least three works each per year (and many produce ten or more), then every year yields a million works of art. How many have there been in the last ten years, and how many in all the time since upper-class art separated from popular art? Millions, obviously. Yet who among the greatest connoisseurs of art has actually not received an impression from all these alleged works of art, but at least come to know of their existence? To say nothing of all the working people, who have no idea of these works, the people of the

upper class cannot know even one-thousandth of all these works and do not remember the ones they did know. All these objects come in the guise of art, produce no impression on anyone, except at times an impression of amusement on an idle crowd of rich people, and disappear without a trace. To this it is usually replied that if it were not for this huge number of unsuccessful attempts, there would be no true works of art. But this reasoning is the same as if a baker, in reply to the reproach that his bread is no good, were to say that if it were not for a hundred ruined loaves, there would not be one that is well baked. It is true that wherever there is gold there is also a lot of sand; but this can in no way serve as a pretext for saying a lot of stupid things in order to say something intelligent.

We are surrounded by works that are considered artistic. Thousands of lyrics, thousands of long poems, thousands of novels, thousands of dramas, thousands of paintings, thousands of musical compositions appear one after another. All the poems describe love, or nature, or the author's state of mind, and all of them observe metre and rhyme; all the dramas and comedies are splendidly designed and performed by excellently trained actors; all the novels are divided into chapters, they all describe love, and contain affecting scenes, and describe true details of life; all the symphonies contain their *allegro*, *andante*, *scherzo* and *finale*, and they all consist of modulations and chords and are played by musicians trained to the point of refinement; all the paintings, in their gilt frames, vividly portray persons and accessories. But among these works of various kinds of art there is one in a hundred thousand which is not simply a little better than the others, but differs from all the rest in the way a diamond differs from glass. The one cannot be bought for any money, so precious it is; the rest not only have no value but are of negative worth, because they deceive and pervert taste. And yet superficially, for a man with a perverted or atrophied sense of understanding of art, they are exactly the same.

The difficulty of recognizing artistic works in our society is also increased by the fact that in false works the superficial worth is not only no worse but is often better than in true works; often the

counterfeit strikes us more than the true work, and the content of the counterfeit is more interesting. How to discriminate? How to find this one work, not differing in any way superficially, among the hundreds of thousands of works deliberately made to resemble the true one perfectly?

For a man of unperverted taste, a labouring man, not a city-dweller, this is as easy as it is for an animal with an unspoiled scent to find, among thousands of trails in forest or field, the one it needs. An animal will unerringly find what it needs; so, too, a man, if only his natural qualities are not perverted in him, will unerringly choose out of thousands of objects the true work of art that he needs, that infects him with the feeling experienced by the artist; but this is not so for people whose taste has been ruined by their upbringing and life. The sense of artistic perception is atrophied in these people, and in evaluating works of art they must be guided by reasoning and examination, and these reasonings and examinations ultimately confuse them, so that the majority of people in our society are totally unable to distinguish a work of art from the crudest counterfeit. People spend long hours sitting in concerts and theatres, listening to the works of the new composers, and they consider it their duty to read the novels of the famous new novelists, and to look at paintings that depict either something incomprehensible or the same things over and over – which they see much better in reality; and above all they consider it their duty to admire it all, fancying that these are all works of art, and they walk right past the true works of art, not only without paying attention, but even with scorn, simply because these works are not counted as works of art in their circle.

The other day I was returning home from a stroll in a depressed state of mind. As I approached the house, I heard the loud singing of a large circle of peasant women. They were greeting and honouring my daughter, who has married and came for a visit. This singing, with shouts and banging on scythes, expressed such a definite feeling of joy, cheerfulness, energy, that without noticing it I became infected by it, and approached the house more cheerfully, reaching it quite cheered up and merry. I found that everyone in the house who had been listening to this singing was in the same

excited state. That very evening an excellent musician, famous for his performing of classical pieces, and especially of Beethoven, came to visit us and played Beethoven's sonata Opus 101.

I consider it necessary to observe, for those who would explain my opinion of this sonata of Beethoven by my non-understanding of it, that, being very susceptible to music, I understood all that others understand in this sonata, as well as in other works of Beethoven's late period, in the same way as they do. For a long time I had been priming myself so as to admire these formless improvisations which make up the content of the works of Beethoven's late period, but the moment I treated the matter of art seriously and compared the impression I get from the works of Beethoven's late period with the pleasant, clear and strong musical impression produced, for example, by the melodies of Bach (his arias), Haydn, Mozart, Chopin – where these melodies are not encumbered by complications and adornments – or of Beethoven himself in his early period, and above all with impressions received from Italian, Norwegian and Russian folk songs, from Hungarian *czardas*,[93] and other such simple, clear, strong things, then that certain vague and almost morbid excitement from the works of Beethoven's late period, which I had artificially called up in myself, was at once destroyed.

When the performance was over, everyone present, though it was obvious that they were all bored, eagerly praised the profound work of Beethoven as they thought they should, not forgetting to mention that they had not understood this later period before, but now saw that it was the very best. And when I allowed myself to compare the impression produced on me by the peasant women's singing, an impression experienced by everyone who had heard it, with that of this sonata, the lovers of Beethoven only smiled scornfully, considering it unnecessary to respond to such strange talk.

And yet the women's song was true art, conveying a definite, strong feeling. While the 101st sonata of Beethoven[94] was only an unsuccessful attempt at art, containing no definite feeling and therefore not infecting one with anything.

For my work on art I have spent this winter reading, diligently and with great effort, the famous novels and stories of Zola, Bourget,[95] Huysmans and Kipling, which are praised all over Europe. And at the same time, in a children's magazine, I chanced upon a story by a completely unknown writer about the preparations for Easter in a poor widow's family.[96] The plot of the story is that the mother, having with difficulty obtained some white flour, poured it out on the table to be kneaded and went to get some yeast, asking the children not to leave the cottage and to watch over the flour. The mother left and the neighbours' children came running to the window, shouting for the ones in the cottage to come out and play. The children, forgetting their mother's order, run outside and start playing. The mother comes back with the yeast and finds a mother hen on the table throwing what is left of the flour to the dirt floor for her chicks to peck up from the dust. The mother, in despair, scolds the children. The children cry. The mother feels sorry for the children, but there is no more white flour, and so, to cheer them up, the mother decides to make a *kulich*[97] from sifted rye flour, glaze it with egg-white, and put eggs around it. 'Rye bread's my delight – it's the grandpa of white' – the mother recites this proverb to the children to comfort them for not having a *kulich* made from white flour. And the children suddenly go from despair to joyful rapture, each one repeating the proverb, and they look forward to the *kulich* with all the more merriment.

And what then? The reading of the novels and stories of Zola, Bourget, Huysmans, Kipling and others, with the most provoking subjects, did not touch me even for a moment, but I was vexed with the authors all the time, as one is vexed with a man who considers you so naïve that he does not even conceal the method by which he wants to catch you. From the first lines you see the intention behind the writing, and all the details become superfluous – you feel bored. Above all, you know that the author never had any other feeling than the desire to write a story or a novel. And therefore no artistic impression results from it. Yet I could not tear myself away from the unknown author's story about the children and the chicks, because I immediately became infected by the

feeling which the author had obviously lived, experienced and conveyed.

In Russia we have the painter Vasnetsov.[98] He painted the icons for the Kiev cathedral; everyone praises him as the founder of some sort of new Christian art of a lofty sort. He worked for decades on these icons. He was paid tens of thousands of roubles. And all these icons are bad imitations of imitations of imitations, and do not contain one scintilla of feeling. And this same Vasnetsov drew an illustration for Turgenev's story 'The Quail' (which tells of how a father killed a quail in his son's presence and then felt sorry for it), portraying the sleeping boy, with a protruding upper lip, and above him, like a dream, the quail. And this illustration is a true work of art.

In the English Academy, two paintings come next to each other. One is by J. C. Delmas and portrays the temptation of St Anthony. The saint is on his knees, praying. Behind him stand a naked woman and some animals. One can see that the artist liked the naked woman very much, but could not have cared less about Anthony, and that the temptation not only does not frighten him (the artist) but is, on the contrary, highly agreeable to him. And therefore, if there is art in this painting, it is very bad and false. In the same catalogue there is, next to this, a small painting by Langley,[99] depicting a wandering beggar boy who has apparently been asked in by a woman who feels sorry for him. The boy, tucking his bare feet pathetically under the bench, is eating; the woman is watching, probably wondering if he wants more; and a girl of about seven, her head propped in her hand, is watching attentively, seriously, not taking her eyes from the hungry boy, obviously realizing for the first time what poverty is, what inequality among people is, and for the first time asking herself questions: why is it that she has everything, while this boy is barefoot and hungry? She feels both pity and joy. And she loves the boy and the good . . . And one feels that the artist loved this girl and what she loved. And this picture, by a painter who, I believe, is little known, is a beautiful and true work of art.

I remember seeing Rossi's performance of Hamlet,[100] in which

the tragedy itself and the actor playing the leading role are considered by our critics to be the last word in dramatic art. And yet, during the whole time of the performance, I experienced both from the content of the play and from its performance that special suffering produced by false simulacra of artistic works. Recently I also read an account of the theatre of a savage people, the Voguls.[101] One of those who were present describes the following performance: one big Vogul and another small one, both dressed in reindeer skins, represent a female reindeer and her calf. A third Vogul represents a hunter with a bow and snowshoes; a fourth imitates a bird's song, warning the reindeer of danger. The drama consists of the hunter following the tracks of the mother reindeer and her calf. The deer run off the scene and come running back. The performance takes place in a small yurt. The hunter gets closer and closer to his quarry. The calf is worn out and clings to its mother. The mother stops to rest. The hunter catches up with them and takes aim. At that moment the bird peeps, warning the deer of the danger. The deer flee. Again the pursuit, again the hunter approaches, overtakes them, and shoots his arrow. The arrow hits the calf. Unable to run, the calf clings to its mother, and the mother licks its wound. The hunter sets another arrow to his bow. The spectators, according to the narrator's account, sit stock still; one hears deep sighs and even weeping. And I felt, from the description alone, that this was a true work of art.

What I am saying will be taken as a mad paradox, at which one can only be amazed, and yet I cannot help saying what I think – namely, that people of our circle, of whom some write verses, stories, novels, operas, symphonies, sonatas, paint various sorts of pictures, make sculptures, while others listen to them and look at them, and still others evaluate and criticize it all, argue, denounce, triumph, erect monuments to each other, and have done so over the course of several generations, that all these people, artists, public, and critics, with very few exceptions, have never, save in early childhood and youth, before they heard any reasoning about art, experienced that simple feeling, familiar to the simplest man and even to a child, of being infected by the feelings of another, which

makes us rejoice over another's joy, grieve over another's grief, merge our souls with another's, and which constitutes the essence of art, and that therefore these people not only cannot distinguish true art from its counterfeits, but always mistake the worst and most false for genuine art, without noticing the genuine, because counterfeits are always more flashy, while true art is modest.

XV

Art in our society has become perverted to such a degree that not only has bad art come to be considered good, but even the very notion of what art is has been lost, so that, in order to speak of art in our society, one must first of all distinguish true art from counterfeit.

One indisputable sign that distinguishes true art from counterfeit is the infectiousness of art. If a man, without any effort on his own part and without any change in his situation, having read, heard or seen a work by another man, experiences a state of mind which unites him with this man and with others who perceive the object of art in the same way as he does, then the object which calls up such a state is an object of art. However poetic, realistic, effectful or diverting an object is, it is not an object of art unless it calls up in a man that feeling, utterly distinct from all other feelings, of joy, of spiritual union with another (the author) and with others (listeners or spectators) who perceive the same artistic work.

It is true that this is an *inner* sign and that people who have forgotten the effect produced by genuine art and who expect from art something quite different – and such people make up the vast majority in our society – may think that the feeling of amusement and a certain excitement which they experience with regard to artistic counterfeits is the aesthetic feeling, and though these people cannot be unpersuaded, just as it is impossible to persuade a Daltonian that green is not red, this sign nevertheless remains quite

definite for people with an unperverted and unatrophied feeling for art, and clearly distinguishes the feeling produced by art from all other feelings.

The chief peculiarity of this feeling is that the perceiver merges with the artist to such a degree that it seems to him that the perceived object has been made, not by someone else, but by himself, and that everything expressed by the object is exactly what he has long been wanting to express. The effect of the true work of art is to abolish in the consciousness of the perceiver the distinction between himself and the artist, and not only between himself and the artist, but also between himself and all who perceive the same work of art. It is this liberation of the person from his isolation from others, from his loneliness, this merging of the person with others, that constitutes the chief attractive force and property of art.

If a man experiences this feeling, if he becomes infected with the author's state of mind, if he feels his merging with others, then the object that calls up this state is art; if there is no such infection, no merging with the author and with those perceiving the work – there is no art. But infectiousness is not merely an indisputable sign of art; the degree of infectiousness is also the only measure of artistic worth.

The stronger the infection, the better the art is as art, regardless of its content – that is, independently of the worth of the feelings it conveys.

Art becomes more or less infectious owing to three conditions: (1) the greater or lesser particularity of the feeling conveyed; (2) the greater or lesser clarity with which the feeling is conveyed; and (3) the artist's sincerity, that is, the greater or lesser force with which the artist himself experiences the feelings he conveys.

The more particular the feeling conveyed, the more strongly does it affect the perceiver. The perceiver experiences the greater pleasure the more particular the state of mind into which he is transferred, and therefore the more willingly and strongly does he merge with it.

The clarity of the expression of the feeling contributes to the infectiousness, because, in merging with the author in his consciousness, the perceiver is the more satisfied the more clearly the feeling

is expressed, which, as it seems to him, he has long known and experienced, and for which he has only now found the expression.

But most of all the degree of infectiousness of art is increased by the degree of the artist's sincerity. As soon as the spectator, listener or reader feels that the artist is himself infected by his work and is writing, singing or acting for himself and not just in order to affect others, this state of mind of the artist infects the perceiver; and contrariwise, as soon as the spectator, reader or listener feels that the author is writing, singing or acting not for his own satisfaction but for him, the perceiver, and that he does not himself feel what he wants to express, there is immediately a resistance, and then the most particular new feeling, the most artful technique, not only do not produce any impression, but become repellent.

I am speaking of three conditions of infectiousness and worth in art, but in fact only the last is a condition, that the artist must experience an inner need to express the feeling he conveys. This condition includes the first, because if the artist is sincere, he will express his feeling as he has perceived it. And since each man is unlike all others, this feeling will be particular for all other men, and will be the more particular the more deeply the artist penetrates, the more heartfelt and sincere he is. And this sincerity will force the artist to find a clear expression of the feeling he wishes to convey.

And therefore this third condition – sincerity – is the most important of the three. This condition is always present in popular art, which accounts for its powerful effect, and it is almost entirely absent in our upper-class art, ceaselessly fabricated by artists for reasons of personal gain or vanity.

These are the three conditions the presence of which distinguishes art from artistic counterfeits and at the same time determines the worth of any work of art regardless of its content.

In the absence of one of these conditions, the work will belong not to art but to its counterfeits. If the work does not convey the individual particularity of the artist's feeling, and is consequently not particular, if it is incomprehensibly expressed, or if it does not proceed from the author's inner need, then it is not a work of art.

But if all three conditions are present, even in the smallest degree, then the work, even if weak, is a work of art.

The presence in differing degrees of the three conditions – particularity, clarity and sincerity – determines the worth of the object of art, regardless of its content. All works of art can be ranked according to their worth by the presence of the first, second and third of these conditions in greater or lesser degree. In one, the particularity of the conveyed feeling may predominate; in another, clarity of expression; in a third, sincerity; in a fourth, sincerity and particularity, but lack of clarity; in a fifth, particularity and clarity, but less sincerity, etc., in all possible degrees and combinations.

Thus art is distinguished from non-art, and the worth of art as art is determined, regardless of its content, that is, independently of whether it conveys good or bad feelings.

But how determine whether art is good or bad in its content?

XVI

How determine whether art is good or bad in its content?

Art, together with speech, is a means of communication, and therefore also of progress – that is, of mankind's movement forward towards perfection. Speech enables people of later generations to know all that preceding generations knew and that the best of their most advanced contemporaries know through experience and reflection; art enables people of later generations to experience all the feelings that people experienced before them and that the best of the most advanced people experience now. And just as in the evolution of knowledge – that is, the forcing out and supplanting of mistaken and unnecessary knowledge by truer and more necessary knowledge – so the evolution of feelings takes place by means of art, replacing lower feelings, less kind and less needed for the good of humanity, by kinder feelings, more needed for that good. This is the purpose

of art. And therefore art is better in its content in so far as it fulfils this purpose better, and is worse in so far as it fulfils it less.

The evaluation of feelings — that is, the recognition of these or those feelings as being more or less good, meaning more or less needed for people's good — is accomplished by the religious consciousness of a given time.

In every specific historical age and in every human society there exists an understanding of the meaning of life which is the highest that has been reached by the people of that society and which defines the highest good for which that society strives. This understanding is the religious consciousness of the given time and society. This religious consciousness is always clearly expressed by certain advanced members of the society, and is more or less vividly felt by all. This religious consciousness, corresponding to its expression, always exists in every society. If it seems to us that there is no religious consciousness in society, that is not because there is indeed none, but because we do not want to see it. And often we do not want to see it because it exposes our life, which often does not conform to it.

The religious consciousness of society is the same as the direction of a flowing river. If a river flows, there is a direction in which it flows. If a society lives, there is a religious consciousness that indicates the direction in which all the people of this society more or less consciously strive.

And therefore religious consciousness has always existed and exists now in every society. And the feelings conveyed by art have always been evaluated in correspondence with this religious consciousness. Only on the basis of this religious consciousness of its time has it ever been possible to single out from the whole boundlessly diverse sphere of art the art which conveyed those feelings which realized in life the religious consciousness of the given time. Such art has always been highly appreciated and encouraged; but art that conveyed feelings coming from the religious consciousness of a previous time — backward, outlived art — has always been condemned and despised. The rest of art, conveying the great variety of feelings by means of which people communicate among

themselves, was not condemned but was allowed, as long as it did not convey any feelings contrary to religious consciousness. Thus, for instance, among the Greeks, art conveying the feelings of beauty, strength and manliness (Hesiod, Homer, Phidias) was singled out, approved and encouraged, while art that conveyed feelings of coarse sensuality, dejection and effeminacy was condemned and despised. The Jews singled out and encouraged art that conveyed the feelings of devotion and obedience to the God of the Jews and his covenants (some parts of the Book of Genesis, the Prophets, the Psalms), and condemned and despised art that conveyed feelings of idolatry (the golden calf); while the rest of art — stories, songs, dances, decoration of houses, utensils, clothing — which was not contrary to religious consciousness was neither noticed nor discussed. This is how the content of art has been evaluated always and everywhere, and this is how it ought to be evaluated, because such an attitude towards art comes from the properties of human nature, and these properties do not change.

I know that according to an opinion widely spread in our time religion is a superstition which mankind has outlived, and it is therefore supposed that in our time there exists no religious consciousness common to all people according to which art could be evaluated. I know that this is the opinion spread among the supposedly educated circles of our time. People who do not recognize Christianity in its true sense, who therefore invent various sorts of philosophical and aesthetic theories for themselves which conceal from them the meaninglessness and depravity of their lives, cannot think otherwise. These people intentionally, and sometimes unintentionally, confuse the concept of religious cult with the concept of religious consciousness, and think that by rejecting cult they are thereby rejecting religious consciousness. But all these attacks on religion and the attempts to establish a world outlook opposite to the religious consciousness of our time are the most obvious proof of the presence of this religious consciousness, which exposes the life of people not in accord with it.

If there does occur a progress — that is, a movement forward — in mankind, then there must inevitably exist an indicator of the

direction of this progress. This indicator has always been religion. All of history shows that the progress of mankind cannot be accomplished otherwise than with the guidance of religion. And if the progress of mankind cannot be accomplished without the guidance of religion – and progress is always being accomplished, which means it is also being accomplished in our time – then there must be religion in our time. And so, whether the so-called educated people of our time like it or not, they must recognize the existence of religion – not the religion -of cult, Roman Catholic, Protestant, etc., but religious consciousness – as the necessary guide of progress in our time as well. And if there exists a religious consciousness among us, then our art must be evaluated on the basis of this religious consciousness; and in exactly the same way as always and everywhere, the art which conveys feelings coming from the religious consciousness of our time should be singled out from all indifferent art, should be recognized, highly appreciated and encouraged, while art that is contrary to this consciousness should be condemned and despised, and the remaining indifferent art should neither be singled out nor encouraged.

The religious consciousness of our time, in its most general practical application, is the consciousness of the fact that our good, material and spiritual, individual and general, temporal and eternal, consists in the brotherly life of all people, in our union of love with each other. This consciousness was expressed not only by Christ and all the best people of the past; it is not only repeated in the most diverse forms and from the most diverse sides by the best people of our time; but it already serves as a guiding thread for the whole complex labour of mankind, which consists, on the one hand, in destroying the physical and moral obstacles that hinder the union of people, and, on the other hand, in establishing those principles, common to all, which can and must unite people into one universal brotherhood. It is on the basis of this consciousness that we must evaluate all the phenomena of our life, including our art, singling out from its whole sphere that which conveys feelings coming from this religious consciousness, highly appreciating and encouraging this art, while rejecting that which is contrary to this consciousness,

and not ascribing to the rest of art a significance that is not proper to it.

The chief mistake made by upper-class people in the time of the so-called Renaissance – a mistake which we still perpetuate – consisted, not in ceasing to appreciate and ascribe significance to religious art (people of that time could not ascribe any significance to it because, just like the upper-class people of our time, they could not believe in what the majority regarded as religion), but in putting in place of this absent religious art a worthless art that had pleasure as its only aim – that is, they began to single out, appreciate and encourage as religious an art that in no way deserved such appreciation and encouragement.

One of the Fathers of the Church said that people's main trouble is not that they do not know God, but that they have put in place of God that which is not God. It is the same with art. The main trouble of the upper-class people of our time is not that they have no religious art, but that in place of lofty religious art, singled out from everything else as especially important and valuable, they have singled out the most worthless and generally the most harmful art, which aims at giving pleasure to some and which by that exclusiveness alone is already contrary to the Christian principle of universal union which constitutes the religious consciousness of our time. In place of religious art, an empty and often depraved art has been set up, and this conceals from people the need for that true religious art which should be present in life, in order for it to be improved.

It is true that art which satisfies the demands of the religious consciousness of our time is totally unlike former art, but despite this dissimilarity, for a man who does not deliberately conceal the truth from himself, it is quite clear and definite what constitutes the religious art of our time. In former times, when the loftiest religious consciousness united only one part of human society among others, even though a very large part – Jews, Athenians, Roman citizens – the feelings conveyed by the art of those times came from a desire for the power, grandeur, glory and prosperity of those societies, and the heroes of art could be people who contributed to that prosperity by their strength, perfidy, cunning, cruelty (Odysseus, Jacob, David,

Samson, Hercules, and all mighty men). The religious consciousness of our time does not single out any 'one' society of people, but, on the contrary, demands the union of all, absolutely all people, without exception, and places brotherly love for all people above all other virtues, and therefore the feelings conveyed by the art of our time not only cannot coincide with the feelings conveyed by former art, but must be opposed to them.

Christian, truly Christian, art could not establish itself and has not yet established itself precisely because Christian religious consciousness was not one of those small steps with which mankind regularly proceeds, but was an enormous revolution which, if it has not yet changed, is bound inevitably to change mankind's whole understanding of life and the whole internal arrangement of that life. True, the life of mankind, like the life of an individual man, proceeds regularly, but amidst this regular movement there occur turning points, as it were, which sharply divide the life before from the life after. Christianity was such a turning point for mankind, or so at least it should seem to us, who live by Christian consciousness. Christian consciousness gave a different, new direction to all human feelings, and therefore completely changed both the content and the significance of art. The Greeks could make use of Persian art, and the Romans of Greek art, as the Jews did of Egyptian art – the basic ideals were the same. The ideal was now the grandeur and prosperity of the Persians, now the grandeur and prosperity of the Greeks or Romans. One and the same art was transferred to different conditions and suited to a new nation. But the Christian ideal changed and turned over everything in such a way that, as the Gospel says, 'what was great among men is abomination in the sight of God'.[102] The ideal became not the grandeur of a pharaoh or a Roman emperor, not the beauty of a Greek or the wealth of Phoenicia, but humility, chastity, compassion, love. The hero was no longer the rich man, but the beggar Lazarus; Mary of Egypt, not in the time of her beauty, but of her repentance;[103] not the acquirers of wealth, but those who gave it away; not those who lived in palaces, but those who lived in catacombs and hovels; not people ruling over others, but people who recognize no other power than God's. And

the highest work of art was no temple of victory with statues of the victors, but the image of a human soul so transformed by love that a tortured and murdered man could pity and love his tormentors.

And therefore people of the Christian world have difficulty resisting the inertia of pagan art, with which they have grown up all their lives. The content of Christian religious art is so new for them, is so unlike the content of former art, that it seems to them that Christian art is a denial of art, and they cling desperately to the old art. And yet in our time this old art, no longer having its source in religious consciousness, has lost all meaning, and we must renounce it, whether we will or no.

The essence of Christian consciousness consists in each man's recognition of his sonship to God, and their consequent union with God and with each other, as it is said in the Gospel,[104] and therefore the content of Christian art is such feelings as contribute to the union of men with God and with each other.

The expression, *the union of men with God and with each other*, may appear vague to people accustomed to hearing these words so often abused, and yet the words have a very clear meaning. These words mean that the Christian union of people, contrary to the partial, exclusive union of some people, is one that unites all people without exception.

Art, all art, has in itself the property of uniting people. All art causes those who perceive the feeling conveyed by the artist to unite in soul, first with the artist, and secondly with all who have received the same impression. But non-Christian art, by uniting certain people with each other, thereby separates them from other people, so that this partial union often serves as a source not only of disunity but of hostility towards other people. Such is all patriotic art, with its hymns, poems, monuments; such is all Church art — that is, the art of particular cults, with its icons, statues, processions, services, churches; such is military art; such is all refined art, essentially depraved, accessible only to people who oppress others, people of the idle, wealthy classes. Such art is backward, non-Christian, uniting some people only in order to separate them still more sharply from other people and even to place them in an

attitude of hostility towards other people. Christian art is that alone which unites all people without exception – either by calling up in them the awareness that they are all in the same position with regard to God and their neighbour, or by calling up in them one and the same feeling, even the most simple, but not contrary to Christianity and proper to all people without exception.

Good Christian art of our time may fail to be understood by people owing to formal flaws or to people's lack of attention, but it must be such that everyone can experience the feelings that are being conveyed to them. It must be art not of some one circle of people, not of some one rank, one nationality, one religious cult – that is, it must not convey feelings accessible only to a person brought up in a certain way, only to a nobleman, a merchant, or only to a Russian or a Japanese, or a Catholic, a Buddhist, etc., but feelings accessible to any man. Only such art can be considered good art in our time, can be singled out from the rest of art and encouraged.

Christian art, meaning the art of our time, must be catholic in the direct sense of the word – that is, universal – and must therefore unite all people. And there are only two kinds of feelings that unite all people: feelings that come from the consciousness of sonship to God and the brotherhood of men, and feelings of the simplest, most everyday sort, accessible to all people without exception, such as the feelings of merriment, tenderness, cheerfulness, peacefulness, and so on. Only these two kinds of feelings constitute in our time the subject matter of art that is good in content.

The effect produced by these two apparently so dissimilar kinds of art is one and the same. The feelings that come from the consciousness of sonship to God and the brotherhood of men, such as feelings of firmness in the truth, trust in the will of God, self-denial, respect and love for man – feelings that come from Christian religious consciousness; and the simplest feelings – of being moved or made joyful by a song or an amusing joke understandable to all, or by a moving story, or a drawing, or a doll – produce one and the same effect: the loving union of people. It sometimes happens that people, while together, are, if not hostile, at least alien to each

other in their moods and feelings, and suddenly a story, a perform-ance, a painting, even a building or, most frequently, music, will unite them all with an electric spark, and instead of their former separateness, often even hostility, they all feel unity and mutual love. Each rejoices that another feels the same thing he does, rejoices at the communion that has been established not only between him and all those present, but also with all people now living who will receive the same impression; moreover, one feels the mysterious joy of a communion beyond the grave with all those in the past who experienced the same feeling, and those who will experience it in the future. This effect is produced equally by art that conveys the feelings of the love of God and one's neighbour and by everyday art that conveys the simplest feelings common to all people.

The difference between evaluating the art of our time and that of former times consists above all in this, that the art of our time – that is, Christian art – being based on a religious consciousness that calls for the union of people, excludes from the sphere of art which is good in content all that conveys exclusive feelings which do not unite people but which separate them, and regards such art as bad in content, while, on the other hand, it includes in the category of art that is good in content an area of art which hitherto was not regarded as worthy of being singled out and respected – universal art, conveying feelings which are most simple and insignificant, yet accessible to all people without exception, and which therefore unite them.

Such art cannot fail to be recognized as good in our time, because it achieves the very aim that Christian religious consciousness sets before mankind in our time.

Christian art either calls up in people those feelings which, through love of God and one's neighbour, draw them towards greater and greater union, which make them ready for and capable of this union, or else it calls up in them feelings which show that they are already united in the oneness of life's joys and sorrows. And therefore Christian art in our time can be and is of two kinds: (1) religious art, which conveys feelings coming from a religious

consciousness of man's position in the world with regard to God and his neighbour; and (2) universal art, which conveys the simplest everyday feelings of life, such as are accessible to everyone in the world. Only these two kinds of art can be considered good art in our time.

The first kind, religious art, conveying positive feelings (the love of God and one's neighbour) as well as negative ones (indignation, horror at the violation of this love), manifests itself mainly in verbal form and partly in painting and sculpture; the second kind, universal art, conveying feelings accessible to everyone, manifests itself in words, painting, sculpture, dance, architecture, and mainly in music.

If I were asked to point to examples of each of these kinds of art in modern art, then, as examples of the highest religious art coming from the love of God and one's neighbour, I would point in literature to Schiller's *Robbers*; and among more recent works, to *Les pauvres gens* of Victor Hugo and his *Les Misérables*; to the stories, tales, and novels of Dickens – *A Tale of Two Cities, The Chimes*, and others; to *Uncle Tom's Cabin*; to Dostoevsky, most of all to his *Dead House*; to *Adam Bede* by George Eliot.

Among paintings of modern times, strange as it seems, there are almost no works of the kind that directly convey the Christian feelings of love of God and one's neighbour, especially among famous painters. There are Gospel paintings, very many of them, all representing historical events with a great wealth of detail, yet they do not and cannot convey religious feelings which their authors do not have. There are many paintings that portray the personal feelings of various people, but there are very few paintings – and most of those by little-known painters, and not finished pictures but more often sketches – that portray deeds of self-denial and Christian love. Such is the sketch by Kramskoy, worth many of his paintings, which portrays a drawing room with a balcony, past which a returning army is solemnly marching. A nurse with a baby and a little boy stand on the balcony. They admire the marching army. But the mother, her face covered with a handkerchief, weeps, leaning on the back of the sofa. Such, too, is the painting by

Langley which I have already mentioned; such, too, is the painting by the French artist Morlon,[105] depicting a lifeboat hastening in a bad storm to help a foundering steamer. There are also paintings that approach this kind, portraying the labouring man with respect and love. Such are the pictures of Millet, particularly his drawing of the man with the hoe; to this same kind belong paintings by Jules Breton, Lhermitte, Defregger[106] and others. As examples of paintings that call up indignation and horror at the violation of the love of God and one's neighbour, Ge's *Judgement* may serve, as may Liezen-Mayer's *Signing the Death Sentence*.[107] Paintings of this kind are also very few. For the most part, a preoccupation with technique and beauty overshadows feeling. Thus, for instance, Gérome's painting, *Pollice verso*,[108] expresses not so much a feeling of horror at what is happening as a fascination with the beauty of the spectacle.

It is still more difficult to point in modern art to examples of the second kind, of good universal everyday art, especially in verbal art and in music. If there do exist works which by their inner content might be placed in this category, such as *Don Quixote*, the comedies of Molière, Dickens's *David Copperfield* and *Pickwick Papers*, the tales of Gogol and Pushkin, and some of the writings of Maupassant, even so these works, by the exclusiveness of the feelings they convey, by the superfluity of specific details of time and place, and above all by the poverty of their content as compared with examples of universal ancient art (for instance, the story of Joseph and his brothers), are mostly accessible only to people of their own nation and even of their own circle. That Joseph's brothers, being jealous over their father, sold him into slavery; that Potiphar's wife wanted to seduce the youth; that the youth attained a high position, felt sorry for his brothers, for his favourite, Benjamin, and all the rest – these are all feelings accessible to a Russian peasant, to a Chinese, to an African, to a child, to an old man, to an educated man or an uneducated; and it is all written with such restraint, is so free of superfluous details, that the story can be transferred to any other milieu you like and still be as understandable and moving for everyone. Not so the feelings of Don Quixote or of Molière's heroes (though Molière is all but the most universal and therefore

the most excellent artist of modern times), still less of Pickwick and his friends. These feelings are very exclusive, not all-human, and therefore, to make them infectious, the authors have surrounded them with abundant details of time and place. And this abundance of detail makes these stories still more exclusive, scarcely understandable for all those who live outside the milieu the author describes.

In the narrative of Joseph there was no need to describe in detail, as is done nowadays, Joseph's blood-stained clothes, Jacob's dwelling and clothes, and the pose and attire of Potiphar's wife when, straightening a bracelet on her left arm, she said, 'Come to me,' and so on, because the feeling contained in this story is so strong that all details except the most necessary ones – for instance, that Joseph went into the next room to weep – all details are superfluous and would only hinder the conveying of the feeling, and therefore this story is accessible to all people, it touches people of all nations, ranks, ages, has come down to our time, and will live on for thousands of years. But take the details from the best novels of our time and what will remain?

Thus it is not possible to point to works of modern verbal art that fully satisfy the demand of universality. Even such as do exist are mostly spoiled by what is called realism and would better be called artistic provincialism.

In music the same thing occurs as in verbal art, and for the same reasons. Owing to a poverty of content, of feeling, the melodies of modern composers are strikingly vapid. And so, to enhance the impression produced by the vapid melody, modern composers heap every worthless melody with complex modulations, not only in their own national harmony, but modulations exclusively peculiar to a certain circle, to a certain musical school. A melody – any melody – is free and can be understood by anyone; but as soon as it is tied to a certain harmony and encumbered by it, it becomes accessible only to people who are accustomed to this harmony, and becomes completely alien not only to other nationalities, but also to people who do not belong to the circle of those who have accustomed themselves to certain forms of harmony. So music, like poetry, turns round in the same false circle. Worthless, exclusive

melodies, to be made attractive, are encumbered with harmonic, rhythmic and orchestral complications, become thereby still more exclusive, and not only not universal, but not even national – that is, accessible only to some people and not to the whole nation.

In music, apart from marches and dances by various composers, which approximate to the demands of universal art, one can point only to the folk songs of various peoples, from Russian to Chinese; in learned music, to very few works – the famous violin aria of Bach, the E-flat major nocturne of Chopin, and perhaps a dozen other things, not whole pieces but selected passages from the works of Haydn, Mozart, Schubert, Beethoven, Chopin.[109]

Although the same thing is repeated in painting as in poetry and music – that is, works of weak content are made more interesting by being supplied with thoroughly studied accessories of time and place, which endow these works with temporal and local interest but make them less universal – still, in painting, more than in other kinds of art, one can point to works that satisfy the demands of universal Christian art, that is, which express feelings accessible to all people.

In the arts of painting and sculpture, so-called genre painting and statues, portrayals of animals, landscapes, caricatures of a content understandable to all, and various sorts of ornaments are universal in content. There are many such works in painting and sculpture (porcelain dolls), but the majority of these objects – various ornaments, for instance – are not considered art, or are considered art of an inferior sort. In reality, all such objects, if they sincerely convey the feeling of the artist (however insignificant it may seem to us) and are understandable to all people, are works of genuine good Christian art.

I fear that at this point I will be reproached that, while denying that the concept of beauty should constitute the subject of art, I contradict myself by recognizing ornaments as objects of good art. This reproach is unjust, because the artistic content of various decorations consists not in beauty but in the feeling of admiration, of delight, which the artist experienced in the combining of lines or colours and with which he infects the viewer. Art was, and is, and

cannot be anything else but the infection by one person of another or others with a feeling experienced by the infector. Among these feelings there is the feeling of admiring what pleases the eye. Objects pleasing to the eye may please a small or a large number of people, and some may please everyone. Such are almost all ornaments. A landscape painting of some exceptional locale or a very special genre painting may not be pleasing to everyone, but ornaments from Yakut to Greek are accessible to everyone and evoke the same feeling of admiration in everyone, and therefore this neglected kind of art should be valued in Christian society more highly than exclusive, pretentious paintings and sculptures.

Thus there exist only two kinds of good Christian art; all the rest that does not fit into these two kinds should be recognized as bad art, which not only should not be encouraged, but should be banished, rejected and despised as art that does not unite but divides people. Such, in verbal art, are all dramas, novels and poems that convey churchly or patriotic feelings, as well as exclusive feelings proper only to the rank of the wealthy, idle people – feelings of aristocratic honour, satiety, tedium, pessimism, and refined, perverse feelings coming from sexual love, which are totally incomprehensible to the vast majority of people.

In painting, such are all falsely religious and patriotic pictures, as well as pictures representing the amusements and delights of exclusive, wealthy and idle living; and such are all so-called symbolic paintings, in which the very meaning of the symbol is accessible only to persons of a certain circle; and, chiefly, all paintings of sensual objects, all that outrageous female nudity which fills all exhibitions and galleries. To the same kind belongs almost all concert and operatic music of our time, beginning with Beethoven – Schumann, Berlioz, Liszt, Wagner – the content of which is accessible only to people who have cultivated in themselves a morbid nervous excitability aroused by this artificial and exceptionally complex music.

'What, the *Ninth Symphony* belongs to the category of bad art?!' I hear indignant voices exclaim.

'Without any doubt,' I reply. All that I have written, I have

written only in order to find a clear, reasonable criterion by which to judge the merits of works of art. And this criterion, coinciding with simple and common sense, unquestionably shows me that Beethoven's symphony is not a good work of art. Of course, for people brought up in the adulation of certain works and their authors, for people whose taste is perverted precisely because they were brought up in this adulation, to acknowledge such a famous work as bad is astonishing and strange. But what is to be done with the indications of reason and common sense?

Beethoven's *Ninth Symphony* is considered a great work of art. To test this assertion, I first of all ask myself: does this work convey the highest religious feeling? And I reply in the negative, because music by itself cannot convey these feelings; and therefore I next ask myself: if this work does not belong to the highest order of religious art, does it have the other property of good art of our time – the property of uniting all people in one feeling; does it belong to universal everyday Christian art? And I cannot help answering in the negative, because not only do I not see how the feelings conveyed by this work could unite people who have not been especially brought up to be subject to this complex hypnosis, but I cannot even imagine a crowd of normal people who could understand anything in this long, intricate and artificial work but short fragments drowning in a sea of the incomprehensible. And therefore I must conclude, whether I will or no, that this work belongs to bad art. Remarkably, to the end of this symphony there is attached a poem by Schiller which, though not clearly, does express precisely the thought that feeling (Schiller speaks only of the feeling of joy) unites people and evokes love in them. Despite the singing of this poem at the end of the symphony, the music does not correspond to the thought of the poem, because it is exclusive music and unites not all but only certain people, singling them out from the rest.

In exactly the same way many, many other works of art that are considered great among the upper classes of our society are to be evaluated. Thus, by this one firm criterion are also to be evaluated the famous *Divine Comedy*, the *Jerusalem Delivered*, and the greater part of the works of Shakespeare and Goethe, as well as the various

portrayals of miracles in painting, Raphael's *Transfiguration*, and others. Whatever the object that passes for a work of art, and however it is praised by people, in order to find out its worth it is necessary to apply to it the question of whether the object belongs to genuine art or to the artistic counterfeits. Having recognized a given object, based on the token of infectiousness for at least a small circle of people, as belonging to the realm of art, it is necessary, based on the token of general accessibility, to decide the next question: does the work belong to bad, exclusive art, opposed to the religious consciousness of our time, or to Christian art which unites people? Then, having recognized the object as belonging to true Christian art, it is necessary, according to whether the work conveys feelings coming from the love of God and one's neighbour, or merely those simple feelings that unite all people, to assign it a place either in religious or in universal everyday art.

Only on the basis of such testing will we be able to single out from the whole mass of what passes for art in our society those objects which constitute a real, important, necessary spiritual nourishment, and separate them from all the harmful and useless art that surrounds us. Only on the basis of such testing will we be able to rid ourselves of the pernicious consequences of harmful art and avail ourselves of the influence of true and good art, which constitutes its purpose, an influence beneficial and necessary for the spiritual life of man and of mankind.

XVII

Art is one of two organs of mankind's progress. Through the word, man communicates in thought, through the images of art he communicates in feeling with all people, not only of the present, but of the past and the future. It is proper for mankind to employ both of these organs of communication, and therefore the perversion of either one of them cannot fail to have harmful consequences for

the society in which the perversion occurs. And these consequences are necessarily twofold: first, the absence in that society of the activity which should be accomplished by the organ, and, secondly, the harmful activity of the corrupted organ. These very consequences are found in our society. The organ of art has been perverted, and as a result the society of the upper classes has in considerable measure been deprived of the activity which this organ should have accomplished. On the one hand, artistic counterfeits, serving only for people's amusement and corruption, have spread in our society on an enormous scale, and, on the other hand, works of worthless, exclusive art, valued as the highest art, have perverted the capacity of the majority of people in our society for being infected by true works of art, and have therefore deprived them of the possibility of knowing the highest feelings to which mankind has attained and which can be conveyed to people only by art.

All the best that mankind has produced in art remains foreign to people deprived of the capacity for being infected by art, and is replaced by false counterfeits of art or by worthless art which they mistake for genuine. People of our time and society admire the Baudelaires, Verlaines, Moréases, Ibsens, Maeterlincks in poetry; the Monets, Manets, Puvis de Chavannes, Burne-Joneses, Stucks and Böcklins in painting; the Wagners, Liszts, Richard Strausses in music, etc., and are no longer capable of understanding either the highest or the simplest art.

Owing to the loss of the capacity for being infected by works of art, people of the upper-class milieu grow up, are educated, and live without the softening, fertilizing effect of art, and therefore they not only do not move towards perfection, do not become better, but on the contrary they become ever more savage, coarse and cruel.

Such is the consequence of the absence of the activity of the necessary organ of art in our society. Yet the consequences of the perverted activity of that organ are still more harmful, and they are many.

The first consequence that strikes the eye is the enormous waste of working people's labour on something not only useless, but for

the most part harmful, and, furthermore, the irredeemable waste of human lives on this needless and bad thing. It is terrible to think with what effort, with what privations, millions of people work, having no time or possibility to do necessary things for themselves and their families, spending ten, twelve or fourteen hours a night typesetting pseudo-artistic books that spread depravity among people, or working for theatres, concerts, exhibitions, galleries, which mostly serve the same depravity; but most terrible is to think that lively, nice children, capable of all good, devote themselves from an early age to spending six, eight or ten hours a day for ten or fifteen years playing scales, or twisting their limbs, walking on their toes and raising their legs above their heads, or singing solfeggios, or declaiming verses with various affectations, or drawing busts, naked models, painting sketches, or writing compositions by the rules of certain periods; and that in these occupations, unworthy of human dignity, continuing often long after full maturity, they lose all physical and intellectual power and all understanding of life. People say it is terrible and pitiful to look at little acrobats putting their legs behind their necks, but it is no less pitiful to look at ten-year-old children giving concerts, and still more so to see ten-year-old children who know by heart the exceptions of Latin grammar . . . But it is not only that these people are crippled physically and mentally – they are also crippled morally, becoming incapable of anything that is really necessary for people. Occupying in society the role of entertainers of the wealthy, they lose their sense of human dignity, they develop in themselves such a passion for public praise that they suffer permanently from unsatisfied vanity, inflated to a morbid degree in them, and they use all the powers of their soul to satisfy just this passion. And most tragic of all is that these people, destroyed in order to live for art, not only are in no way useful to this art, but cause it the greatest harm. In the academies, schools, conservatories, they are taught how to counterfeit art, and, while being taught this, they become so perverted that they lose all ability to produce genuine art and become purveyors of that counterfeit or worthless or depraved art that fills our world. This is the first consequence of the perversion of the organ of art to strike the eye.

The second consequence is that the works of art-amusement, produced in such frightful quantities by the army of professional artists, enable the wealthy people of our time to live a life that is not only unnatural but contrary to the principle of humaneness professed by these same people. To live as wealthy, idle people live, the women especially, away from nature and from animals, in artificial conditions, with muscles atrophied or abnormally developed by gymnastics, and with a weakened vital energy, would be impossible were it not for what is called art, were it not for the diversion, the amusement which turns these people's eyes from the meaninglessness of their lives and saves them from the boredom that oppresses them. Take from all these people the theatres, concerts, exhibitions, piano playing, ballads, novels with which they occupy themselves in the conviction that this is a very refined, aesthetic and therefore good occupation, take from the Maecenases of art, who buy paintings, patronize musicians, keep company with writers, their role as patrons of the important matter of art, and they will be unable to go on with life, they will all die of boredom, tedium, the awareness of the meaninglessness and lawlessness of their life. Only the occupation with what is considered art among them enables them, in violation of all natural conditions of life, to go on living without noticing the meaninglessness and cruelty of their life. And this supporting of the false life of the wealthy is the second and not insignificant consequence of the perversion of art.

The third consequence of the perversion of art is the confusion it produces in the notions of children and the people. Those who are not perverted by the false theories of our society – working people, children – have a very definite idea of what one can be honoured and praised for. According to the understanding of simple people and children, the grounds for praising and glorifying people can only be either physical strength (Hercules, mighty men, conquerors) or moral, spiritual strength (Shakya-muni abandoning his beautiful wife and his kingdom in order to save men, or Christ going to the cross for the truth he professed, and all martyrs and saints). Both are comprehensible to simple people and children. They understand that one cannot but respect physical strength, because it makes itself

respected; as for the moral strength of the good, an unspoiled man cannot but respect it, because he is drawn to it by his entire spiritual being. And then these children and simple people suddenly see that besides those who are praised, honoured and rewarded for their physical or moral strength, there are also some who are praised, glorified, rewarded on an even greater scale than the heroes of strength and goodness merely because they sing well, write poetry, are good dancers. They see that singers, writers, painters, dancers make millions, that they are given greater honours than saints, and these simple people and children become perplexed.

When, fifty years after Pushkin's death, cheap editions of his works were published and spread among the people, and a monument was erected to him at the same time in Moscow, I received more than ten letters from different peasants asking why Pushkin was so glorified. Just the other day I was visited by a literate tradesman from Saratov who had apparently lost his mind over this question and was going to Moscow to expose the clergy for having contributed to the erecting of the 'monamint' to Mr Pushkin.

In fact, one need only imagine the situation of such a man of the people when he learns, from the newspapers and rumours that reach him, that the clergy, the authorities, all the best people of Russia have triumphantly unveiled a memorial to the great man, the benefactor, the glory of Russia – Pushkin, of whom he has hitherto heard nothing. He reads or hears about it from all sides and thinks that if such honours are rendered a man, the man probably did something extraordinary, either of strength or of goodness. He tries to find out who Pushkin was, and, having found out that Pushkin was not a mighty man or a military leader, but was a private person and a writer, he concludes that Pushkin must have been a holy man and teacher of the good, and he hastens to read or hear about his life and writings. But how great must be his perplexity when he learns that Pushkin was a man of worse than light morals, that he died in a duel – that is, while attempting to murder another man – and that his entire merit consists merely in having written poems about love, often quite indecent ones.

That some mighty man, as Alexander of Macedon, Genghis

Khan or Napoleon, were great he can understand, because any one of them could crush him and thousands like him; he also can understand that Buddha, Socrates and Christ are great, because he knows and feels that he and all people ought to be like them; but why a person should be great because he wrote poems about the love of women – that he cannot understand.

The same must go on in the head of a Breton or Norman peasant who learns of the setting up of a memorial, *une statue*, as if to the Mother of God, to Baudelaire, when he reads or is told of the contents of *Les Fleurs du Mal*, or – still more amazing – to Verlaine, when he learns of the pathetic, depraved life the man led, and reads his poetry. And what confusion must occur in the heads of simple people when they learn that some Patti or Taglioni[110] is paid 100,000 per season, that a painter gets as much for a picture, and that the authors of novels describing love scenes get even more.

The same also happens with children. I remember experiencing this astonishment and perplexity myself, and becoming reconciled with this extolling of artists on a par with mighty men and moral heroes only by lowering in my consciousness the significance of moral worth and accepting the false, unnatural significance of works of art. The same thing happens in the soul of every child or simple person when he learns of the strange honours and rewards rendered to artists. This is the third consequence of our society's false attitude towards art.

The fourth consequence of such an attitude is that people of the upper classes, as they encounter more and more frequently the contradiction between beauty and the good, place the ideal of beauty higher, thereby freeing themselves from the demands of morality. These people, instead of recognizing the art they serve for what it is – that is, as a backward thing – pervert the roles and recognize morality as a backward thing which can have no importance for people of a high degree of development, such as they fancy themselves to be.

This consequence of the wrong attitude towards art has long been manifest in our society, but lately, with its prophet Nietzsche and his followers, as well as the decadents and English aesthetes

identical with them, it has been expressing itself with particular insolence. Decadents and aesthetes like Oscar Wilde choose as the theme of their works the denial of morality and the praise of depravity.

This art has partly produced and partly coincided with a similar philosophical teaching. I recently received from America a book entitled *The Survival of the Fittest: Philosophy of Power*, by Ragnar Redbeard (Chicago, 1896). The essence of this book, as expressed in the publisher's preface, is that to evaluate the good by the false philosophy of Hebrew prophets and weeping messiahs is madness. Right results not from any teaching, but from power. All laws, commandments and teachings about not doing to others what you do not want done to yourself inherently mean nothing, and acquire meaning only from cudgel, prison and sword. A truly free person is not obliged to obey any injunctions, human or divine. Obedience is the sign of degeneracy; disobedience is the sign of the hero. People should not be bound by traditions invented by their enemies. The whole world is a slippery battlefield. Ideal justice consists in the vanquished being exploited, tormented, despised. The free and brave can conquer the whole world. And therefore there should be eternal war for life, for land, for love, for women, for power, for gold. (Something similar was voiced several years ago by the famous and refined academician Vogüé.[111]) The earth with its treasures is the 'booty of the bold'.

The author, obviously on his own, independently of Nietzsche, has come to the same conclusions as are professed by modern artists.

Expounded in the form of a teaching, these principles strike us. In fact, these principles are contained in the ideal of art that serves beauty. The art of our upper classes has cultivated in people this ideal of the superman – which in fact is the old ideal of Nero, Stenka Razin, Genghis Khan, Robert Macaire, Napoleon,[112] and all their accomplices, satellites and flatterers – and maintains it in them with all its might.

This supplanting of the ideal of morality by the ideal of the beautiful – that is, of pleasure – is the fourth consequence, and a terrible one, of the perversion of art in our society. It is frightening

to think of what would happen to mankind if such art were to spread among the popular masses. And it is already beginning to do so.

The fifth thing, finally, and the chiefest, is that the art which flourishes in the milieu of the upper classes of European society directly corrupts people by infecting them with the worst and humanly most harmful feelings of the superstition of patriotism and, chiefly, of sensuality.

Look attentively at the causes of ignorance in the popular masses and you will see that its chief cause is by no means the lack of schools and libraries, as we are accustomed to think, but the superstitions, churchly as well as patriotic, with which they are imbued and which are constantly being generated by all the resources of art. For church superstitions – by the poetry of prayers, hymns, the painting of icons, the sculpting of statues, by singing, organs, music, and architecture, and even by dramatic art in church services. For patriotic superstitions – by verses, by stories told even in schools; by music, singing, solemn processions, royal entrances, military paintings, and memorials.

If it were not for the constant activity of all branches of art in maintaining churchly and patriotic stupefaction and embitterment among the people, the popular masses would long ago have attained to true enlightenment. But it is not only churchly and patriotic corruption that art accomplishes.

In our time art also serves as the main cause of people's corruption in the most important question of social life – sexual relations. We all know from our own selves, and fathers and mothers also know from their children, what terrible spiritual and bodily sufferings, what a useless waste of energy people experience only because of the licentiousness of sexual lust.

Since the world began, since the time of the Trojan War, which was started because of sexual licentiousness, and down to the suicides and murders on account of love reported in almost every day's newspaper, a great share of mankind's suffering has been caused by this licentiousness.

And what then? All art, both genuine and counterfeit, with the

rarest exceptions, is devoted solely to describing, portraying, arousing all sorts of sexual love, in all its forms. One has only to recall all the novels with lust-inciting descriptions of love, most refined ones and most crude ones, with which the literature of our society is filled; all those paintings and statues portraying the naked female body and all sorts of nastiness that passes into illustrations and advertisements; only to recall all the vile operas, operettas, songs, ballads with which our world teems – and one involuntarily thinks that existing art has only one definite aim: the widest possible spreading of depravity.

Such are, if not all, at least the most certain consequences of the perversion of art that has taken place in our society. And thus what is called art in our society not only does not contribute to mankind's movement forward, but perhaps more than anything else it hinders the realization of the good in our life.

And therefore the question involuntarily asked by any man who is free from artistic activity and therefore not bound to existing art by any self-interest – the question I put at the beginning of this writing – whether it is just that such sacrifices be offered to what we call art, which belongs to only a small part of society, sacrifices in human labour and in human lives – receives its natural answer: no, it is not just and it should not be so. This is the answer of common sense and of unperverted moral instinct. Not only should it not be so, not only should no sacrifices be offered to that which is recognized as art among us, but, on the contrary, all the efforts of people who wish to live a good life should be directed towards destroying this art, because it is one of the cruellest evils oppressing our mankind. So that if the question were put as to which would be better for our Christian world, to lose all that is now regarded as art, including *all* that is good in it, together with false art, or to continue to encourage or allow the art that exists now, I think that any reasonable and moral person would again decide the question the way it was decided by Plato for his republic and by all Church Christian and Muhammadan teachers of mankind – that is, he would say: 'Better that there be no art than that the depraved art, or simulacrum of it, which exists now should continue.' Fortunately,

no one is faced with this question, and no one has to decide it one way or the other. All that man can do, all that we so-called educated people, who are in a position to be able to understand the meaning of the phenomena of our life, can and must do is understand the delusion we are in, and not persist in it, but seek to get out of it.

XVIII

The cause of the falsehood into which the art of our society has fallen was that upper-class people, having lost faith in the truths of the so-called Christian teaching of the Church, did not dare to accept true Christianity in its real and chief meaning – as sonship to God and the brotherhood of men – and went on living without any faith, trying to make up for the absence of faith, some by hypocrisy, pretending that they still believed in the absurdities of Church faith, others by the bold proclamation of their unbelief, others by refined scepticism, and still others by a return to the Greek worship of beauty, acknowledging the legitimacy of egoism and elevating it into a religious teaching.

The cause of the disease was the non-acceptance of Christ's teaching in its true – that is, its full – meaning. The cure of the disease lies in one thing only – the acknowledgement of this teaching in all its meaning. This acknowledgement is not only possible in our time, but also necessary. In our time it is no longer possible for a man who has come up to the level of knowledge in our time, whether he be a Catholic or a Protestant, to say that he believes in the dogmas of the Church – in God as Trinity, in Christ as divinity, in the redemption, and so on – and it is no longer possible for him to be satisfied by the proclaiming of unbelief, scepticism, or a return to egoism and the worship of beauty, and above all it is no longer possible to say that we do not know the true meaning of Christ's teaching. The meaning of this teaching has not only become accessible to all people of our time, but all human

life in our time is pervaded by the spirit of this teaching and, consciously or unconsciously, is guided by it.

However differently in form the people of our Christian world define the destiny of man, whether they recognize it as the progress of mankind in whatever sense, as the uniting of all people into a socialist state or commune, whether they recognize this destiny as a world federation, whether they recognize it as union with a fantastic Christ or the union of mankind under the guidance of one Church – however diverse in form these definitions of the destiny of human life may be, all people of our time recognize that the destiny of man is the good; and the highest good in life accessible to people of our world is attained in their uniting together.

However hard upper-class people may try – sensing that their significance is based on their separating themselves, as wealthy and learned, from working people, the poor and unlearned – to invent new world views which might enable them to keep their advantages, whether it be the ideal of a return to the old days, or of mysticism, Hellenism, supermanhood, they must recognize, whether they will or no, the truth that affirms itself on all sides in life, consciously and unconsciously, that our good lies only in the union and brotherhood of men.

Unconsciously this truth is affirmed by the establishing of means of communication (telegraph, telephone, the press), and the ever-increasing availability of the goods of this world to all people; consciously it is affirmed by the destruction of superstitions that divide people, by the spreading of the truths of knowledge, by the expression of the ideals of the brotherhood of men in the best works of art of our time.

Art is a spiritual organ of human life, and it cannot be destroyed, and that is why, despite all the efforts of upper-class people to conceal the religious ideal by which mankind lives, that ideal is being recognized more and more by people, and more and more often is being partially expressed by science and art amid our perverted society. More and more often since the beginning of this century there have appeared, in literature and painting, works of the highest religious art, pervaded by the true Christian spirit, as

well as works of popular everyday art accessible to all. So that art itself knows the true ideal of our time and is striving towards it. On the one hand, the best works of art of our time convey feelings that draw towards the union and brotherhood of men (such are the works of Dickens, Hugo, Dostoevsky; in painting, of Millet, Bastien-Lepage,[113] Jules Breton, Lhermitte and others); on the other hand, they strive to convey feelings not proper only to upper-class people, but such as may unite all men without exception. Such works are still few, but the need for them is already understood. Besides that, in recent times there have been more and more frequent attempts at popular editions of books and pictures, at generally accessible concerts and theatres. All this is still very far from what it ought to be, but one can already see the direction in which art is striving of itself in order to come out on the proper path.

The religious consciousness of our time, which consists in recognizing the union of people as both the general and the individual aim of life, has already become sufficiently clear, and the people of our time now have only to reject the false theory of beauty according to which pleasure is recognized as the aim of art, and then religious consciousness will naturally become the guide of art in our time.

And as soon as religious consciousness, which unconsciously already guides the life of people in our time, is consciously recognized by people, the division of art into art of the lower and art of the upper classes will of itself immediately be annulled. Once there is a common, brotherly art, then of itself there will be rejected, first, that art which conveys feelings discordant with the religious consciousness of our time – feelings which do not unite but disunite people – and, secondly, that worthless, exclusive art which now occupies a significance for which it is unsuited.

And as soon as this happens, art will immediately cease to be what it has been in recent times – a means of brutalizing and corrupting people – and will become what it always has been and should be – a means of mankind's movement towards unity and well-being.

Terrible as it may be to say it, what has happened to the art of

our circle and time is the same as happens with a woman who sells her feminine attractions, destined for motherhood, for the pleasure of those who are tempted by such pleasures.

The art of our time and circle has become a harlot. And this comparison holds true in the smallest details. It is, in the same way, not limited in time, is always in fancy dress, is always for sale; it is just as alluring and pernicious.

The genuine work of art can manifest itself in an artist's soul only rarely, as a fruit of all his previous life, just as a child is conceived by its mother. Counterfeit art is produced by artisans and craftsmen continually, as long as there are consumers.

Genuine art has no need for dressing up, like the wife of a loving husband. Counterfeit art, like a prostitute, must always be decked out.

The cause of the appearance of genuine art is an inner need to express a stored-up feeling, as love is the cause of sexual conception for a mother. The cause of counterfeit art is mercenary, just as with prostitution.

The consequence of true art is the introduction of a new feeling into everyday life, as the consequence of a wife's love is the birth of a new person into life. The consequence of counterfeit art is the corruption of man, the insatiability of pleasures, the weakness of man's spiritual force.

This is what people of our time and circle must understand in order to get rid of the filthy stream of this depraved, lascivious art that is drowning us.

XIX

People speak of the art of the future, meaning an especially refined new art, which is supposed to develop out of the art of one class of society, now considered the highest art. But such a new art of the future cannot and will not be. Our exclusive art of the upper classes

of the Christian world has reached a dead end. There is no going further on the path it has followed. This art, having once parted with the chief demand of art (that it be guided by religious consciousness), becoming more and more exclusive and therefore more and more perverted, has come to nothing. The art of the future – as it really will be – will not be a continuation of present-day art, but will emerge on completely different, new principles, having nothing in common with those by which our modern upper-class art is guided.

The art of the future – that is, as much of art as will be singled out from the whole of art spread among mankind – will consist not in the conveying of feelings accessible only to some people of the wealthy classes, as happens now, but will be that art alone which realizes the highest religious consciousness of the people of our time. Those works alone will be considered works of art which convey feelings drawing people towards brotherly union, or such all-human feelings as will be able to unite all people. Only such art will be singled out, allowed, approved and disseminated. But art that conveys feelings coming from obsolete religious teachings, outlived by the people – Church art, patriotic art, sensual art, art that conveys the feelings of superstitious fear, pride, vanity, the admiration of heroes, art that arouses sensuality or an exclusive love of one's own nation – will be regarded as bad, harmful art, and will be condemned and despised by public opinion. All the rest of art, which conveys feelings accessible only to some people, will be considered unimportant, and will be neither condemned nor approved. And, generally, it will not be a separate class of rich people that appreciates art, but the whole people; so that for a work of art to be recognized as good, to be approved and disseminated, it will have to satisfy the demands, not of some people who live in identical and often unnatural conditions, but of all people, of the great mass of people who are in natural working conditions.

And the artists who produce art will no longer be, as now, only rare people from the wealthy classes, or close to them, selected from a small portion of the whole people, but all the gifted representatives of the whole people who show a capacity for and an inclination towards artistic activity.

Artistic activity will then be accessible to all people. It will become accessible to every simple person because, first, the art of the future will not require that complex technique which disfigures the works of art of our time and requires great effort and expenditure of time, but, on the contrary, will require clarity, simplicity and brevity – conditions acquired not by mechanical exercises but by the education of taste. Secondly, artistic activity will become accessible to all members of the people, because instead of the existing professional schools, accessible only to the few, in the people's primary schools everyone will study music and painting (singing and drawing), together with reading and writing, so that each person, having acquired the first principles of painting and music, could, if he felt an ability and a calling for one of the arts, become perfected in it; and, thirdly, because all the forces now spent on false art will be employed in spreading true art among the whole people.

It is thought that, unless there are special art schools, the technique of art will weaken. It will undoubtedly weaken, if by technique we understand those complications of art which are now regarded as merits; but if by technique one understands clarity, beauty, simplicity and economy in works of art, then technique not only will not weaken, as all popular art shows, but will be perfected a hundred times over, even if there are no professional schools, even if the principles of drawing and music are not taught in the people's schools. It will be perfected because all the artists of genius now hidden among the people will participate in art, and, needing no complicated technical training, as now, and having examples of true art before them, will give new examples of genuine art, which will be, as it has always been, the best school of technique for artists. Even now, every true artist learns not at school, but from life, by the examples of the great masters; but when the most gifted from the whole people will be participants in art, and there will be more of these examples, and these examples will be more accessible, then the school training, which future artists will be deprived of, will be compensated for a hundred times over by the training the artist gets from the numerous examples of good art spread through society.

This will be one difference between the art of the future and that of the present. Another difference will be that the art of the future will not be produced by professional artists who are remunerated for their art and who are occupied with nothing else but their art. The art of the future will be produced by all the people, who will occupy themselves with it whenever they feel a need for such activity.

It is thought in our society that an artist will work better, will do more, if he is materially secure. This opinion proves once again with full evidence, if there is still any need to prove it, that what is regarded as art among us is not art but is merely a simulacrum of it. It is quite correct that the division of labour is very advantageous for the production of boots or bread, that a shoemaker or a baker who has no need to prepare dinner or chop wood for himself will make more boots or bread than if he has to see to his dinner and firewood himself. But art is not a handicraft, but the conveying of a feeling experienced by the artist. And feeling can be born in a man only if he lives the many-sided life natural and proper for human beings. And that is why giving artists security in their material needs is the most harmful condition for artistic productivity, because it releases the artist from the condition proper to all men of struggling with nature to support his own and other people's lives, and thereby deprives him of the occasion and the possibility of experiencing the most important feelings proper to human beings. No situation is more harmful for artistic productivity than the situation of complete security and luxury in which artists usually live in our society.

The artist of the future will live the ordinary life of a human being, earning his living by some kind of labour. He will strive to give the fruit of that supreme spiritual force which passes through him to the greatest number of people, because this conveying of the feelings that have been born in him to the greatest number of people is his joy and his reward. The artist of the future will not even understand how it is possible for an artist, whose joy consists in the widest dissemination of his works, to give these works only in exchange for a certain payment.

Until the sellers are driven out of the temple, the temple of art will not be a temple.[114] The art of the future will drive them out.

And therefore the content of the art of the future, as I picture it to myself, will be completely unlike that of present-day art. The content of the art of the future will not consist in the expression of exclusive feelings – vanity, tedium, satiety, and sensuality in all possible forms, accessible and interesting only to people who have forcibly liberated themselves from the labour proper to human beings – but will consist in the expression of feelings experienced by a man who lives a life proper to all people and coming from the religious consciousness of our time, or feelings accessible to all people without exception.

To people of our circle, who do not, or cannot, or do not wish to know the feelings that must make up the content of the art of the future, it seems that this content is very poor in comparison with the subtleties of the exclusive art with which they are now occupied. 'What new can be expressed in the sphere of Christian feelings of love for one's neighbour? And the feelings accessible to all people are so insignificant and monotonous,' they think. And yet, in our time, the only feelings that can truly be new are religious, Christian feelings, or feelings accessible to all. The feelings that come from the religious consciousness of our time, Christian feelings, are infinitely new and varied; only not, as some think, in the sense of portraying Christ and episodes from the Gospels, or repeating in new form the Christian truths of unity, brotherhood, equality and love, but in the sense that all the oldest, most ordinary phenomena of life, long known from all sides, call up the newest, most unexpected and touching feelings as soon as one regards them from a Christian point of view.

What can be older than the relations between spouses, of parents to children, of children to parents, the relations of people to their compatriots, to foreigners, to attack, defence, property, land, animals? But as soon as one regards these phenomena from a Christian point of view, there at once arise the most new, complex, touching and infinitely varied feelings.

In just the same way there is not a narrowing but a broadening

of the area of content for the art of the future which will convey the most simple, everyday feelings, accessible to all. In our former art, what was considered worthy of being conveyed in art was only the expression of feelings proper to a certain exclusive position, and that only on condition that they be conveyed in a most refined way, inaccessible to the majority of people; but the whole enormous realm of popular children's art — jokes, proverbs, riddles, songs, dances, children's games, mimicry — was not considered a worthy object of art.

The artist of the future will understand that to invent a little tale, a touching song, a ditty, an amusing riddle, a funny joke, to make a drawing that will give joy to dozens of generations, or to millions of children and adults, is incomparably more important and fruitful than to write a novel or a symphony or paint a picture that will for a short time divert a few members of the wealthy classes and then be forgotten for ever. The realm of this art of simple feelings accessible to all is enormous and as yet almost untouched.

Thus the art of the future will not only not be impoverished, but, on the contrary, will be infinitely enriched in content. In just the same way, the form of the art of the future will not only not be inferior to the present-day form of art, but will be incomparably superior — superior not in the sense of refined and complex technique, but in the sense of the skill of briefly, simply and clearly conveying, without any superfluities, the feeling that the artist has experienced and wishes to convey.

I remember once talking with a famous astronomer who gave public lectures on the spectral analysis of the stars of the Milky Way, and telling him what a good thing it would be if he, with his knowledge and skill, would give a public lecture in cosmography, touching only on the most familiar movements of the earth, because among the listeners to his lectures on the spectral analysis of the stars in the Milky Way there were certainly many people, especially women, who did not quite know why there are day and night, winter and summer. The wise astronomer replied with a smile: 'Yes, that would be a very good thing, but it is very difficult. To lecture on the spectral analysis of the Milky Way is much easier.'

It is the same in art: to write a long poem about the time of Cleopatra, or paint a picture of Nero burning Rome, or compose a symphony in the spirit of Brahms or Richard Strauss, or an opera in the spirit of Wagner, is much easier than to tell a simple story without any superfluities, and at the same time in such a way that it conveys the narrator's feelings, or to pencil a drawing that would touch the beholder or make him laugh, or to write four measures of a simple clear melody that would convey a mood and be remembered by its hearers.

'It is impossible for us now, with our development, to return to primitive ways,' say the artists of our time. 'It is impossible for us to write such stories as the story of Joseph the Dreamer or the *Odyssey*, to make such statues as the Venus de Milo, to write such music as folk songs.'

And indeed it is impossible for the artists of our time, but not for the artist of the future, who will not know all the depravity of technical improvements concealing the absence of content, and who, not being a professional artist and getting no remuneration for his activity, will produce art only when he feels an irrepressible inner need.

Thus the art of the future will be completely different from what is now considered art, both in content and in form. The content of the art of the future will be only those feelings that draw people towards union or already unite them; as for the form of this art, it will be accessible to everyone. And therefore the ideal of perfection in the future will be, not the exclusiveness of a feeling accessible only to some, but, on the contrary, its universality. And in form it will be, not cumbersomeness, obscurity and complexity, as it is now considered, but, on the contrary, brevity, clarity and simplicity of expression. And only when art becomes like that will it cease to distract and corrupt people, as it does now, calling for the expenditure of their best forces, and become what it should be – a means of transferring Christian religious consciousness from the realm of mind and reason to the realm of feeling, thereby bringing people closer, in practice, in life itself, to the perfection and unity indicated to them by religious consciousness.

XX

CONCLUSION

I have done the best I could with this work which has occupied me for fifteen years on a subject close to me – art. In saying that it has occupied me for fifteen years, I do not mean to say that I have spent fifteen years writing it, but only that when I began writing about art fifteen years ago, I thought the task I had undertaken would be finished without interruption; but it turned out that my thoughts on this subject were then still unclear, that I could not expound them in a way that would satisfy me. Since then, I have thought this subject over incessantly, and have started writing six or seven times, but each time, after writing quite a lot, I felt unable to bring the thing to a conclusion and abandoned work on it. Now I have finished this work, and however poorly I have done it, I hope that my basic thought about the false path that the art of our society has taken and is following, and the cause of this, and what makes up the true purpose of art, is correct, and that therefore my work, though far from complete, and requiring a great many explanations and additions, will not be in vain, and that art will sooner or later abandon the false path it has taken. But in order for that to happen and for art to take a new direction, it is necessary that another human spiritual activity – science, upon which art has always been closely dependent – also abandon the false path on which it finds itself.

Science and art are as closely tied to each other as lungs and heart, so that if one organ is perverted, the other cannot function properly.

True science studies and introduces into human consciousness the truths and the knowledge which are regarded as most important by the people of a certain period and society. Art transfers these truths from the realm of knowledge to the realm of feeling. Therefore, if the path that science follows is false, so, too, will the path of art be false. Science and art are like those barges with kedge-anchors, 'machines' as they were called, that used to work our rivers. Like

the boats that carry the anchor ahead and drop it, science prepares for the movement, the direction of which is given by religion, while art is like the winch worked from the barge, which, by pulling the barge to the anchor, accomplishes the movement itself. And therefore the false activity of science inevitably entails an equally false activity of art.

As art in general is the conveying of various kinds of feelings – and yet we call art in the narrow sense of the word only that which conveys feelings we recognize as important – so, too, science in general is the conveying of all possible knowledge – and yet we call science in the narrow sense of the word only that which conveys knowledge we recognize as important.

The degree of importance both of the feelings conveyed by art and of the knowledge conveyed by science is determined for people by the religious consciousness of the given time and society – that is, the general understanding among people of that time and society of the purpose of their life.

That which contributes most of all to the fulfilment of this purpose is studied most of all and is considered the chief science; that which contributes less is considered less important; that which does not contribute at all to the fulfilment of the purpose of human life is not studied at all, or, if it is studied, this study is not considered science. So it has always been, and so it should be now, because such is the property of human knowledge and human life. But the science of the upper classes of our time, which not only recognizes no religion, but considers all religion to be superstition, could not and cannot do this.

And therefore the men of science of our time maintain that they study *everything* equally, but since there is too much of everything (everything being an infinite number of objects), and it is impossible to study everything equally, this is maintained only in theory; in reality, what is studied is not everything and is studied far from equally, but is only that which, on the one hand, is more needed, and, on the other, is more pleasing for those who occupy themselves with science. And for men of science who belong to the upper classes, what is needed most of all is to maintain the order in which

those classes enjoy their privileges; and what is most pleasing is what satisfies idle curiosity, does not call for great mental effort, and can have practical applications.

And therefore one area of science, including theology, philosophy as applied to the existing order, history and political economy of the same sort, is occupied predominantly with proving that the existing order of life is the very one which ought to exist, which came into being and continues to exist by unchanging laws, not subject to human will, and therefore any attempt to violate it is unlawful and useless. The other area – experimental science, including mathematics, astronomy, chemistry, physics, botany, and all natural science – is occupied only with what has no direct relation to human life, with what is curious and may have profitable applications to the life of upper-class people. And to justify the choice of subjects of study, made in accordance with their own position by the men of science of our time, they have invented a theory of science for science's sake, exactly like the theory of art for art's sake.

As according to the theory of art for art's sake it appears that to be occupied with all those objects which please us is art, so, according to the theory of science for science's sake, the study of objects that interest us is science.

So that one part of science, instead of studying how people should live in order to fulfil their destiny, demonstrates the lawfulness and immutability of the bad and false existing order of life; and the other – experimental science – occupies itself with questions of simple curiosity or with technical improvements.

The first area of science is harmful not only in that it muddles people's concepts and provides false solutions, but also in that it exists and takes up the place that ought to be taken by true science. It is harmful in that every man, in order to set about studying the most important questions of life, needs first, before resolving them, to refute those structures of falsehood that have been heaped up over the ages and that are maintained by all the powers of the mind's inventiveness with regard to each of the most essential questions of life.

And the second area – the very one that modern science is so

especially proud of, and which is regarded by many as the only genuine science – is harmful in that it diverts people's attention from really important subjects to insignificant ones, and, besides that, is directly harmful in that, granting the false order of things which is justified and maintained by the first area of science, the greater part of the technical achievements of this area of experimental science turn not to the benefit of mankind but to its harm.

Only to people who have devoted their lives to these studies does it seem that all the discoveries made in the realm of natural science are very important and useful. But it seems so to these people only because they do not look around themselves and do not see what is really important. They need only tear themselves away from the psychological microscope under which they examine the objects they study and look around themselves in order to see how worthless is all the knowledge that is a source of such pride to them – I am not speaking of imaginary geometry,[115] the spectral analysis of the Milky Way, the form of atoms, the size of the skulls of Stone Age people, and other such trifles, but of the knowledge of microorganisms, X-rays, and so on – compared with the knowledge we have neglected and left to be perverted by professors of theology, jurisprudence, political economy, financial science, and so on. We need only look around ourselves to see that the proper activity of genuine science is not the study of something we have accidentally become interested in, but of how human life should be arranged – the questions of religion, morality, social life, without resolving which all our knowledge of nature is harmful and worthless.

We rejoice and feel proud that our science makes it possible for us to exploit the energy of a waterfall and make this power work in factories, or that we have pierced tunnels through mountains, and so on. But the trouble is that we make this power of the waterfall work not for the benefit of people, but for the enriching of capitalists, who produce objects of luxury or tools for destroying human beings. The same dynamite with which we blow up mountains to make tunnels through them, we also use in war, which we not only do not want to renounce, but which we regard as necessary and for which we are constantly preparing.

If we now know how to make preventive inoculations against diphtheria, to find a needle in a body by means of X-rays, to straighten a hunchback, to cure syphilis, to perform extraordinary surgeries, and so on, we would not be so proud of these achievements, however indisputable, if we fully understood the true purpose of genuine science. If only one-tenth of the forces now spent on objects of mere curiosity and practical application were spent on true science, on arranging the lives of people, then the greater part of those who are now ill would not have those illnesses, of which only a tiny portion are now cured in clinics and hospitals; there would be no undernourished, hunchbacked children growing up in factories, there would be no fifty per cent infant mortality, as now, whole generations would not become degenerate, there would be no prostitution, no syphilis, no killing of hundreds of thousands in war, no horrors of insanity and suffering which present-day science regards as a necessary condition of human life.

We have so perverted the concept of science that people of our time find odd the mention of such sciences as would make it so that there is no infant mortality, no prostitution, no syphilis, no degeneracy of whole generations, no mass killing of people. It seems to us that science is only science when a man in a laboratory pours a liquid from one vial into another, breaks down the spectrum, cuts up frogs and guinea-pigs, or produces, in a special scientific jargon, some obscure theological, philosophical, historical, juridical, or politico-economical lacework of conventional phrases, half-intelligible to himself, which purports to show that things are as they ought to be.

But science, genuine science – a science that would indeed merit the respect now demanded by representatives of one part, and the least important part, of science – does not consist in that; genuine science consists in discovering what ought or ought not to be believed; in discovering how the overall life of mankind ought or ought not to be arranged: how to arrange sexual relations, how to bring up children, how to use the land, how to cultivate it without oppressing others, how to relate to foreigners, how to relate to animals, and many other things important for human life.

Such has true science always been, and such it ought to be. And such science is emerging in our time; but, on the one hand, this true science is rejected and refuted by all those scientists who defend the existing order of life; and, on the other hand, it is considered empty and useless, an unscientific science, by those who are engaged in experimental science.

Books and tracts appear, for instance, proving the obsolescence and absurdity of religious fanaticism and the necessity of establishing a reasonable religious world view that corresponds to our time, and yet many theologians occupy themselves with refuting these works, sharpening their wits again and again to maintain and justify long-outlived superstitions. Or there appears a tract showing that one of the main reasons for the poverty of the people is the landlessness of the proletariat that exists in the West. It would seem that science, genuine science, should welcome this tract and develop further conclusions from it. But the science of our time does nothing of the sort; on the contrary, political economy proves the opposite – namely, that landed property, as well as any other, ought to be concentrated more and more in the hands of a small number of owners, as is asserted, for instance, by contemporary Marxists. In the same way, it would seem that the business of genuine science is to prove the unreasonableness and unprofitableness of war, of capital punishment, or the inhumanity and perniciousness of prostitution, or the senselessness, harmfulness and immorality of using drugs or animal foods, or the unreasonableness, wickedness and backwardness of patriotic fanaticism. And there exist such works, but they are all regarded as unscientific. While those works are considered scientific which either prove that all these phenomena must exist or which are engaged with questions of idle curiosity that have no relation to human life.

The deviation of the science of our time from its true purpose can be seen with striking clarity in the ideals that some men of science set up for themselves and which are not rejected but are acknowledged by the majority of scientists.

These ideals are voiced not only in stupid, fashionable books describing the world 1,000 or 3,000 years from now, but also by

sociologists who regard themselves as serious scientists. These ideals are that food, instead of being obtained from the earth by agriculture and the raising of livestock, will be prepared in laboratories by chemical means, and that human labour will be replaced almost entirely by the utilization of natural forces.

Man will not, as he does now, eat an egg laid by a hen he has raised, or bread grown in his own field, or an apple from a tree he has been tending for years, which blossomed and ripened before his eyes, but will eat tasty, nourishing food prepared in laboratories by the combined labours of many people, in which he will take no part.

There will be almost no need for man to labour, and thus all people will be able to give themselves to that same idleness to which the ruling upper classes now give themselves.

Nothing shows more obviously than these ideals how far the science of our time has deviated from the true path.

People in our time, the vast majority of people, lack wholesome and sufficient nourishment (the same holds for housing, clothing, and all primary necessities). Moreover, this same vast majority of people are forced to work constantly, beyond their strength and to the detriment of their well-being. Both misfortunes can very easily be removed by abolishing mutual struggle, luxury, the improper distribution of wealth, and generally by abolishing the false, harmful order of things and arranging human life in a reasonable way. Yet according to science, the existing order of things is immutable, like the movement of the heavenly bodies, and therefore the task of science lies not in elucidating the falseness of this order and establishing a new, reasonable system of life, but in feeding all the people while maintaining the existing order, and giving them all the opportunity to be as idle as the ruling classes are now, living their depraved life.

With all that, it is forgotten that nourishment on bread, vegetables, fruits grown from the earth by one's own labour is the most pleasant, healthful, light and natural nourishment, and that the work of exercising one's muscles is as necessary a condition of life as the oxygenating of the blood by means of breathing.

To invent ways for people to be well nourished by means of chemically prepared food and to make the forces of nature work for them, while the distribution of property and labour remains wrong, is the same as inventing a means of pumping oxygen into the lungs of a man who is locked up in a room with bad air, when all that need be done is to stop keeping the man in the locked room.

No professors will ever set up a laboratory for the production of food that is better than the one that has been set up in the vegetable and animal world, and to use the fruits of this laboratory and participate in it, man has only to give himself to the ever-joyful need for labour, without which man's life is a torment. And here the scientists of our age, instead of applying all their forces to removing what hinders man from using these blessings prepared for him, recognize the situation in which man is deprived of these blessings as immutable, and, instead of arranging the life of men so that they could work joyfully and be nourished by the earth, they devise ways of turning them into artificial freaks. It is the same as if, instead of taking a man from a locked room out into the fresh air, one invented ways of pumping the necessary oxygen into him, enabling him to live not in a house but in a stuffy basement.

Such wrong ideals could not exist if science were not on the wrong path.

And yet the feelings conveyed by art arise on the bases given by science.

What feelings can be called up by this science which stands on the wrong path? One part of this science calls up backward feelings which have been outlived by mankind, feelings which in our time are bad and exclusive. The other part, occupied with the study of subjects that by their very essence have no relation to human life, cannot serve as a basis for art.

So that the art of our time, in order to be art, must by-pass science and make its own path, or else take direction from the unacknowledged science that is rejected by scientific orthodoxy. And this is what art does when it at least partially fulfils its purpose.

It is to be hoped that the work I have attempted to do with respect to art will also be done with respect to science, that the

incorrectness of the theory of science for science's sake will be pointed out to people, that they will be clearly shown the necessity of accepting the Christian teaching in its true meaning, and that on the basis of this teaching a re-evaluation will be made of all the knowledge we possess and of which we are so proud; that they will be shown how secondary and worthless experimental knowledge is, and how primary and important religious, moral and social knowledge are; and that such knowledge will not be left to the guidance of the upper classes only, but will constitute the chief object of all those free, truth-loving people who, not always in agreement with the upper classes, but running counter to them, have moved forward the true science of life.

As for mathematics, astronomy, physics, chemistry, as well as biological, technical and medical sciences, they will be studied in so far as they contribute to liberating people from religious, juridical and social deceptions, or serve the good of all and not of one class.

Only then will science cease to be what it is now – on the one hand, the system of sophisms necessary for maintaining an obsolete order of life; on the other hand, a formless heap of varied knowledge, mostly of little use or altogether unnecessary – and become a harmonious, organic whole with a definite and reasonable purpose, understandable to all people – namely, the introducing into people's consciousness of the truths that come from the religious consciousness of our time.

And only then will art, which always depends on science, be what it can and should be – an organ of the life and progress of mankind as important as science.

Art is not pleasure, consolation, or amusement; art is a great thing. Art is an organ of mankind's life, which transmutes people's reasonable consciousness into feeling. In our time, the common religious consciousness of men is the consciousness of the brotherhood of men and their well-being in mutual union. True science should indicate various ways of applying this consciousness to life. Art should transmute this consciousness into feeling.

The task facing art is enormous: art, genuine art, guided by religion with the help of science, must make it so that men's

peaceful life together, which is now maintained by external measures – courts, police, charitable institutions, workplace inspections, and so on – should be achieved by the free and joyful activity of men. Art should eliminate violence.

And only art can do that.

All that presently makes it possible for men to live together, independently of the fear of violence and punishment (and in our time an enormous part of the order of life is based on this) – all of it has been brought about by art. If through art there could be conveyed the customs of treating religious objects in a certain way, of treating parents, children, wives, relations, strangers, foreigners in a certain way, of treating elders, persons of higher rank, enemies, animals, the suffering in a certain way – and this has been observed by millions of people over generations, not only without the least violence, but in such a way that it cannot be shaken by anything but art – then this same art can evoke other customs, more closely corresponding to the religious consciousness of our time. If art could convey the feeling of reverence for icons, for the Eucharist, for the person of a king, of shame at the betrayal of friendship, of loyalty to a flag, the necessity of revenging an insult, the need of donating one's labour for the building and adorning of churches, the duty of defending one's honour or the glory of one's fatherland, then the same art can evoke reverence for each man's dignity, for every animal's life; it can evoke the shame of luxury, of violence, of revenge, of using for one's pleasure objects that are a necessity for other people; it can make people sacrifice themselves to serve others freely and joyfully, without noticing it.

Art should make it so that the feelings of brotherhood and love of one's neighbour, now accessible only to the best people of society, become habitual feelings, an instinct for everyone. By calling up the feelings of brotherhood and love in people under imaginary conditions, religious art will accustom people to experiencing the same feelings in reality under the same conditions; it will lay in people's souls the rails along which the life behaviour of people brought up by art will naturally run. And uniting the most diverse people in one feeling and abolishing separation, the art of the whole

people will educate mankind for union, will show them, not in reasoning but in life itself, the joy of general union beyond the barriers set up by life.

The purpose of art in our time consists in transferring from the realm of reason to the realm of feeling the truth that people's well-being lies in being united among themselves and in establishing, in place of the violence that now reigns, that Kingdom of God – that is, of love – which we all regard as the highest aim of human life.

Perhaps in the future science will open to art still newer, higher ideals, and art will realize them; but in our time, the purpose of art is clear and definite. The task of Christian art is the realization of the brotherly union of men.

Appendix I

L'Accueil

Si tu veux que ce soir, à l'âtre je t'accueille,
Jette d'abord la fleur, qui de ta main s'effeuille,
Son cher parfum ferait ma tristesse trop sombre;
Et ne regarde pas derrière toi vers l'ombre,
Car je te veux, ayant oublié la forêt
Et le vent, et l'écho et ce qui parlerait
Voix à ta solitude ou pleurs à ton silence!
Et debout, avec ton ombre qui te devance,
Et hautaine sur mon seuil, et pâle, et venue
Comme si j'étais mort ou que tu fusses nue!

Henri de Régnier
Les jeux rustiques et divins[116]

Oiseau bleu couleur du temps

Sais-tu l'oubli
D'un vain doux rêve,
Oiseau moqueur
De la forêt?
Le jour pâlit,
La nuit se lève,
Et dans mon cœur
L'ombre a pleuré;

O chante-moi
Ta folle gamme,
Car j'ai dormi
Ce jour durant;

Le lâche émoi
Où fut mon âme
Sanglote ennui
Le jour mourant . . .

Sais-tu le chant
De sa parole
Et de sa voix,
Toi qui redis
Dans le couchant
Ton air frivole
Comme autrefois
Sous les midis?

O chante alors
La mélodie
De son amour,
Mon fol espoir,
Parmi les ors
Et l'incendie
Du vain doux jour
Qui meurt ce soir.

Francis Vielé-Griffin
Poèmes et poésies

Énone au clair visage

Énone, j'avais cru qu'en aimant ta beauté
Où l'âme avec le corps trouvent leur unité,
J'allais, m'affermissant et le cœur et l'esprit,
Monter jusqu'à cela qui jamais ne périt,
N'ayant été crée, qui n'est froideur ou feu,
Qui n'est beau quelque part et laid en autre lieu;
Et me flattais encor' d'une belle harmonie
Que j'eusse composé du meilleur et du pire,
Ainsi que le chanteur qui chérit Polymnie,
En accordant le grave avec l'aigu, retire

Un son bien élevé sur les nerfs de sa lyre.
Mais mon courage, hélas! se pâmant comme mort,
M'enseigna que le trait qui m'avait fait amant
Ne fut pas de cet arc que courbe sans effort
La Vénus qui naquit du mâle seulement,
Mais que j'avais souffert cette Vénus dernière,
Qui a le cœur couard, né d'une faible mère,
Et pourtant, ce mauvais garçon, chasseur habile,
Qui charge son carquois de sagette subtile,
Qui secoue en riant sa torche, pour un jour,
Qui ne pose jamais que sur de tendres fleurs,
C'est sur un teint charmant qu'il essuie les pleurs,
Et c'est encore un Dieu, Énone, cet Amour.
Mais, laisse, les oiseaux du printemps sont partis,
Et je vois les rayons du soleil amortis.
Énone, ma douleur, harmonieux visage,
Superbe humilité, doux honnête langage,
Hier me remirant dans cet étang glacé
Qui au bout du jardin se couvre de feuillage,
Sur ma face je vis que les jours ont passé.

Jean Moréas
Le Pèlerin passionné

Berceuse d'ombre

Des formes, des formes, des formes
Blanche, bleue, et rose, et d'or
Descendront du haut des ormes
Sur l'enfant qui se rendort.
 Des formes!

Des plumes, des plumes, des plumes
Pour composer un doux nid.
Midi sonne: les enclumes
Cessent; la rumeur finit . . .
 Des plumes!

Des roses, des roses, des roses
Pour embaumer son sommeil,
Vos pétales sont moroses
Près du sourire vermeil.
 O roses!

Des ailes, des ailes, des ailes
Pour bourdonner à son front,
Abeilles et demoiselles,
Des rhythmes qui berceront.
 Des ailes!

Des branches, des branches, des branches
Pour tresser un pavillon,
Par où des clartés moins franches
Descendront sur l'oisillon.
 Des branches!

Des songes, des songes, des songes
Dans ses pensers entr'ouverts
Glissez un peu de mensonges
A voir la vie au travers.
 Des songes!

Des fées, des fées, des fées
Pour filer leurs écheveaux
De mirages, de bouffées
Dans tous ces petits cerveaux.
 Des fées!

Des anges, des anges, des anges
Pour emporter dans l'éther
Les petits enfants étranges
Qui ne veulent pas rester . . .
 Nos anges!

Comte Robert de Montesquiou-Fezensac
Les Hortensias bleues

Appendix II

Here is the content of the *Ring of the Nibelungen*.

In the first part it is told that the nymphs, daughters of the Rhine, have for some reason been made the guardians of some sort of gold on the Rhine, and they sing: *Weia, Waga, Woge du Welle, Walle zur Wiege, Wage zur Wiege, Wage la Weia, Wala la Welle, Weia,* and so on. While thus singing, the nymphs are pursued by the dwarf Nibelung, who wishes to possess them. The dwarf cannot catch any of them. Then the nymphs who guard the gold tell the dwarf something they ought rather to have concealed – namely, that whoever renounces love can steal the gold they are guarding. The dwarf renounces love and carries off the gold. That is the first scene.

In the second scene, a god and goddess lie in a field, within sight of a city; then they wake up and rejoice over the city that the giants have built for them, saying that they will have to give the giants the goddess Freya in return for their work. The giants come to get their pay. But the god Wotan does not want to give them Freya. The giants are angry. The gods learn that the dwarf has stolen the gold and promise to take it back and pay the giants for their work. But the giants do not believe it and seize the goddess Freya as a pledge.

The third scene takes place underground. The dwarf Alberich, who stole the gold, gives the dwarf Mime a beating for some reason and snatches from him a helmet that has the property of making its wearer invisible or turning him into other creatures. The gods come, Wotan and others; they quarrel with each other and with the dwarfs, wishing to take the gold, but Alberich will not let them and, like everyone else, does all he can to ruin himself: puts the helmet on, turns into a dragon, then into a toad. The gods catch the toad, take the helmet off him, and lead Alberich away.

In the fourth scene, the gods bring Alberich home with them and

tell him to order his dwarfs to bring all the gold. The dwarfs bring it. Alberich gives them all the gold, saving a magic ring for himself. The gods take the ring from him as well. For that, Alberich puts a curse on the ring and says that it will bring misfortune to anyone who possesses it. The giants come, bringing Freya, and demand the ransom. They set up poles to measure Freya's height and heap up the gold – this is the ransom. There is not enough gold. They throw in the helmet and ask for the ring. Wotan will not give it to them, but the goddess Erda comes and tells him to give the ring away because it brings misfortune. Wotan does so. Freya is released, but the giants, having got hold of the ring, start fighting, and one kills the other. This is the end of the Prelude; then the First Day begins.

A tree is placed in the middle of the stage. Siegmund runs in, weary, and lies down. Enter Sieglinda, the mistress of the house, Hunding's wife; she gives him a magic drink, and they fall in love with each other. Sieglinda's husband comes, learns that Siegmund belongs to an enemy race, and wants to fight with him the next day, but Sieglinda gives her husband a potion and comes to Siegmund. Siegmund learns that Sieglinda is his sister, and that his father stuck a sword into a tree so that no one can pull it out. Siegmund snatches out the sword and commits incest with his sister.

In the second act, Siegmund has a fight with Hunding. The gods discuss to whom they should give the victory. Wotan wants to spare Siegmund, approving of his incest with his sister, but, influenced by his wife Fricka, he tells the Valkyrie Brunhilda to kill Siegmund. Siegmund goes to the fight. Sieglinda swoons. Brunhilda comes and wants to slay Siegmund; Siegmund wants to kill Sieglinda as well, but Brunhilda tells him not to, and so he fights with Hunding. Brunhilda defends Siegmund, but Wotan defends Hunding; Siegmund's sword breaks and he is killed. Sieglinda flees.

Act III. The Valkyries are on stage. They are warrior women. Enter the Valkyrie Brunhilda on horseback with Siegmund's body. She is fleeing from Wotan, who is angry with her for her disobedience. Wotan catches her and, as punishment for her disobedience, dismisses her from the Valkyries. He puts a spell on her so that she

must fall asleep and sleep until a man awakens her. And when she is awakened, she will fall in love with this man. Wotan kisses her; she falls asleep. He produces a fire which encircles her.

The content of the Second Day consists of the dwarf Mime forging a sword in the forest. Enter Siegfried. He is the son born of the incest committed by the brother and sister, Siegmund and Sieglinda, and has been brought up in the forest by the dwarf. Siegfried learns of his origin and that the broken sword is his father's; he tells Mime to reforge it and exits. Enter Wotan in the guise of a wanderer. He says that one who has not learned to fear will reforge the sword and defeat everyone. The dwarf guesses that it is Siegfried and wants to poison him. Siegfried comes back, reforges the sword of his father, and runs off.

In the second act, Alberich is sitting watching over the giant, who, in the guise of a dragon, is watching over the gold he was given. Enter Wotan, who for no apparent reason declares that Siegfried will come and kill the dragon. Alberich awakens the dragon and asks him for the ring, promising in return to protect him from Siegfried. The dragon will not give him the ring. Alberich exits. Enter Mime and Siegfried. Mime hopes that the dragon will teach Siegfried to fear. But Siegfried is not afraid; he chases Mime away and kills the dragon, after which he dips his finger in the dragon's blood and puts it to his lips, which enables him to know the secret thoughts of men and the language of birds. The birds tell him where the treasure and the ring are, and that Mime wants to poison him. Enter Mime, who says aloud that he wants to poison Siegfried. This must signify that Siegfried, having tasted the dragon's blood, understands the secret thoughts of men. Having learned his thoughts, Siegfried kills Mime. The birds tell him where Brunhilda is, and Siegfried goes to her.

In the third act, Wotan calls up Erda. Erda prophesies to Wotan and advises him. Enter Siegfried, who quarrels with Wotan and fights with him. It suddenly happens that Siegfried's sword breaks Wotan's spear – the one that was most powerful of all. Siegfried goes to the fire where Brunhilda is; he kisses Brunhilda, she awakens, says farewell to her divinity, and throws herself into Siegfried's arms.

The Third Day.

Three norns braid a golden rope and talk about the future. The norns exit; enter Siegfried and Brunhilda. Siegfried says goodbye to her, gives her the ring, and exits.

Act I. On the Rhine, the king wants to get married and also to marry off his sister. Hagen, the king's wicked brother, advises him to take Brunhilda and marry his sister to Siegfried.

Enter Siegfried. He is given a love potion which makes him forget all the past, fall in love with Gutrune, and go with Gunther to get him Brunhilda for his bride. The set changes. Brunhilda sits with the ring; a Valkyrie comes to her, tells her that Wotan's spear has been broken, and advises her to give the ring to the Rhine nymphs. Siegfried comes, transformed into Gunther by means of the magic helmet, demands the ring from Brunhilda, snatches it from her, and drags her off to sleep with him.

Act II. On the Rhine, Alberich and Hagen discuss how to get the ring. Enter Siegfried. He tells how he has obtained the bride for Gunther and spent the night with her, having placed the sword between them. Brunhilda arrives, recognizes the ring on Siegfried's hand, and reveals that it was he, not Gunther, who was with her. Hagen arouses everyone against Siegfried and decides to kill him the next day while hunting.

Act III. The Rhine nymphs tell over again everything that has happened. Enter Siegfried, who is lost. The nymphs ask him for the ring; he will not give it to them. Enter hunters. Siegfried tells his story. Hagen gives him a drink which makes him recover his memory; he tells how he awakened and acquired Brunhilda, and everyone is surprised. Hagen stabs him in the back, and the set changes. Gutrune meets the body of Siegfried; Gunther and Hagen argue about the ring, and Hagen kills Gunther. Brunhilda weeps. Hagen wants to take the ring from Siegfried's hand, but the hand rises. Brunhilda takes the ring from Siegfried's hand, and, as Siegfried's body is carried to the pyre, she mounts her horse and throws herself into the flames. The water of the Rhine rises and comes up to the fire. There are three nymphs in the river. Hagen throws himself into the fire to get the ring, but the nymphs seize him and draw him away with them. One of them holds the ring.

And the work is over.

The impression of my retelling is, of course, incomplete. But, incomplete as it may be, it is certain to be incomparably better than the impression one gets from reading the four booklets in which it has been published.

Notes

Tolstoy gave no documentation for his references apart from what he included in the body of the text itself. We give references for all but the most well-known or readily identifiable persons mentioned.

1. Tolstoy lists a number of movements, mainly French or of French origin, that were influential towards the end of the nineteenth century. The Parnassians were named after their journal, *Le Parnasse contemporain*, the three issues of which appeared between 1866 and 1876. The symbolists emerged around 1885, taking their inspiration from Verlaine and Rimbaud, and rallying around the poet Stéphane Mallarmé. Both movements stood for 'art for art's sake' and 'pure form', though they differed in other ways. *Les mages* ('the Magi') included the writers Paul Adam (1862–1920) and the curious figure of Joseph Peladan (1859–1918), who called himself Josephin and Sâr Peladan ('sâr' meaning 'magus'); they united on the basis of anarchism and mysticism, with occult and erotic overtones. The term 'decadent' is more capacious, including Verlaine and others who preceded and accompanied the symbolists.

2. Ernest Renan (1823–92), French writer, a lapsed Catholic and rationalist religious historian, defended the theory of the rule of the elect in his book *Marcus Aurelius and the End of Antiquity*.

3. Richard Kralik (1852–1934), German aesthetician; his book is entitled *World Beauty, a Study in Universal Aesthetics*. Marie-Jean Guyau (1854–88), French philosopher, wrote *Problems in Aesthetics*. These two works, together with the books by Knight and Schassler cited later, form the basis for most of Tolstoy's discussion in this and the following three chapters.

4. 'They are the aesthetic treatment of the five senses.'

5. 'It is usually thought that artistic material can be treated by only two or at the most three of the senses, but I think this is hardly right. I cannot avoid considering the fact that, in the general sense, for example, cooking is regarded as an art ... It is, of course, an aesthetic success when the art of cooking manages to make from the corpse of an animal something agreeable to the sense of taste. Thus the basic principle of the art of the sense of taste (hereafter referred to as the art of cooking) is this: all that is edible must be treated as the sense-image of a certain idea, and must, in any given case, correspond to the idea that is to be expressed.'

6. 'If the sense of touch lacks colour, it furnishes us instead with a notion that the eye alone cannot give us and that is of considerable aesthetic value: that of *the soft, the silky, the smooth*. What characterizes the beauty of velvet is its softness to the touch no less than its sheen. In the idea we fashion for ourselves of the beauty of a woman, the velvetiness of her skin enters as an essential element.

'Each of us, with a little attention, can probably recall pleasures of taste which were true aesthetic pleasures.'

7. Alexander Gottlieb Baumgarten (1714–62), in his *Philosophical Meditations from Nowhere* (1735), first applied the word 'aesthetic' to a specific science, thus becoming the founder of aesthetics.

8. Herbert Spencer (1820–1903), English philosopher and sociologist, was a founder of evolutionist philosophy. Charles Grant Allen (1848–99), scholar and novelist, was a professor of natural history and logic and a propagator of Darwinism.

9. Hippolyte Taine (1828–93), French philosopher, historian and literary critic, published his *Philosophie de l'art* in 1882.

10. To this list of the most famous names in German philosophy, Tolstoy adds that of Max Alexander Friedrich Schassler (1819–1903), a German art historian, whose *Kritische Geschichte der Ästhetik* ('Critical History of Aesthetics') was published in 1872. Victor Cousin (1792–1867), French philosopher, head of the eclectic spiritualist school, published his *Du vrai, du bien et du beau* ('Of the True, the

Good and the Beautiful') in 1858. Charles Lévêque (1818–1900) was professor of Greek and Latin philosophy at the Collège de France; his major work, *La science du beau étudiée dans ces principes, dans ses applications et dans son histoire* ('The Science of the Beautiful Studied in Its Principles, Its Applications and Its History') was published in 1861.

11. *The Philosophy of the Beautiful*, by William Angus Knight (1836–1916).

12. 'No science has been more given to the reveries of metaphysicians than aesthetics. From Plato to the official doctrines of our day, art has been made into I don't know what sort of an amalgam of quintessential fantasies and transcendental mysteries, which find their supreme expression in the absolute conception of ideal beauty as the immutable and divine prototype of real things.' From *L'esthétique* (1878) by Eugène Véron (1825–89), French journalist and critic.

13. *The Aesthetics of Aristotle and His Successors* by Charles Bénard (1807–98), was published in 1889. The author of *Geschichte der Ästhetik im Altertum* ('A History of Ancient Aesthetics') was Julius Walter (1841–1922).

14. Johann Joachim Eschenburg (1743–1820), German erudite, historian of literature and aesthetician, was a friend of Lessing and the first German translator of Shakespeare. Johann August Eberhardt (1739–1809) published his *Theorie der Schönen Künste und Wissenschaft* ('Theory of the Fine Arts and Science') between 1783 and 1790.

15. Ludwig Schütz (1838–1901) was a German philosopher and aesthetician. Johann Georg Sulzer (1720–79), Swiss philosopher and physicist, left many writings, some of them on aesthetics. Moses Mendelssohn (1729–93), religious writer and philosopher, an associate of Lessing, translated the Bible into German. Karl Philipp Moritz (1756–93), German writer and professor at the Academy of Fine Arts in Berlin, influenced the *Sturm und Drang* movement.

16. *Geschichte der Kunst des Altertums* ('A History of Ancient Art'), by Johann Joachim Winckelmann (1717–68), influential historian, archaeologist, and theorist of art.

17. Anthony Cooper, 3rd Earl of Shaftesbury (1671–1713), published his *Characteristics of Men, Manners, Opinions and Times* in 1711. Francis Hutcheson (1694–1746), Irish philosopher, moralist and writer on aesthetics, was a theorist of disinterested pleasure in art. Henry Kames, Lord Home (1696–1782) was an English jurist and moralist; his *Essays on the Principles of Morality and Natural Religion* appeared in 1761. The Anglo-Irish statesman and philosopher Edmund Burke (1729–97) published his book on the sublime and the beautiful in 1757. Finally, William Hogarth (1697–1764), the great English painter and engraver, also wrote a book on art, *The Analysis of Beauty*, published in 1753.

18. Yves-Marie André, known as le Père André (1675–1764), professor of mathematics and partisan of Cartesian idealism, published his *Essai sur le Beau* ('Essay on Beauty') in 1741. Charles Batteux (1713–80), French man of letters and philosopher, is best known for his *Les Beaux-Arts réduits à un même principe* ('The Fine Arts Reduced to a Single Principle'), published in 1746.

19. Francesco Mario Pagano (1748–99), Italian politician, jurist and writer, was professor of law at the university of Naples.

20. Ludovico Antonio Muratori (1672–1750) was a priest and doctor of theology, who left a number of works in historical criticism, biographies of poets, studies of inscriptions; his work on aesthetics is *Reflections on Good Taste in the Sciences and the Arts*. A. Spaletti's book, *An Essay on Beauty*, was published in 1765.

21. Franciscus Hemsterhuis (1721–90), Dutch philosopher and writer, influenced the German romantics with his philosophy of sentiments as well as with his aesthetic ideas.

22. Adam Müller (1779–1829) was a conservative German publicist and aesthetician.

23. *Readings in Aesthetics*, by Karl Wilhelm Solger (1780–1819), a German philosopher and theorist of romanticism.

24. Karl Christian Friedrich Krause (1781–1832), German philosopher, authored a doctrine of pantheism inspired by the thought of Schelling. His *Essay on the Scientific Basis of Morality* was published in 1810.

25. Christian Hermann Weisse (1801–66), German philosopher and theist, published his *System of Aesthetics Considered as the Science of the Idea of the Beautiful* in 1830. Arnold Ruge (1802–80) was a German politician, philosopher and publicist. Karl Rosenkrantz (1805–79), a disciple of Hegel, published *My Reform of the Hegelian Philosophy* in 1852. Friedrich Theodor Vischer (1807–87) published his *Aesthetics or the Composition of the Beautiful* in 1846–57.

26. Johann Friedrich Herbart (1776–1841) was a German philosopher, psychologist and pedagogue.

27. Karl Edward von Hartmann (1842–1906) is best known for his *Philosophy of the Unconscious*. Julius Kirchmann (1802–84) was a philosopher and jurist. Hermann von Helmholtz (1821–94), physicist and physiologist, discovered the role of harmonics in the timbre of musical notes, and also studied optics and electricity. Julius Bergmann (1840–1904) was a philosopher. Joseph Jungmann published *Über das Schöne* ('On the Beautiful') in 1887.

28. Théodore Jouffroy (1796–1842) taught in the École Normale, the Collège de France, and the Sorbonne; his *Du beau et du sublime* ('Of the Beautiful and the Sublime') was published in 1816, and his *Cours d'esthétique* ('Course in Aesthetics') in 1843. Adolphe Pictet (1799–1875) was a Swiss writer, a specialist in linguistic palaeontology. Felix Lacher Ravaisson-Mollien (1813–1900) was a philosopher and archaeologist; his *Morale et metaphysique* ('Morals and Metaphysics') appeared in 1893.

29. 'The most divine and principally the most perfect beauty contains the secret.' 'The entire world is the work of one absolute beauty, which is the cause of things only through the love it puts in them.'

30. 'Let us not be afraid to say that a truth which is not beautiful is only a logical game of the mind, and that the only truth which is solid and worthy of the name is beauty.' From *Du fondement de l'induction* ('The Foundation of Induction') by Charles Renouvier (1815–1903), a philosopher of Kantian tendency, one of the founders of French 'neo-criticism'.

31. Victor Cherbuliez (1829–99), novelist and literary critic, published *Études de littérature et d'art* in 1873 and *L'art et la nature* in 1892. Charles de Coster (1827–79), Belgian writer, philosopher and collector of folk tales, is the author of *The Legend of Thyl Eulenspiegel*.

32. Mario Pilo (1859–1920) was an Italian writer on art; his book is *The Psychology of the Beautiful and of Art*, the title of which Tolstoy, drawing on Guyau, gives in French.

33. Hippolyte Fierens-Gevaert (1870–1926) was a Belgian writer on art; his book, *Essays on Contemporary Art*, appeared in 1890.

34. 'There is no other Reality than God, there is no other Truth than God, there is no other Beauty than God.' From *Idealist and Mystical Art*, by Sâr Peladan (see note 1).

35. Thomas Reid (1704–96), Scottish philosopher, opposed the sceptical paradoxes of Hume with the primary convictions of 'common sense'. Archibald Alisson (1757–1839) was an English writer. Erasmus Darwin (1731–1802), doctor, naturalist and poet, is the author of the poem *The Botanical Garden*.

36. John Todhunter (1839–1916) was a writer, historian of literature, and professor. John Morley of Blackburn (1838–1923) was a writer and politician and author of a study of Burke published in 1879. Edward Ker (1835–1908) was a philosopher.

37. James Sully (1842–1923), English writer, psychologist and professor, studied psychology in the light of physiology, with special attention to art, education and social order.

38. Johannes Immanuel Volkelt (1848–1930), German philosopher

and art historian, published his *Questions of Contemporary Aesthetics* in 1895.

39. Richard Muther (1860–1909) was a German art historian.

40. In English in the original; earlier Tolstoy summarized the same passage in Russian (see note 37).

41. Kaspar Hauser (1812–33) was a mysterious figure who appeared in Nuremberg one day in 1828, dressed as a peasant and carrying a letter saying that he had been entrusted to peasants at birth. Arrested as a vagabond, he attracted attention by his total lack of education. Much literature has been devoted to him.

42. Prince Vladimir I of Novgorod (*c.* 956–1015), grand prince of Kievan Rus (980–1015), adopted Christianity as the religion of all his people in 988, as the emperors Constantine and Charlemagne had done earlier for their peoples.

43. Flavius Claudius Julianus, known as Julian the Apostate (331–63), Roman emperor 361–63, attempted to restore paganism in the Roman empire after Constantine's adoption of Christianity as the official religion.

44. The Paulicians were a heretical Manichaean sect founded in Armenia in the seventh century, most probably named after Paul of Samosata, third-century bishop of Antioch who defied the authority of the synod that removed him from office. Defeated by the Greeks in 872, the Paulicians were exiled to the Balkan peninsula. There, in the tenth century, arose the sect of Bogomils, who held much the same ideas as the Paulicians. A similar heretical sect appeared in the south of France around 1160, in the preaching of Petrus Waldo (Latin name of Pierre de Vaux), after whom the Waldensians, or Vaudois, were named. All were non-Church or anti-Church movements.

45. Tolstoy's chronology is mistaken; papal infallibility was declared dogma only in 1870, by Pius IX.

46. Peter Kelchitsky (1390–1460), Czech religious reformer, known

as 'the continuer of Jan Hus', attacked the Church and taught a return to evangelical purity.

47. *Catharsis*, i.e. purification. The sense in which Aristotle uses this word in his *Poetics* is much debated; it is generally thought to mean a moral purification through vicarious experience (e.g. the experience of art).

48. 'For one who wants to look closely at it, the theory of beauty and the theory of art are completely separated in Aristotle, as they are in Plato and in their successors.' For Bénard, see note 13.

49. 'The gap of five hundred years that separates the aesthetic views of Plato and Aristotle from those of Plotinus seems astonishing. However, one cannot in fact maintain that during this period of time there had been absolutely no discussion of aesthetic questions or that there exists a total absence of connection between the latter philosopher's views of art and those of the philosophers I have mentioned first. Though the science founded by Aristotle ceased entirely to develop further, there still occurred some interest in aesthetic questions. However, after Plotinus (the few philosophers who follow him in time – Longinus, Augustine *et al.* – are hardly worth mentioning, being, apart from everything else, quite close to him in their views), not five but fifteen centuries went by during which one can find no trace of scientific interest in the world of the beautiful or in art.

'This millennium and a half in the course of which the world spirit, in various struggles, worked out entirely new forms of life, gave nothing to aesthetics in the sense of its further scientific development.' From *The Critical History of Aesthetics*, by Max Schassler (Berlin, 1872), p. 253. (Tolstoy's note.)

50. 'Books have their fate according to the understanding of their readers' (Latin).

51. Thomas Robert Malthus (1766–1834), English economist and Anglican pastor, published the first version of his famous *Essay on the Principles of Population* anonymously in 1798; concerned with the

problem of poverty, he found its principal cause in the fact that population grows more quickly than subsistence.

52. '. . . it is the weariness with life, the scorn of the present age, the longing for another time perceived through the illusion of art, the taste for paradox, the need to make oneself noticed, the aspiration of the refined towards simplicity, the infantile worship of the marvellous, the morbid seductiveness of reverie, the unsettling of the nerves, and above all the exasperated appeal of sensuality'. From *Les jeunes: études et portraits* ('The Young: Studies and Portraits') by traditionalist scholar and critic René Doumic (1860–1937).

53. Marcel Prévost (1862–1941) was a novelist and member of the Académie Française, author of *Lettres à Françoise* ('Letters to Françoise'), *Les Demi-vierges* ('The Half-Virgins') etc.

54. Remy de Gourmont (1858–1915), writer and erudite, was the author of many novels and essays in literary and philosophical criticism; considered the most authoritative critic of the symbolist group.

55. Pierre Louÿs (1870–1925), French poet and novelist, is most famous for his *Chansons de Bilitis*, of a mystical eroticism. Joris-Karl Huysmans (1848–1907), French novelist and critic, started as a naturalist and ended as a Christian; his book *Certains* ('Certain Ones'), published in 1889, contains his judgements on modern art.

56. Baudelaire dedicated *Les Fleurs du Mal* to his 'master and friend' Théophile Gautier (1811–72), poet and novelist, theorist of 'art for art's sake', who prefaced the posthumous 1868 edition.

57. Music first of all,
 And for that prefer the Uneven,
 More vague and more soluble in air,
 With nothing in it that weighs or drags.

 And you also must not go choosing
 Your words without a certain disdain:
 Nothing's more precious than a tipsy song
 Where Indistinct is joined to Precise.

* * *

> Music again and always!
> Let your verse be that winged thing
> That one feels fleeing from a parting soul
> Towards other loves in other skies.
>
> Let your verse be the lucky chance
> Scattered on the tense morning wind
> That goes sniffing at mint and thyme . . .
> And all the rest is literature.

These are the opening and closing stanzas of 'The Art of Poetry' from Verlaine's *Jadis et Naguère* ('Long Ago and Recently'), 1884.

58. 'I think there should be nothing but allusion. The contemplation of objects, the fleeting image of the reveries they call up, are the song: the Parnassians, for their part, take the thing as a whole and display it; as a result they lack mystery; they deprive our minds of the delicious joy of believing that they are creating. To *name* an object is to suppress three-quarters of the *poet's enjoyment, which is made from the happiness of divining little by little; suggestion – that is the dream.* It is the perfect use of this mystery that constitutes the symbol: to evoke an object little by little and release a state of soul from it by a series of decipherments.

'. . . If a person of average intelligence and insufficient literary preparation chances to open a book made in this way and tries to enjoy it, there is a misunderstanding, things must be put back in their place. *There must always be enigma in poetry*, and that is the aim of literature; there is no other – the evocation of objects.' Tolstoy's italics.

From Mallarmé's response to the *Enquête sur l'évolution littéraire* ('Survey on Literary Evolution') of French journalist and essayist Jules Huret (1864–1915), who also took surveys in North America, Argentina and Germany, finding the form congenial.

59. 'It is also time we were done with this famous theory of obscurity that the new school has in fact raised to the level of a dogma.' From *Les Jeunes* by René Doumic (see note 52).

60. The quoted phrase, in English in the original, is a misquotation of a passage Tolstoy earlier quoted correctly from Grant Allen's *Psychological Aesthetics*.

61. Jean Moréas (1856–1910), French symbolist poet of Greek origin, was the author of the *Manifesto of Symbolism*; his *Le Pèlerin passionné* ('The Passionate Pilgrim') was published in 1891 and 1893. Charles Morice (1861–1919), a writer of idealist and mystical leanings, belonged to Mallarmé's circle. He translated Dostoevsky, wrote on the theory of symbolism in his *Littérature de tout à l'heure* ('Literature Right Now'), published in 1888, was the publisher of Gauguin's autobiography, and later in his life returned to Roman Catholicism. Henri de Régnier (1864–1936), poet and novelist, was influenced by the symbolists but was a writer of marked originality. René Ghil (1862–1925), a poet of Mallarmé's circle, produced, among other works, a treatise on the colour and instrumental value of vowels, his *Traité du verbe* ('Treatise on the Word'), published in 1886. Albert Aurier (1865–92), writer and art critic, was one of the founders of the *Mercure de France*, an influential literary magazine; an early admirer of Gauguin, he also wrote studies of van Gogh, Monet and Pissarro. The poet Saint-Pol-Roux, nicknamed 'le Magnifique' (1861–1940), belonged to the symbolists, but retained his own romantic manner and heritage and at the same time pointed towards modernist developments of this century. Georges Rodenbach (1855–98) was a Belgian poet and novelist, best known for his collections, *La Jeunesse blanche* ('White Youth') and *Le Règne du silence* ('The Kingdom of Silence'), published in 1886 and 1891 respectively. Robert, Comte de Montesquiou-Fezensac (1855–1921), was a minor symbolist poet; his *Les Hortensias bleus* ('Blue Hydrangeas') was published in 1896. For the Magi, see note 1; Dr Gérard Encausse, known as Papus le mage (1865–1916), was a poet and adept of occultism; Jules Bois (1871–1941) was a poet of the same circle.

62. I worship you as I do the nocturnal vault,
 O vase of sadness, O tall and silent one,
 And I love you the more, my beauty, in that you flee me,
 And that you seem to me, ornament of my nights,
 More ironically to accumulate the leagues
 That separate my arms from blue immensities.

 I advance to the attack, and I climb to the assaults,
 Like a choir of earthworms after a cadaver,
 And I cherish, O implacable and cruel beast!
 Even that coldness which makes you more beautiful to me.

 Flowers of Evil XXIV

63. DUELLUM

 Two warriors rushed at each other; their weapons
 Spattered the air with flashes and with blood.
 These games, this clash of iron are the din
 Of youth that is a prey to puling love.

 The blades are broken! like our youth,
 My dear! But the teeth, the steely nails,
 Soon avenge the sword and treacherous dagger.
 – Oh, the fury of mature hearts ulcerated by love!

 Into the ravine haunted by lynxes and leopards,
 Our heroes, coiling wickedly, have rolled,
 And their skins will make the arid brambles bloom.

 – That pit is hell, peopled by our friends!
 Let us roll there without remorse, inhuman amazon,
 To eternalize the ardour of our hatred!

 Flowers of Evil XXXV

64. THE STRANGER

'Whom do you love best, enigmatic man, tell me: your father, your
mother, your sister, or your brother?'

 'I have no father, or mother, or sister, or brother.'

'Your friends?'

'There you make use of a word the meaning of which has remained unknown to me to this day.'

'Your country?'

'I do not know in what latitude it is situated.'

'Beauty?'

'I would gladly love her, goddess and immortal.'

'Gold?'

'I hate it as you hate God.'

'Eh! what do you love, then, extraordinary stranger?'

'I love the clouds . . . the passing clouds . . . there . . . there . . . the wonderful clouds!'

The Spleen of Paris I

65. SOUP AND CLOUDS

My foolish little darling was giving me dinner, and through the open window of the dining room I was contemplating the shifting architectures that God makes from the vapours, wonderful constructions of the impalpable. And I was saying to myself as I contemplated: 'All this phantasmagoria is almost as beautiful as the eyes of my beautiful darling the monstrous little green-eyed fool.'

And all at once I got a violent punch in the back, and I heard a husky and charming voice, a hysterical voice, as if hoarse from brandy, the voice of my dear little darling, saying: 'Are you going to eat your soup one of these days, you d—— b—— of a cloud merchant?'

The Spleen of Paris XLIV

66. THE GALLANT MARKSMAN

As the carriage crossed the park, he had it stop in the vicinity of a shooting gallery, saying he would find it pleasant to take a few shots in order to *kill* Time. Is the killing of that monster not the most ordinary and legitimate occupation of each one of us? – And he gallantly offered his hand to his dear, delicious and execrable

wife, to that mysterious wife to whom he owes so many pleasures, so many pains, and perhaps also a large part of his genius.

Several shots hit wide of the mark; one even went into the ceiling; and as the charming creature laughed wildly, making fun of her husband's inaccuracy, the latter turned abruptly to her and said: 'Do you see that doll, there, to the right, that holds its nose in the air and has such a haughty look? Well, my dear angel, I am going to pretend that it's you.' And he closed his eyes and pulled the trigger. The doll was neatly decapitated.

Then bending towards his dear, his delicious, his execrable wife, his inevitable and pitiless Muse, and respectfully kissing her hand, he added: 'Ah, my dear angel, how I thank you for my accuracy!'

The Spleen of Paris XLIII

67.

The wind in the plain
Suspends its breath.
– Favart

It is languorous ecstasy,
It is amorous fatigue,
It is all the shivers of the woods
Amid the embrace of breezes,
It is the choir of small voices
Near the grey branches.

Oh, the frail and fresh murmur!
It babbles and lisps,
It resembles the soft cry
Breathed out by stirred grass . . .
You'd say the dull rolling
Of pebbles under turning water.

The soul that mourns itself
In this sleeping lament
Is ours, is it not?
Mine, say, and yours,

On this mild night, exhaling
Its soft antiphon.

Forgotten Ariettas I

68.

In the unending
Boredom of the plain
The uncertain snow
Shines like sand.

The sky is brass
Without any glimmer,
You'd think you were watching
The moon live and die.

Like cloud swarms greyly
The oak trees drift
In the nearby forests
Among the mists.

The sky is brass
Without any glimmer,
You'd think you were watching
The moon live and die.

Rasping crow
And you scrawny wolves,
What's coming to you
On these bitter blasts?

In the unending
Boredom of the plain
The uncertain snow
Shines like sand.

Forgotten Ariettas VIII

69.

I only want to think now of my mother Mary,
Seat of wisdom and source of forgiveness,
Mother of France also *from whom we await
Unshakeably the honour of our country.*

The correct title of the volume from which these lines come is *Sagesse* ('Wisdom'), without the article. It was published in 1881 and reflects Verlaine's conversion to Christianity after his imprisonment. The italics are Tolstoy's.

70. Hushed to the whelming low
Cloud of basalt and lava
Even to the slavish echoes
By a trumpet without virtue

What sepulchral shipwreck (you
know it, foam, but slaver there)
Supreme one among the wrecks
Abolishes the divested mast

Or that which furious for lack
Of some most high perdition
The whole vain abyss deployed

In the so white hair that trails
Will greedily have drowned
A siren's infant flank.

71. When he went out
(I heard the door)
When he went out
She gave a smile . . .

But when he came back
(I heard the lamp)
But when he came back
Another was there . . .

And I saw it was death
(I heard his soul)
And I saw it was death
Who waits for him still . . .

They came to say
(My child, I'm afraid)

They came to say
He was going away . . .

With lighted lamp
(My child, I'm afraid)
With lighted lamp
I went up closer . . .

At the first door
(My child, I'm afraid)
At the first door
The flame trembled . . .

At the second door
(My child, I'm afraid)
At the second door
The flame spoke . . .

At the third door
(My child, I'm afraid)
At the third door
The light died . . .

And if he comes back one day
What shall I tell him?
Tell him she died
Of waiting for him . . .

And if he asks more
Without seeing who I am,
Speak to him like a sister,
It may be he's suffering . . .

And if he asks where you are
What shall I tell him?
Give him my gold ring
And say nothing more . . .

And if he asks why
The room is deserted?

Show him the lamp dark
And the door open . . .

And if he asks me then
About the last hour?
Tell him I smiled
For fear he might weep.

72. Francis Vielé-Griffin (1864–1937), French symbolist poet born in Norfolk, Virginia, was a practitioner of *vers libres* (rhymed verse in irregular metres), though the sample Tolstoy gives in Appendix I is metrically regular.

73. The passage that follows comes from a diary kept by Tolstoy's daughter Tatiana Sukhotin-Tolstoy, an amateur painter herself, during a trip to Paris in February 1894. Tolstoy recasts the passage into masculine gender in the original.

74. ' . . . effects – fog effect, evening effect, sunset.'

75. Arnold Böcklin (1827–1901), Swiss painter, was the 'father' of German symbolist art, which in the younger generation included such painters and sculptors as Franz Stuck (1863–1928), Max Klinger (1857–1920) and Schneider (1870–1927). Böcklin also had a strong influence on the surrealists of this century, particularly Giorgio de Chirico.

76. The architect comes from *The Master-Builder* (1892), the old woman and child from *Little Eyolf* (1894), both plays by Henrik Ibsen. The blind men are from Maeterlinck's play *The Blind Men* (1891) and the bell is from *The Drowned Bell* (1896) by German playwright, Gerhart Hauptmann (1862–1946).

77. 'The quicker it goes, the longer it lasts.' Alphonse Karr (1808–90) was a witty Parisian pamphleteer.

78. Auguste, Comte de Villiers de l'Isle Adam (1838–89) was a symbolist prose writer, author of strange and fantastic works; his *Contes cruels* ('Cruel Stories') were published in 1883.

79. *Abscons* is a French adjective meaning 'recondite' or 'difficult to understand'.

80. Eugène Morel (b. 1865) is a now-forgotten French writer; the important literary magazine *Revue Blanche* ('White Review') serialized his novel *Terre promise* ('Promised Land').

81. Tolstoy includes in this rather distinguished list the name of the French painter Hippolyte (known as Paul) Delaroche (1797–1856), whose half-classical, half-romantic historical paintings had great success during the artist's lifetime.

82. The story of Joseph is told in Genesis 37–50. Shakya-muni (meaning 'the solitary shakya') was one of the names of Siddhartha Gautama (c. 563–483 BC), the Buddha ('enlightened one'), founder of Buddhism.

83. Sanskrit hymns collected in four sacred books, considered as revelations from Brahma, which the Aryans brought with them into India, forming the foundation of the religion of the Hindus.

84. 'All genres are good, except the boring genre' (Voltaire). Tolstoy's variants: 'All genres are good, except the one that is not understood' or 'that does not make its effect'.

85. 'Having much life experience'.

86. Edmond Rostand (1868–1918), French poet and playwright, is best known for his heroic comedy in verse, *Cyrano de Bergerac* (1897).

87. That is, *Hanneles Himmelfahrt* ('Hannele Goes to Heaven') by Gerhart Hauptmann, first produced in 1895.

88. 'There exists a special apparatus in which a very sensitive arrow, connected with the tension of the muscle of the arm, shows the physiological effect of music on nerves and muscles.' (Tolstoy's note.)

89. Quoted both times in English in the original (see note 60).

90. Alexander Ostrovsky (1823–86), the 'Russian Shakespeare', wrote over fifty plays – domestic tragedies, satires, poetical fairy tales, historical dramas; of this last sort, *Kozma Minin* (1862) is an example. Alexei Konstantinovich Tolstoy (1817–75), author of historical novels, also wrote a trilogy of historical dramas in verse, of which *Tsar Boris* (1870) is the third.

91. Karl Pavlovich Briullov (1799–1852), head of the Russian romantic school, painted historical subjects and court portraits.

92. In 1876 King Ludwig II of Bavaria built a theatre in Bayreuth for the production of Wagner's operas, which were and are still performed there at an annual festival.

93. The *czardas* (pl. *czardas*) is a Hungarian folk dance that begins slowly and ends in a wild whirl.

94. Tolstoy means 'Opus 101', but the error may be deliberate.

95. Paul Bourget (1852–1935), French essayist and novelist, was very popular in his day.

96. The unknown writer was a peasant, F. F. Tishchenko, with whom Tolstoy was in correspondence.

97. A *kulich* is a rich and dense yeast bread, cylindrical in form, baked especially for Easter.

98. Viktor Mikhailovich Vasnetsov (1848–1926), Russian artist, was among those who tried to adapt Church iconography to the techniques and tastes of nineteenth-century oil painting, with unfortunate results.

99. According to Aylmer Maude's 1898 English translation of *What Is Art?*, Tolstoy is referring here to the catalogue of the English Academy exhibition of 1897. Walter Langley (1852–1922) was an English genre painter. Delmas, whom Maude calls Dolman, we have not been able to identify.

100. Ernest Rossi (1827–96), Italian tragic actor, toured Russia in 1877 and 1896.

101. The Voguls are a hunting and gathering people of Ugro-Finnish origin who live in the northern Urals of western Siberia.

102. Tolstoy misquotes Luke 16:15: 'that which is highly esteemed among men is abomination in the sight of God'.

103. The story of the beggar Lazarus is in Luke (16:19–31). St Mary of Egypt, a prostitute of the fifth century who repented and then spent forty years in the desert, is one of the most greatly venerated saints in the Eastern Orthodox Church.

104. See John 17:21: 'That they all may be one; as thou, Father, art in me, and I in thee, that they also may be one in us: that the world may believe that thou hast sent me' (King James Version).

105. Ivan Nikolaevich Kramskoy (1837–87) was a Russian genre painter. Antoine Morlon (1868–1905) was a French painter of marine subjects.

106. Jean-François Millet (1814–75), French painter of the Barbizon school, painted rural scenes and landscapes of a touching pathos and sincerity. Jules Breton (1827–1906) was a French poet, writer and painter who painted village scenes and peasant life. Léon Lhermitte (1844–1925) was also a French painter of rural subjects. Franz von Defregger (1835–1921), an Austrian painter, depicted Tyrolean popular scenes.

107. Nikolai Nikolaevich Ge (1831–94), Russian genre painter, often applied himself to Gospel subjects, of which his *Judgement of the Sanhedrin* is an example. The full title of the painting by German artist Alexander Liezen-Mayer (1839–98) is *Queen Elizabeth Signing the Death Sentence of Mary Stuart*.

108. French painter Jean-Léon Gérome (1824–1904) depicts the end of a gladiatorial combat in the Roman circus in his painting *Pollice verso* ('Thumbs down' in Latin); his works are generally of a neo-Greek academic style.

109. 'In suggesting examples of what I consider the best art, I

do not attach much importance to my selection, since, besides being insufficiently informed in all kinds of art, I belong to the rank of people whose taste has been perverted by the wrong upbringing. And therefore I can, by old acquired habit, be mistaken, taking the impression that the thing produced on me when I was young for absolute merit. I cite examples of works of both kinds only in order better to clarify my thought, to show how I, with my present views, understand the merit of art by its content. I must note, besides, that I rank my own artistic works on the side of bad art, except for the story "God Sees the Truth", which wants to belong to the first kind, and the "Prisoner of the Caucasus", which belongs to the second.' (Tolstoy's note.)

110. Adelina Patti (1843–1919) was an Italian singer, born in Madrid, of European renown, who triumphed in the operas of Mozart, Rossini and Verdi. Maria Taglioni (1804–84) was a celebrated dancer.

111. Eugène-Melchior, Vicomte de Vogüé (1848–1910), a member of the Académie Française, wrote a study of the Russian novel which introduced the French to nineteenth-century Russian writers; he belonged to the neo-Christian movement inspired by Tolstoy and Dostoevsky in reaction to naturalism in literature and scientism in philosophy.

112. To this list of notorious 'supermen' Tolstoy adds the names of Stenka Razin (c. 1630–71), a Don Cossack who became a popular hero by leading a peasant uprising in 1667–70, and of the fictional character Robert Macaire, from the melodrama L'Auberge des Adrets (1823), played by the famous actor Frédérick Lemaître and made into a caricature of the swindler in the lithographs of Honoré Daumier.

113. Jules Bastien-Lepage (1848–84) was a painter of popular and sentimental subjects, later attracted to impressionism.

114. Tolstoy is referring to Christ's casting out of 'all them that sold

and bought in the temple' (see Matthew 21: 12–13, Mark 11: 15–17, Luke 19: 45–6).

115. Nikolai Ivanovich Lobachevsky (1793–1856), Russian mathematician, was one of the creators of non-Euclidean geometry; the title of his book on the subject is *Imaginary Geometry*.

116. The following are translations of the poems in Appendix I.

The Welcome

If you wish me to welcome you tonight at the fireside,
First throw away that flower which sheds its petals from your hand,
Its dear fragrance would make my sadness too gloomy;
And do not look behind you towards the darkness,
For I want you, having forgotten the forest
And the wind, and the echo, and what would speak
Voices to your solitude or tears to your silence!
And standing, with your shadow that precedes you,
Haughty on my threshold, and pale, having come
As if I were dead or as if you were naked!

Henri de Régnier
Games Rustic and Divine

Blue bird the colour of time

Do you know the oblivion
Of a vain sweet dream,
Scoffing bird
Of the forest?
Day pales,
Night falls,
And in my heart
The shade has wept;

Oh, sing me
Your wild scale,
For I have slept

The day around.
The cowardly alarm
Where my soul was
Sobs boredom
In the dying day . . .

Do you know the song
Of her speech
And of her voice,
You who repeat
In the sunset
Your frivolous tune
As you did before
In the noontimes?

Oh, then sing
The melody
Of her love,
My mad hope,
Among the golds
And conflagration
Of the vain soft day
That dies tonight.

Francis Vielé-Griffin
Poems and Verses

Enone of the Bright Face

Enone, I had thought that in loving your beauty
Where soul with body find their unity,
To go on mounting, ever firmer in heart and mind,
As far as that which never perishes,
Never having been created, which is not chill or fire,
Which is not beautiful somewhere and ugly somewhere else;
And I still flattered myself with a beautiful harmony
That I would have composed of best and worst,
As the singer who cherishes Polyhymnia,

By according low pitch and high, draws
So lofty a sound from the nerves of his lyre.
But, alas! my courage, fainting as in death,
Taught me that the dart which had made me a lover
Did not come from that bow effortlessly bent
By the Venus who is born solely of the male,
But that I had suffered from that latter Venus,
Cowardly of heart, born of a feeble mother,
And yet that wicked boy, a skilful hunter,
Who loads his quiver with subtle feathered shafts,
Who, laughing, shakes his torch, for a day,
Who only alights upon the tender flowers,
Dries the tears on a charming complexion,
And still he is a god, Enone, this Amor.
But let it be, the birds of spring have flown,
And the sun's rays I see are grown subdued.
Enone, my sorrow, harmonious face,
Superb humility, gentle honest speech,
Yesterday looking at myself in that frozen lake
Covered under foliage at the garden's end,
Upon my face I saw that the days have gone.

Jean Moréas
The Passionate Pilgrim

Shady Lullaby

Forms, forms, forms
White, blue, pink and gold
Will come down from the tops of the elms
On the child lulled back to sleep.
 Forms!

Plumes, plumes, plumes
To make up a soft nest.
Noon strikes: the anvils
Stop; the noise is stilled . . .
 Plumes!

Roses, roses, roses
To perfume her sleep,
Your petals are sullen
Next to her ruby smile.
 Oh roses!

Wings, wings, wings
To murmur at her brow,
Bees and dragonflies,
Rhythms to rock her by.
 Wings!

Branches, branches, branches
To plait into a bower,
Through which less candid lights
Will fall on the little chick.
 Branches!

Dreams, dreams, dreams
In her half-opened thoughts
Slip a little falsehood
Through which life can be seen.
 Dreams!

Fairies, fairies, fairies
To spin out their skeins
Of mirages, of cloud puffs,
In all their little heads.
 Fairies!

Angels, angels, angels
To carry off in the ether
These strange little children
Who don't want to remain . . .
 Our angels!

Comte Robert de Montesquiou-Fezensac
Blue Hydrangeas

ANNA KARENINA

'All the variety, all the charm, all the beauty of life is made up of
light and shadow'

The heroine of Tolstoy's epic of love and self-destruction, Anna
Karenina has beauty, wealth, popularity and an adored son, but
feels that her life is empty until she encounters the impetuous
officer Count Vronsky. Their subsequent affair scandalizes society
and family alike, and brings jealousy and bitterness in its wake.
Contrasting with this is the vividly observed story of Levin, a man
striving to find contentment and a meaning to his life – and also
a self-portrait of Tolstoy himself. This award-winning translation
has been acclaimed as the definitive English version of Tolstoy's
masterpiece.

Translated by Richard Pevear and Larissa Volokhonsky
with a Preface by John Bayley

ISBN: 978 0 14 044 9174

WAR AND PEACE

'God is the same everywhere'

At a glittering society party in St Petersburg in 1805, conversations
are dominated by the prospect of war. Terror swiftly engulfs the
country as Napoleon's army marches on Russia, and the lives of
three young people are changed forever. The stories of quixotic
Pierre, cynical Andrey and impetuous Natasha interweave with a
huge cast, from aristocrats and peasants, to soldiers and Napoleon
himself. In *War and Peace* (1868-9), Tolstoy entwines grand
themes – conflict and love, birth and death, free will and fate –
with unforgettable scenes of nineteenth-century Russia, to
create a magnificent epic of human life in all its imperfection
and grandeur.

Translated with an Introduction and Notes by Anthony Briggs
with an Afterword by Orlando Figes

ISBN: 978 0 14 044 7934

THE NEED FOR ROOTS

Simone Weil

'Rootedness is perhaps the most important and least known
human spiritual need'

What do humans require to be truly nourished? Simone Weil, one
of the foremost philosophers of the last century, envisaged us all
as being bound by unconditional, eternal obligations towards
every other human being. In *The Need for Roots*, her most famous
work, she argued that our greatest need was to be rooted: in a
community, a place, a shared past and collective future hopes.
Written for the Free French movement while she was exiled in
London during the Second World War, Weil's visionary
combination of philosophy, politics and mysticism is her
answer to the question of what life without occupation - and
oppression - might be.

Translated by Ros Schwartz
with an introduction by Kate Kirkpatrick

ISBN: 978 0 24 146 797 8

A ROOM OF ONE'S OWN

Virginia Woolf

'But, you may say, we asked you to speak about women and fiction – what has that got to do with a room of one's own?'

A Room of One's Own grew out of a lecture that Virginia Woolf had been invited to give at Girton College, Cambridge in 1928 and became a landmark work of feminist thought. Covering everything from why a woman must have money and a room of her own if she is to write, to authors such as Jane Austen, Aphra Behn and the Brontë sisters, and the tragic story of Shakespeare's fictional sister Judith, it remains a passionate assertion for female creativity and independence in a world dominated by men.

ISBN: 978 0 24 138 752 8

AS I CROSSED A BRIDGE OF DREAMS

Lady Sarashina

'I lie awake,
Listening to the rustle of the bamboo leaves,
And a strange sadness fills my heart'

As I Crossed a Bridge of Dreams is a unique autobiography in
which the anonymous writer known as Lady Sarashina intersperses
personal reflections, anecdotes and lyrical poems with accounts
of her travels and evocative descriptions of the Japanese country-
side. Born in 1008, Lady Sarashina felt an acute sense of melancholy
that led her to withdraw into the more congenial realm of the
imagination – this deeply introspective work presents her vision
of the world. While barely alluding to certain aspects of her life
such as marriage, she illuminates her pilgrimages to temples and
mystical dreams in exquisite prose, describing a profound
emotional journey that can be read as a metaphor for life itself.

Translated with an Introduction by Ivan Morris

ISBN: 978 0 14 044 282 3